REFLECTIONS OF CALIFORNIA *The Athalie Richardson Irvine Clarke Memorial Exhibition*

This book was published in conjunction with
Reflections of California: The Athalie Richardson Irvine Clarke Memorial Exhibition

EXHIBITION ITINERARY

Richard Nixon Library and Birthplace
Yorba Linda, California
5 May 1994 through 5 September 1994

Jimmy Carter Library
Atlanta, Georgia
15 October 1994 through 15 January 1995

The Irvine Museum
Irvine, California
23 February 1995 through 17 June 1995

Palm Springs Desert Museum
Palm Springs, California
19 September 1995 through 21 January 1996

Copyright ©1994 The Irvine Museum
Twelfth Floor
18881 Von Karman Avenue
Irvine, California 92715

Library of Congress Catalog Card Number 94-076124
ISBN 0-9635468-2-1
Printed in the United States of America

COVER:
Paul DeLongpre (1855–1911)
Wild Roses (detail), 1898
watercolor, 15 x 24 inches

TITLE PAGE:
Jack Wilkinson Smith (1873–1949)
Crystal Cove State Park
oil on canvas, 52 x 70 inches

Athalie Richardson Irvine Clarke, 1986.
Photo by Figge Photography, Newport Beach.

TABLE OF CONTENTS

Jean Stern

Joan Irvine Smith

REFLECTIONS

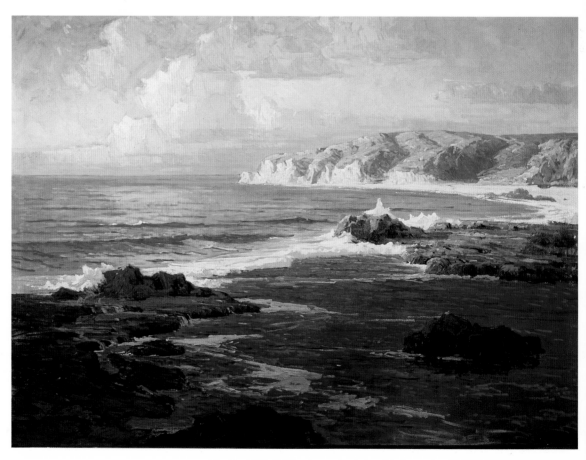

OF CALIFORNIA

The Athalie Richardson Irvine Clarke

Memorial Exhibition

The Irvine Museum

RICHARD NIXON

February 24, 1994

 My congratulations to the Irvine Museum, the
Nixon and Carter Libraries, and the other venues
selected for the exhibition being mounted in honor
of my longtime friend Athalie Clarke.

 The paintings selected for the show are
filled with sunlight and warmth -- both words that
remind me of Athalie. What I hope people remember
most about Pat Nixon is the sunshine of her smile.
The same is true of Athalie Clarke. Mrs. Nixon
was my First Lady. Mrs. Nixon and I always agreed
that Athalie was our First Lady.

Richard Nixon

2-24-94

INTRODUCTIONS

The Irvine Museum is pleased to organize this memorial exhibition, *Reflections of California,* in remembrance of Athalie Richardson Irvine Clarke, who died last year after ninety years of vigorous and spirited life. Among her many accomplishments, Athalie R. Clarke, together with her daughter, Joan Irvine Smith, founded The Irvine Museum in 1992. This exhibition of California Impressionist paintings offers a wonderful way to portray her remarkable life and, at the same time, to share with our patrons the wondrous joy and the extraordinary beauty of California Impressionist art.

Moreover, we are grateful to the three distinguished institutions that have joined us in presenting this exhibition to their constituents: the Richard Nixon Library and Birthplace in Yorba Linda, the Jimmy Carter Library in Atlanta, and the Palm Springs Desert Museum. Each in its own way represents a distinct aspect of Athalie R. Clarke's life. She was a close friend and stalwart supporter of President Richard M. Nixon, from his very early days in California politics; President Jimmy Carter reappointed her to the Committee for the Preservation of the White House, an assignment which originated with the Nixon Presidency and continued under President Gerald R. Ford; and she always kept a warm and nostalgic spot in her heart for the desert community of Palm Springs, a place she loved throughout her adult life.

Finally, we are most appreciative and grateful to Joan Irvine Smith, who devoted much of her time and energy these past few months to a labor of love: researching and preparing her insightful and intimate narrative about the life of Athalie R. Clarke, her mother.

JEAN STERN
Executive Director, The Irvine Museum

Joseph Kleitsch (1882–1931), *San Juan Capistrano,* 1924 (detail), oil on canvas, 24 x 30 inches

RICHARD NIXON LIBRARY & BIRTHPLACE

The Athalie Richardson Irvine Clarke Memorial Exhibition is an apt tribute to a legendary Californian, Athalie Clarke, whose life is inextricably a part of the flower-drenched mountain vistas and warm garden scenes depicted in the works The Irvine Museum has chosen for the exhibition. The Richard Nixon Library & Birthplace, dedicated to the life and times of another quintessential Californian, and indeed the only President born in the Golden State, is honored to be the exhibition's first venue.

Athalie Clarke was Orange County's first lady, Richard Nixon its favorite son. Together, they were a mighty team. Beginning in the late 1940s, Mrs. Clarke was one of Congressman, Senator, Vice President, and finally President Nixon's most enthusiastic supporters, volunteers, dinner-ticket sellers, and, not incidentally, political advisors.

The Nixon archives are full of letters, memoranda, newspaper clippings, and other items detailing the broad range of the relationship. When Judge and Mrs. Clarke visited Washington during the 1950s, the visit was not complete without a call on the Vice President. When Nixon was planning his 1962 gubernatorial candidacy, one of his first letters was to the Clarkes, seeking advice and counsel. When he needed a quiet place to write his acceptance speech for the 1972 Republican convention, he again turned to Mrs. Clarke, who offered her house in Corona del Mar.

As in all great friendships, ties between President Nixon and Mrs. Clarke were strengthened by adversity. After he and Mrs. Nixon had left the White House in 1974 and come home to California, Athalie Clarke was steadfast and true. Early in 1979, she learned that President Carter had invited the former President to the White House for a dinner in honor of Chinese leader Deng Xiaopeng. The message she flashed to the San Clemente office was typical of her: if he wanted to stay at her farm near the capital, she said, "the fires will be lit and the staff will be waiting to welcome him with open arms."

Throughout her life, from her support of his congressional candidacy to her loyal service as a founding member of the Board of Directors of our institution, Mrs. Clarke always went the extra mile for Richard Nixon. But even he may not have realized how many extra miles she was willing to go until 1960, when he was preparing for his first campaign for the Presidency.

He had always lauded Mrs. Clarke for her indefatigable energy in selling tickets to the fund raisers that are the lifeblood of any political career.

He always said that if Athalie Clarke was chairwoman of an event, it was certain to be a success. That June he received a letter from Mrs. Clarke on the stationery of the Grand Hotel in Oslo. She and Judge Clarke were touring Scandinavia following a visit to the Soviet Union, and she wanted the Vice President to know that she had sold a table to every American in their Soviet tour group for a dinner she was putting together for him later that summer in Los Angeles — including a young Texan who had been a lifelong Democrat. The grateful Vice President's reply: "It is a rare person who can make Republican political hay while in Moscow!"

In a high-tech age it is easy to forget that political success is nurtured by old-fashioned, timeless values such as friendship, loyalty, and faith. It is hard to imagine Richard Nixon accomplishing all that he did without the friendship of Athalie Clarke — whose own life in turn was greatly enriched by her public service, including her support of the 37th President. Those who visit this exhibition, and see these artists' visions of the landscapes from which these two extraordinary Americans sprang, will learn much about them, and about the boundless spirit of California they personified.

JOHN H. TAYLOR
Director

Jimmy Carter Library

The Museum of the Jimmy Carter Library is pleased to be one of the institutions presenting this special exhibition of paintings from the collection of Mrs. Athalie Richardson Irvine Clarke. Mrs. Clarke was appointed to the Committee for the Preservation of the White House by President Jimmy Carter in 1977. During their time in the White House, President and Mrs. Carter took great pride in their work with the Committee to build and maintain a collection of historically and artistically important furnishings and artwork in their home, the President's house.

The great benefit of this tribute to Mrs. Clarke is the opportunity to take part in her love of the California landscape. President and Mrs. Carter share with Mrs. Clarke a deep and abiding appreciation for the natural beauty of this country. The Museum of the Carter Library joins with The Irvine Museum in honoring Mrs. Athalie Richardson Irvine Clarke for her service through this memorial exhibition.

Donald B. Schewe
Director

Palm Springs Desert Museum

On behalf of the Palm Springs Desert Museum, I express sincere gratitude to The Irvine Museum for generously lending the Athalie Richardson Irvine Clarke Memorial Exhibition for presentation in Palm Springs. Passionately committed to California art — its acquisition, care, placement and exhibition — the Irvine family has made significant contributions to the preservation of California's artistic heritage.

Our Museum has a particular interest in traditional California art and is captivated by The Irvine Museum's eagerness to share the richness and joy of art personally collected by Mrs. Clarke. In many ways the transcendental mood of the paintings reflects the contemplative nature of our desert environment. While the paintings in this collection reveal the influence of traditional academic styles, many were painted by artists who came to California at the turn of the twentieth century questioning established values. These artists were inclined to take risks and perceive reason and emotion as an entanglement from which profound points of view could emerge. In these works, viewers are offered diverse approaches to painting, which lead to a better understanding and appreciation of California's art legacy. In this collection there is a powerful concentration of visual energy, intense emotion and vibrant color. The body of work has an astonishing consistency of quality that proclaims Mrs. Clarke's commitment to the serious challenges of art collecting. It is a pleasure for the Palm Springs Desert Museum to share these paintings with our desert community. Not only are they aesthetic and instructive, they also serve to foster and encourage the community's active support of the visual arts.

KATHERINE PLAKE HOUGH
Director of Collections and Exhibitions

PROLOGUE

Athalie R. Clarke, Orange County's beloved "First Lady," greeted her own mortality with the grace and wisdom that colored her life. "When the time is right," she told her only child, Joan Irvine Smith, "the fruit will fall. You must not grieve. I will go to be with your father and with my parents."

"Symbol of a vanishing generation...matriarch...grande dame... twentieth century pioneer...a woman of valor, [Mrs. Clarke leaves behind] a legacy of causes well served and a country whose topography she helped shape. Orange County is better because of her," editorialized the *Los Angeles Times*.

"She was a giving, loving, understanding, compassionate person," Joan Irvine Smith said when her mother died at age 90. "She watched over all of us. She wasn't just a mother, she was my best friend and staunchest supporter and ally. We were partners in everything. Now that she is no longer here to counsel us directly, I feel her presence even more intimately. She is a guardian angel for all of us."

When he learned of Mrs. Clarke's death, Richard M. Nixon, former President of the United States, said from his home in Park Ridge, New Jersey, "Athalie Clarke's loss is an enormous one for the nation and for the State of California. I knew her as a volunteer in my early campaigns. I knew her as a great Republican. I knew her as an advisor. I knew her as a legendary philanthropist. I knew her as a wonderful wife and mother. And I knew her as a friend. Her vision, energy and generosity transformed the face of Orange County, and Orange County cannot be the same without her."

Former President Gerald R. Ford described Mrs. Clarke as, "A good friend and great American . . . [Mrs. Ford and I] knew her well because of her deep feeling for the White House and what it represented in the history of our nation. I was honored to have the opportunity to appoint Mrs. Clarke to the Committee for the Preservation of the White House, where she served with distinction. Her relatives should be very proud of her fine contributions to the preservation of the White House and others which are historically significant."

Former President Jimmy Carter said in a letter to Mrs. Joan Irvine Smith, "Rosalynn and I were saddened to learn of Athalie Clarke's death. You can be proud of the many years your mother dedicated to the Committee for the Preservation of the White House. She will be greatly missed by the many people whose lives she touched."

Athalie Richardson Irvine Clarke, 1903–1993

Former President Ronald Reagan said, "Athalie was a dedicated servant to her government and society. Her work on the Committee for the Preservation of the White House contributed so much to the protection of a cherished American treasure. She will be sorely missed."

Mrs. Clarke spent over four decades shaping the transformation of Orange County from the lima beans and citrus of yesterday to today's urban landscape. Working closely with her daughter, Joan Irvine Smith, Mrs. Clarke encouraged the Irvine Company to make a significant gift of land to the University of California for a new campus on the Irvine Ranch and to adopt a master development plan for the Irvine Ranch lands.

Mrs. Clarke became an active and sophisticated investor. She managed farming and commercial real estate investments. She served as a director of the Irvine Company until she relinquished her seat to her daughter in 1957. Together, they crusaded for responsible development of the Irvine Company's vast holdings long before the "shareholder activism" of today. Mrs. Clarke also served as a director of the Irvine Industrial Complex until its dissolution. The "lady pirates," as Athalie dubbed herself and Joan after reading a newspaper article, "fought some tough battles when most people expected a woman mainly to stay out of sight," according to the *Times*. Irvine historian Judy Liebeck commented shortly after Mrs. Clarke's death, "She was nobody's fool . . . Athalie and her daughter Joan were two women in a county of men, in an era when everything was male. All these men were trying to shove them around." Mrs. Clarke and her daughter persevered, and they emerged stronger and as determined as ever.

Public service both through philanthropic endeavors and personal leadership was an important component of Athalie Clarke's life. Near the end of that life, she again joined with her daughter to found The Irvine Museum. Athalie loved California Impressionist paintings. Beyond aesthetics, however, it was a way she could share her recollections of the California she had known as a girl. Through it, she hoped to inspire a sense of environmental responsibility. With it, she has left a legacy for us all.

RUSSELL G. ALLEN
Member of the Board of Directors, The Irvine Museum

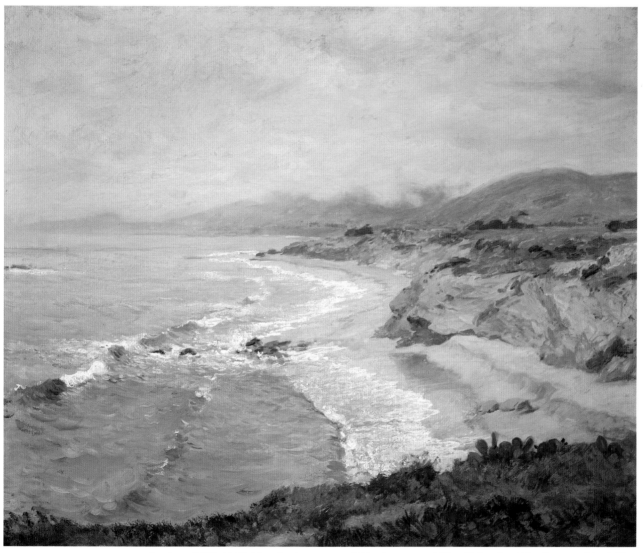

Guy Rose (1867–1925), *Lifting Fog, Laguna,* circa 1916, oil on canvas, 23 $^1/_2$ x 28 $^1/_2$ inches. Gift of James and Linda Ries.

REFLECTIONS OF CALIFORNIA: THE PLEIN AIR PERIOD 1890–1930

JEAN STERN

Starting with the late 1880s and continuing into the early part of the twentieth century, artists working in California produced an artistic style which focused primarily on the boundless landscape and unique light of this Golden State. This style, which is often called California Impressionism or California Plein Air painting, after the French term for "in the open air," combined several distinctive aspects of American and European art.

As a regional variant of American Impressionism, the California Plein Air style is an amalgam of traditional American landscape painting with influences from French Impressionism. It is part of the continuum of American art's passion with landscape, a lineage that began with the early years of the American Republic and, during most of the nineteenth century, found its greatest expression in the works of a group of artists known as the Hudson River School. This group of landscape artists, led by Thomas Cole (1801–1848) and Asher B. Durand (1796–1886), ventured into the "wilderness" of upstate New York. They were in awe of the beauty and grandeur of nature and developed a popular and long-lived style that centered on landscape as a primary subject.

At the same time, America nurtured a vigorous school of painters who recorded the "ordinary things" of American life. These genre painters, most notably Winslow Homer (1836–1910), specialized in scenes of everyday life in a country that, at the time, was perceived as a land of farms and small towns.

The tradition of American landscape painting is inseparable from the American spirit. Indeed, from Colonial times, American art had been governed by two dominant factors: the absence of religious patronage and a penchant for portraying the everyday character of American life. Landscape painting was an ideal vehicle in both cases, as it afforded an avenue to express God and Nature as one, an understanding of spirituality that disavowed religious patronage, and it created a metaphor of the American landscape as the fountainhead from which sprang the bounty and opportunity of rustic American life. In both circumstances, the artist's objective was for careful and accurate observation; thus Realism and its associated variants was the style of choice. The desire for realistic portrayal of forms has always been associated with American art.

John Gamble (1863–1957),
Santa Barbara Landscape (detail),
oil on canvas, 24 x 36 inches

Ironically, latent puritanical roots in American society played a minor yet critical role in fostering landscape painting. The representation of the human figure, particularly the female figure, although popular and conventional in Europe, met with considerable opposition in America. It was widely believed that figure painting fostered sensual and carnal desires and, if unchecked, would lead to the corruption of American morals. This societal restriction compelled many of our best figure artists to work and exhibit in France. In America, the best nude figure works of the mid nineteenth century could only be created and displayed, indeed to large crowds, after being "clothed" with the cachet of idealism, such as allegory, history or mythology.

Throughout the greater part of western cultural history, the principal patron of the artist was the religious establishment. Up until the Renaissance, and especially during the Middle Ages, artists were uniquely employed by the church, primarily to illustrate the stories of the Old and New Testaments to a society where very few people could read, and also to create an atmosphere conducive to spiritual devotion. This inherent religious sponsorship of the arts lasted until the rise of centralized political leaders, which began in the early Renaissance. This new sponsor demanded art of heroic and historical nature, aimed at justifying the role of the patron rulers. Later still, the institutionalization of a moneyed class based on commerce created a demand for genre and decorative works, whose purpose was to manifest the social position of the patron.

The artist as political propagandist is a time honored role. The rulers of ancient Rome, starting with Julius Caesar himself, realized the advantage that was gained from having their portraits placed on coins, the money issued in payment for the services and loyalty of the army that kept them in power. Later, with the demise of the feudal system, the artist played a vital role in institutionalizing the rising class of nationalistic rulers, often referred to as "Petty Kings" and "Tyrants" and exemplified by the Prince in Machiavelli's opus.

What Michelangelo did for the Medici and what Jacques-Louis David did for Napoleon could not happen in America. The American political system has always been democratic and none of our rulers has ever needed to embody his power as "by the Grace of God." The constitutional separation of church and state and the rejection of the monarchial system precluded any exclusive artistic sponsorship in church or political matters. Thus, the artist in America gravitated to genre painting, the representation of everyday or ordinary life, and also to landscape painting.

Towards the middle of the nineteenth century, a widespread and forceful artistic movement swept across Europe. That movement was Realism. Realism's purpose was to give a truthful, objective and impartial representation of the real world, based on meticulous observation of contemporary life.

The French were quick to adopt and popularize Realism. As practiced by Gustave Courbet (1819−1877) and Jean Francois Millet (1814−1875), it became associated with social activism and thus met with considerable resistance among the French art community.

In France, a prominent aspect of Realism was directed towards nature and embraced its social mission by emphasizing life in the rustic settings of France. Coming at the height of the adverse consequences of the Industrial Revolution, with its attendant mass urbanization, environmental pollution and social transformations, Realism repudiated the urban environment and harkened to the idyllic life of the immediate past, to a time, real or imagined, when people were in harmony with nature and its bounty. It was a movement to democratize art, affiliated with other

mid-century demands for social and political democracy.

Declaring that art must have relevance to contemporary society, the Realists refused to paint moralistic or heroic models from the past and instead directed their attention to themes that acclaimed people and events in more commonplace circumstances and in their own time. In that vein, Millet, who painted the daily life of the French farmer, promoted an idealistic and romantic model emphasizing the dignity of peasant life. While Millet favored figural scenes over pure landscapes and chose the farm as his subjects, he nonetheless worked in a studio and painted from posed models.

Theodore Rousseau (1812–1867) and Charles-Francois Daubigny (1817–1878) were among a group of Romantic-Realist painters who specialized in landscape painting. They imbued their works with a dramatic sense of light, most often energizing their compositions with vivid end-of-the-day sky effects. These plein air artists lived and painted in the village of Barbizon, thus giving name to this aspect of Realism, a romantic model of people and nature handled with a broader stroke and coupled with dramatic lighting. The Barbizon Style found a quick and willing group of followers in late nineteenth century Europe and America.

George Inness (1825–1894) was the most respected American landscape painter of his time. As the principal artist of the "third generation" of Hudson River School painters, his conversion to the Barbizon style spurred a large following of landscape painters to do the same.

The art of painting underwent a revolution starting in the 1860s. The cumulative result of a systematic study of light and color, coupled to a rising interest in scientific observation and the preference by artists for on-site plein air painting, modified the age-old effort of trying to capture or duplicate the true, natural representation of

Anna Hills (1882–1930), *Summer in the Canyon,* oil on canvas, 18 x 26 inches

John Frost (1890–1937), *The Pool at Sundown,* 1923, oil on panel, 24 x 28 inches

light to representing the *effect* of light in terms of an optical stimulus/response sensation.

This revolution in art was spurred by numerous scientific color theories that were circulated in the latter part of the 19th century. This trend was prompted by newly published scientific investigations of physiological optics and, most importantly, in the active involvement of the artists in these fields. The artistic inheritors of this revolution were the Impressionists in the early 1870s, and, more so, the Neo-Impressionists in the 1880s.

Among the many color theories that influenced art in the late nineteenth century, the most popular were those of Eugene Chevreul, originally published in French in 1839 with an English translation appearing in 1872. Chevreul was a consulting chemist who was asked to improve the quality of dyes used in a tapestry factory. He conducted many experiments, looking for ways to produce colors that were more vivid. He deduced that the role of the chemist was not as important as the role of the artist, and that more potent dye formulations would not significantly improve results as effectively as proper color placement.

Thus evolved Chevreul's Law of Simultaneous Contrast of Colors. It states, in part, "The apparent intensity of color does not depend as much on the inherent pigmentation . . . as it does on the hue of the neighboring color." Furthermore, Chevreul states, "When two colored objects are scrutinized together, the color of each will be influenced by the complementary color of its neighbor." Moreover, "In the case where the eye sees at the same time two contiguous colors, they will appear as dissimilar as possible, both in their optical composition and in the height of their tone."

Chevreul's work was truly revolutionary because it was based on recent advancements in the scientific study of physiological optics. His law explored the role of color as a stimulus on the human eye, not necessarily on its role in nature. He advised the artist to realize that, "There are colors inherent to the model which the painter cannot change without being unfaithful to nature [and] there are others at his disposal which must be chosen so as to harmonize with the first." In addition, he cautioned, "The greater the difference between the colors, the more they mutually beautify each other; and inversely, the less the difference there is, the more they will tend to injure one another."

A variety of scientific theories of color were quickly accepted and systematized by the Impressionists in the early 1870s and to a greater degree by the Neo-Impressionists, followers of Georges Seurat (1859–1891), in the 1880s. The immediate outcome of this scientific infusion in art was the appearance of intensely bright paintings, particularly in sunlit outdoor scenes. The utilization of the previously discussed laws of color contrast and color harmony enabled the artist to present the effect of intense sunlight and, at the same time, the effect of cool, lively shade,

without arbitrarily darkening the shadow. Overall, the Impressionist painting was designed to create movement on the optical plane by the juxtaposition of selected color patches, a movement which closely approximated the natural fluidity of light.

The concerns of artistic methodology and preference of subject matter caused the Impressionists to part company with the Realists. Technically speaking, the Realism of Courbet and the Romantic-Realism of Daubigny were in effect academic approaches, differing only in subject matter and objective content. Like Realism, its immediate predecessor, Impressionism repudiated most of the tenets of the Academy. The time consuming, over-worked method of painting which required days or weeks to produce a painting was spurned by the Impressionists. They lamented the artificiality of light and color which often characterized an academic canvas, a consequence of painting in the studio. Impressionists preferred instead to paint directly on primed canvas and to set the easel out-of-doors.

Philosophically, Impressionists sought more relevance in subject matter, turning to everyday life for artistic motivation. They aspired for art that reflected the people as they were, and that necessitated acceptance of the urban setting and rejection of the false ideal of peasant life as simply another artistic convention not based on reality. Reluctant to pose a composition, Impressionists explored the "fleeting moment" or the "temporal fragment" in ordinary life. Where the Realists yearned for a contemporary view of history, the Impressionists sought an instantaneous view.

Impressionism made its debut in Paris in 1874. The new style of painting was greeted with much criticism and derision. In all, the small group of painters, including Claude Monet (1840–1926), Camille Pissarro (1830–1903), Pierre-Auguste Renoir (1841–1919), Edgar Degas (1832–1917), Alfred Sisley (1839–1899), Georges Seurat and Paul Cezanne (1839–1906), among others, exhibited together only eight times. Strong disagreements over theory and practice led to the eventual break-up. Mary Cassatt (1844–1926), an American painter living in France, was accepted as a member of the group in 1879, and participated in later exhibitions. Theodore Robinson (1852–1896), lived a great part of his short life in France and was a friend of Claude Monet. Although he did not exhibit

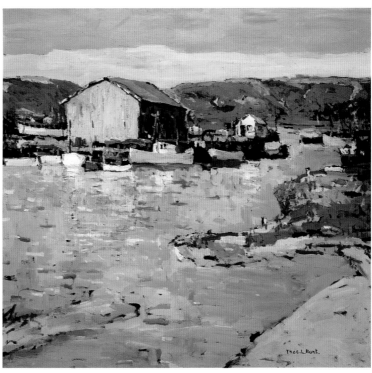

Thomas L. Hunt (1882–1938), *Newport Harbor,* oil on canvas, 28 x 31 inches

with the Impressionists, he nevertheless was one of the first American artists to return to the United States espousing Impressionism.

The first exhibition of French Impressionist paintings in America was held in Boston in 1883. The display consisted of works by Monet, Pissarro and Sisley, among others. In 1893, the World's Columbian Exposition in Chicago had a significant art section devoted to American Impressionist painters, and in 1898 "The Ten American Painters" was formed in New York. "The Ten" was a group of professional Impressionist artists who organized for the purpose of exhibition and sale of their paintings. They were Frank W. Benson (1862–1951), Joseph De Camp (1858–1923), Thomas W. Dewing (1851–1938), Childe Hassam (1859–1935), Willard L. Metcalf (1853–1925), Robert Reid (1862–1929), E. E. Simmons (1852–1931), Edmund C. Tarbell (1862–1938), John H. Twachtman (1853–1902), J. Alden Weir (1852–1919) and William Merritt Chase (1849–1916), who was invited to join after the death of Twachtman.

Just as the original group of French Impressionists consisted of diverse personalities with disparate aims and philosophical approaches, American Impressionists likewise were practicing different forms of the style, and on occasion straining the limits of what can be loosely defined as Impressionism. There was no theoretician to lead the movement.

Moreover, Impressionism came to America at least a decade after its riotous debut in France. As such, American painters benefited from the soothing effects of time on a critical art public. Also, they had the luxury of picking and choosing from among a number of techniques and approaches, many of which were developed by artists who had progressed beyond Impressionism. These methods concerned themselves with specific uses of subject, color and line, and related to painting techniques followed by Post-Impressionist artists such as Paul Gauguin (1848–1903) and Vincent van Gogh (1853–1890).

By 1900, Impressionism, or what may be more properly termed "Impressionistic Realism," was the style of choice among American painters. Stylistically, it was a modified and somewhat tempered variant of the prototype French movement. The significant contributions of French Impressionism to American art were in the use of color and the specialized brushwork. Americans, in general, did not dissolve forms, a common practice with Claude Monet and his followers. The penchant for realistic observation of scenes, long a staple of American painting, survived the Impressionist onslaught. The scientific theories of color, as revealed by Chevreul, were indeed well received by Americans, even by those who did not consider themselves Impressionists, and the outcome showed in paintings with brilliant and convincing effect of natural light. The loose, choppy brush stroke that characterizes an Impressionist work was both the consequence of the quick manner of paint application and the desire to produce a brilliant surface covered with a multitude of small daubs of bright color.

The principal American teacher of Impressionism was William Merritt Chase. At first with the Art Students League in New York, and later in his own art school in New York City and at Shinnecock, Long Island, Chase was insistent on imparting to his students the discipline and technique of painting "en plein air." To impress on them the necessity for quickness when painting outdoors, he admonished them, "Take as long as you need to finish the painting, take two hours if necessary."

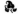

California in the late 1880s was a relatively isolated part of the world. The opening of the transcontinental railroad in 1869 confirmed San Francisco as the capital of the West, a title bestowed earlier in the 1850s with the thousands of arrivals caught up in the Gold Rush. Los Angeles was by contrast a sleepy hamlet. In 1876, a railway was laid between San Francisco and Los Angeles, affording access to products from the rich agricultural lands around Los Angeles.

Finally, in 1885, the Southern Pacific Railway opened a route from Chicago to Los Angeles and started a cycle of land booms which continued into the twentieth century.

The first influx of artists in California came with the Gold Rush. They produced narrative works of life in the gold fields as well as still-life and topographical views of San Francisco. Eventually, they found patronage with the social elite of San Francisco, and by the latter part of the nineteenth century, the dominant art style in California was French inspired, with landscapes that relied heavily on influences from the Barbizon School. The best known of these San Francisco Barbizon painters was William Keith (1839–1911), whose paintings are often moody, late-in-the-day pastorals, with somber tones and darkening shadows of deep browns, all of which were attributes of the later works of George Inness.

The most prominent early artist in Los Angeles was Elmer Wachtel (1864–1929), who came in 1882 and supported himself as a concert violinist as well as a painter. Even though he studied with William Merritt Chase in New York, Wachtel's early works are markedly in the dark, moody tonalities of the Barbizon aesthetic, with glimpses here and there of an elegant line reminiscent of Art Nouveau. *In the Arroyo Seco* (page 132) is one of these moody, tonal notes on California's landscape. In time, and with the influence of Impressionism, he lightened his palette and used brighter color harmonies.

Home of Paul DeLongpre, Hollywood, California.
Photo courtesy of George Stern Fine Arts, Encino

By 1890, many artists in southern California were young, Impressionist inspired painters. As they were unable find a niche in San Francisco, where the tastes and demands of the art establishment called for more traditional styles, they had come south. Others were visitors who traveled here in search of picturesque and unusual subject matter and on occasion settled here.

Benjamin C. Brown (1865–1942) visited California as early as 1885 and settled in Pasadena in 1896, where he taught painting to supplement his income as an artist. His style is boldly Impressionistic, with a profusion of bold colors applied in strong, definite strokes. *Poppy Field near Pasadena* (page 35) shows Brown's brilliant use of masses of small daubs of color.

Early in his career, Brown exhibited in a New York art gallery and was meeting considerable success. The art dealer suggested that they could boost sales by concealing that Brown was a Californian. Brown protested loudly and from that point, he always put "California" boldly below his signature on the finished painting (see *A Quiet Reach, Matilija Creek,* page 127).

French artist Paul DeLongpre (1855–1911) came to Los Angeles in 1898. He came from a large family of artists based in Lyons, France, at the time the center of French textile design. DeLongpre was already a renowned painter of flowers, earning fame in Paris and New York before coming to Los Angeles.

Wild Roses (cover and page 111) was one of Mrs. Clarke's favorite paintings and it is fitting that this powerful work, with its allusions to nostalgia and commemoration, be used as the lead image for this exhibition. Painted in 1898, the first year of DeLongpre's residency in California, it evokes both the vitality and permanence of life in California.

Once here, DeLongpre purchased a large lot on the corner of Hollywood Boulevard and Cahuenga Avenue and built a palatial Moorish style mansion. The DeLongpre Gardens were planted with a large variety of roses and it became one of the great tourist attractions of Los Angeles in the early years of the twentieth century.

Philadelphia born Granville Redmond (1871–1935) became deaf at the age of three due to a severe bout of scarlet fever. He could neither hear nor speak and communicated all his life through sign language or by writing notes. Scholars and collectors have long noted the quiet tranquility of his gentle landscapes, particularly the somber toned, moody works which he preferred to his more popular wildflower scenes (see pages 86, 103 and 142).

Overcoming his outward handicap, Redmond traveled to Paris and studied at the Academie Julian. He returned to Los Angeles in 1898 and shared his time between northern and southern California.

One of Redmond's friends and patrons was Charlie Chaplin. Redmond kept a painting studio on the Chaplin Movie Studio lot and even appeared in small, walk-on roles in a few of Chaplin's silent movies.

The most gifted of California's Impressionist artists, Guy Rose (1867–1925) was the only artist of this period to be born in southern California. His father, L. J. Rose owned the Sunny Slope Ranch, which encompassed a good part of the San Gabriel Valley.

Rose studied at the California School of Design, in San Francisco in 1886 and 1887, before continuing his studies in Paris. In France, Rose adapted well to Impressionism and like scores of other art students and young painters visited Giverny, the small village where Monet lived. He returned to Giverny in 1904 and lived there with his wife Ethel, also an artist, until 1912, when

Guy Rose (1867–1925), *In the Olive Orchard,* oil on canvas, 15 x 18 inches

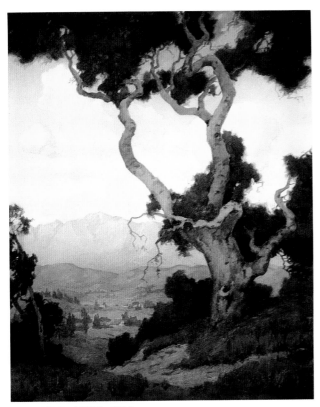

Marion Wachtel (1876–1954),
Landscape, watercolor and pastel, 20 x 16 inches

he returned to the United States. Sources vary as to the extent of the friendship between Rose and Monet, whose influence is clearly evident in Rose's work. *Laguna Rocks, Low Tide* (page 58) and *Lifting Fog, Laguna* (page 17), both painted about 1916, are evocative of the delicate Impressionism practiced by Monet and his followers.

Back in America, Rose worked in New York and returned to Los Angeles in 1914, settling in Pasadena. The seven year period between 1914 and 1921, when he was disabled by a stroke, confines his California works. In that brief time, Rose painted in La Jolla, Laguna Beach, San Gabriel, Pasadena, the Carmel-Monterey area, the Sierra Nevada and the Mojave Desert.

Rose was the most Impressionistic of all artists in California, pursuing a delicate and elegant brush stroke coupled to soft, harmonious colors. He was the only one of our artists who had a direct association with the

French Impressionists and his work is highly evocative of Monet's. In 1894, Rose suffered a debilitating bout of lead poisoning, the result of constant exposure to oil paints. For several years, he rarely worked in oils, turning instead to pen and ink or watercolor illustration work for many major periodicals. By 1904, his first year of residency in Giverny, he had sufficiently recovered to paint on a frequent basis. He did not paint from 1921, the year of his stroke, to his death in 1925.

Marion Kavanagh Wachtel (1876–1954) was certainly the most gifted watercolorist in California. As a young woman, she came west from Milwaukee and studied with William Keith in San Francisco. On his advice, she came to Los Angeles in 1903 to continue her studies with Elmer Wachtel. They fell in love and were married in 1904.

Marion Wachtel's style also underwent a transition with the advent of Impressionism. Many of her watercolors show a strong tendency toward the Barbizon aesthetic, probably from Elmer Wachtel's initial and considerable influence. *Sunset* (page 84) expresses much of the Barbizon precept, with its poetic use of moody colors and the vivid end-of-the-day sky effect. The tall trees in the painting, the blue eucalyptus, are a frequent sight in southern California, the preferred trees for wind breaks in agricultural areas.

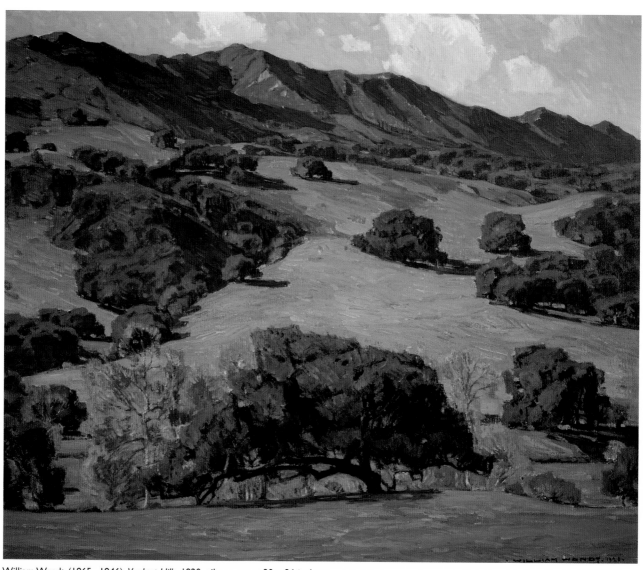

William Wendt (1865–1946), *Verdant Hills*, 1920, oil on canvas, 30 x 36 inches

Franz A. Bischoff (1864–1929) was a fully trained European artist when he came to America in 1885. His specialty was porcelain painting and he excelled at the rendition of flowers, particularly roses. Prior to coming to California, he lived in Dearborn, Michigan, where he taught porcelain decoration and watercolor painting. In 1905, he visited San Francisco with the aim of moving his family. The earthquake of 1906 forced him to reconsider his choice and instead he built a home and studio in South Pasadena. Thus he began a second career as a landscape painter.

Arroyo Seco Bridge (page 38) was painted about 1915. Spanish for "dry stream," the Arroyo Seco runs between Pasadena and Los Angeles and is dry most of the year. The scene pictured in our painting is now part of the Pasadena Freeway and the bridge, the York Boulevard Bridge, still stands but now has lanes of freeway running beneath.

San Juan Capistrano Mission Yard (page 110) shows the fountain at the Mission. As subject matter, the Capistrano Mission is the most popular architectural landmark in southern California art. Always a flower painter, Bischoff focuses on the hollyhocks and geraniums around the fountain and creates a vivid and brilliant statement of California's light.

German born William Wendt (1865–1946) came to the United States in 1880 and settled in Chicago. Largely self taught, he immediately took to landscape painting, winning many prizes in numerous exhibitions in Chicago.

During the late 1890s, Wendt visited California on several occasions with his painting companion George Gardner Symons (1862–1930). Wendt was enchanted by the landscape and in 1906, he and his wife, the sculptor Julia Bracken Wendt (1871–1942), bought a studio-home in Los Angeles.

Wendt is often described as the most spiritual of California's landscape painters. His works are intimate and personal views of the land and the environment. The human presence is rarely seen and at times that presence is shown to the detriment of the land. Wendt was fond of using quotes from the Bible and from epic poetry to title his paintings. *There is No Solitude, Even in Nature* (page 114) and *Sermons in Stone* (page 117) were both painted in Laguna Canyon. A well respected artist among his peers, he was called the "dean" of southern California's landscape painters.

Alson S. Clark (1876–1949) was born in Chicago and studied in New York under William Merritt Chase. In 1900, he went to Paris where he sat for lessons with James A. Whistler. From 1902 to 1914, Clark and his wife Medora spent most of their time between their home in Chicago and an apartment in Paris. Clark was a tireless traveler, painting in such diverse locales as France, Italy, Spain, England, Dalmatia, Czechoslovakia, Canada, Panama and Mexico.

Clark served as an aerial photographer in the U.S. Navy during World War I. After the war he was advised to seek a warm climate to recuperate from a nagging ear affliction. He and Medora came to California in 1919, fell in love with the locale and bought a lot in Pasadena. When they returned with all their possessions on January 1, 1920, they hailed a taxi at Union Station and asked to be driven to Pasadena. The cab driver looked at them in astonishment and said it was impossible, due to the Rose Parade. Nevertheless, five hours later, they arrived at their new home.

Once in California, Clark restricted his travels to several trips in Mexico, as well as sojourns in La Jolla, the Sierra Nevada Mountains and the desert around Palm Springs.

Maurice Braun (1877–1941) was a well known portrait and figure painter in New York when he decided to move to California and concentrate on landscape. In 1910, he opened a studio on Point Loma in San Diego. He painted wonderful views of the landscape around San Diego. *San Diego Countryside with River* (below) shows a view of the San Diego River as it winds through Mission Valley. In 1954, the art critic John Fabian Kienitz wrote:

"Maurice Braun was an artist of deep philosophical conviction for whom all expressions of life were divine. So it is natural that in the look and feel of his work you should find pastoral peace. This peace is born of his sense of wholeness. Through an interplay of religious respect and aesthetic resolve, he found equilibrium and this was for him, as it can be for us, the secret of life itself."

Donna Schuster (1883–1953) trained in Chicago at the Art Institute and at the Boston Museum School under Edmund Tarbell and Frank Benson. Her early works clearly show the soft delicate brush work of the Boston School. Her studies with William Merritt Chase, in 1912, influenced her toward a broader, more painterly stroke.

Schuster arrived in Los Angeles in 1914 and became an active member of the local art community, exhibiting widely and frequently and teaching at Otis Art Institute. An astute and daring painter, her work shows a large range, from the elegant Impressionism of the Boston School, to some paintings with exceptionally bright and bold color harmonies (see *On the Beach,* page 46), and even to starkly Modernist compositions. Schuster does not lend herself to simple classification. She experimented with a multitude of art styles, seeking inspiration at various times from Chase, Monet, Stanton MacDonald-Wright (1890–1973) and from contemporary French movements, possibly the School of Paris.

Edgar Payne (1883–1947) first visited California in 1911, painting for a few months in Laguna Beach. Largely self-taught, Payne lived and worked in Chicago, only occasionally venturing west with his wife Elsie Palmer Payne (1884–1971), also an artist, to paint in Santa Barbara, Laguna Beach and other locales in southern California. By 1918, they were living in Laguna Beach. He founded the Laguna Beach Art Association and served as its first president.

Payne is best known for his majestic views of the snow-capped Sierra Nevada Mountains, but he is also highly regarded for his views of California's valleys and canyons, usually in late afternoon or evening light (see *Hills of Altadena,* page 39), and for his powerful seascapes. He and Elsie were frequent sojourners throughout the Southwest. On these trips, he painted luminous works of Canyon de Chelly, often with a few small figures of Navajos riding

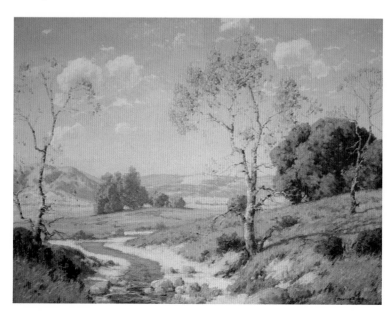

Maurice Braun (1877–1941), *San Diego Countryside with River,* oil on canvas, 30 x 40 inches

quietly beneath the immense stillness of the towering rock walls. Other works from Arizona show expansive vistas of the desert, with imposing cumulus clouds blossoming in the deep blue sky.

In 1922 and 1923, Payne, with his wife and daughter Evelyn, toured Europe, painting in Brittany and along the Riviera. They also visited Switzerland, where Payne was captivated by the snow covered Alps, and then traveled down to the Adriatic for sketching interludes in Venice and nearby ports. Payne would continue to paint canvases of the French fishing boats and the Swiss Alps long after he returned to California.

The Plein Air style continued to be popular in California until the end of the 1920s. By that time, many of the key figures that had made the style the vibrant and dynamic phenomenon of earlier years had died or ceased to paint. Moreover, the new generation of California artists, who had admired, sought out and trained under the Impressionists, had been lured into "new" styles, based on tenets and concepts of European Modernism. Indeed, by the start of the Depression, the direction of California art was set by an entirely new group of artists and the California Impressionists were consigned to the past.

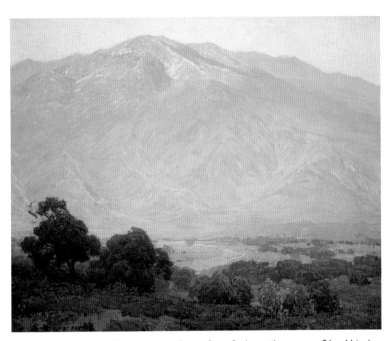

Edgar Payne (1883–1947), *Mountains at Sunset, Santa Barbara,* oil on canvas, 36 x 44 inches

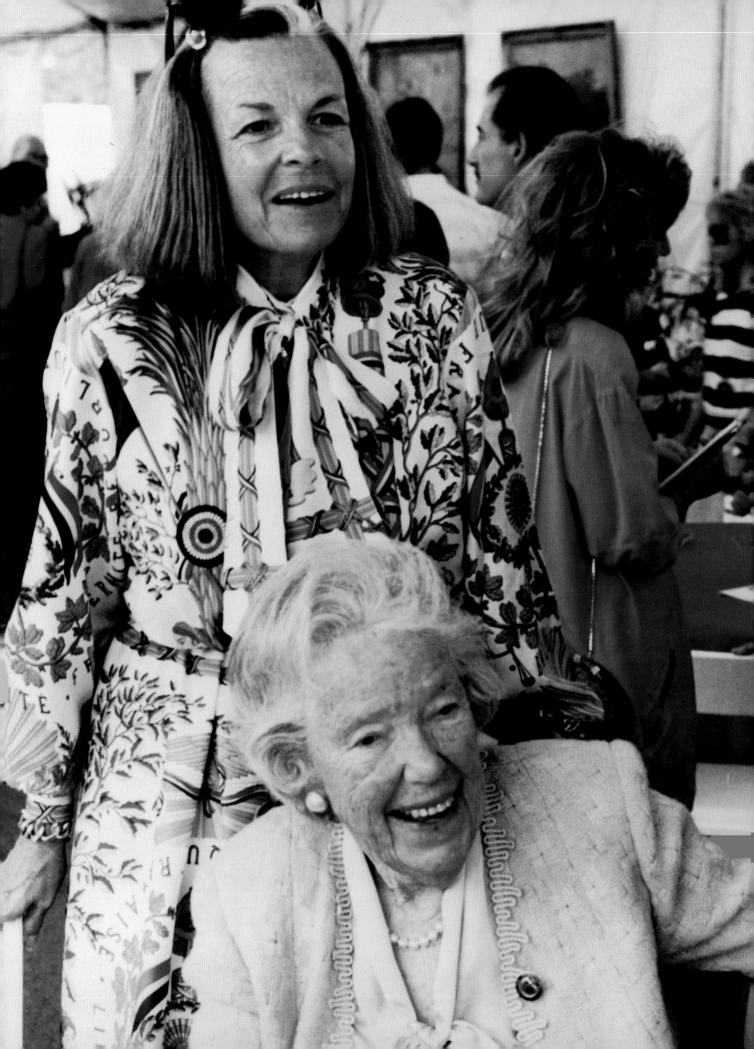

MEMORIES OF MY MOTHER

Joan Irvine Smith

It was just past the turn of the 20th century when my mother, Athalie Richardson Irvine Clarke, was born on February 3, 1903, in Los Angeles. When she died on May 22, 1993, in Newport Beach, one of the most valuable legacies she left to me was her memoirs. Although she would not release them for publication, saying they were only for the family, I feel I can draw on this material in order to recount her story in her own words, just as she related it to me. This is how my mother recalled her early years:

My father, George H. Richardson, was a young physician who was born and educated in Chicago and came to California to establish his practice. In 1899, he married my mother, Cora Margaret Mather, who was born in Missouri but had come to California as a young girl with her parents, the William H. Mathers. My parents lived in a large two-story frame house, painted grey with white trim, at the corner of West 25th Street and Congress in the West Adams district.

I started my life being on time. Dr. Cowles, the obstetrician who was scheduled to be there, was not on time. My father had to deliver me before the doctor arrived. After a few weeks, my mother said she could no longer breast feed me. Why, I don't know. According to my parents, I could not tolerate a substitute feeding. I remember my mother saying what a time she had during my infancy. She told me of the anxious weeks that followed after I was born. She said nothing

Opposite
Joan Irvine Smith and Athalie Richardson Irvine Clarke at The Oaks Classic, 1989. Photo courtesy of *On Course* Magazine.

At right
Richardson Family Christmas card with photo of Baby Athalie, 1903

Sincere greetings for Christmas and best wishes for the New Year

agreed with me. I continued to lose weight. She said this was later diagnosed as cholera infantum. I must have given my parents cause for concern as my weight diminished at quite an alarming rate. This I was told about years later. I guess, in desperation, my father tried a food called Reed & Carnigues Soluble Food. Apparently this worked like a miracle and at eighty-five I am still enjoying this beautiful world.

When I was about three, I can remember on Sundays my father always took me for a stroll in my go-cart. There were few homes on West Adams Street. I remember the big log cabin at the corner of Adams and Twenty-Fifth Street where the street car turned.

In the spring the fields were blanketed in yellow. Mustard blooms and California poppies were everywhere. I remember it was like a golden carpet as far as the eye could see. I had to get out of that go-cart. I just had to pick some of that yellow mustard. More within my reach were the hundreds of golden poppies. The soft yellow sprays of mustard were harder to pick, the stems were tough. My father would take out his pocket knife and would cut them to help me gather a bouquet. When I had as many as two small hands

Baby Athalie, 1903

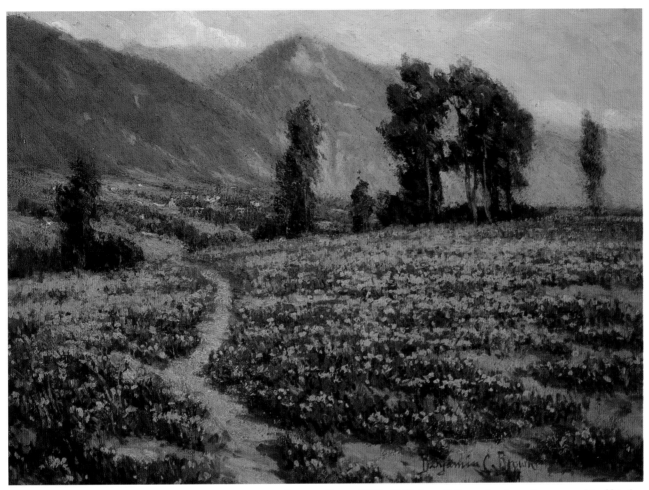

Benjamin Brown (1865–1942), *Poppy Field near Pasadena*, oil on canvas, 16 x 22 inches

could hold, my father would pick me up from the golden fields and place me in my stroller, always with a hug, a kiss and an approving smile. Then we would continue our Sunday outing and take the flowers home to my mother.

When we returned, my mother was always sitting on the front porch waiting for us. Her joy was complete when I gave her two small bouquets. I was never happier than when I saw how pleased she was with the flowers I had gathered for her.

Our next door neighbors on Congress Street, the Madison P. Joneses, had one daughter a few years older than I. Her name was Winifred. She was a very precocious little girl.

Winifred loved to tease me. Because of this, I didn't like her. She had a beautiful collie dog and I loved to play with him. He enjoyed coming over to our house. I remember one rainy afternoon going outside. The rain had cleared. I was fascinated by the amount of water racing and swirling down the street in front of our home. It was like a rushing current in a river. Of course, I wanted to stand on the curbing and watch. Other children were doing the same thing. The storm had subsided. The swift current had picked up a lot of mud so the rain water had become a deep chocolate brown. The current was swift as it headed towards the underground storm drain. This was about

fifty feet from our sidewalk. I was looking for my playmate, the big collie dog. I guess he was being kept inside because of the heavy rain. Because he didn't like to be confined in the house, he would howl like a coyote when he wanted to go outside. It was sometimes quite a show. Whenever his mistress opened the front door, he would run toward me, jumping, prancing and enjoying his freedom. I remember how glad I was to see him and I turned facing the collie and he put his two front paws on my shoulders. I guess I was looking only at him when I was stepping backwards and I suddenly fell off the curb into the rushing current. I was swept almost to the opening of the storm drain before someone pulled me out. I choked on the muddy water as I was quickly swept away. The rushing water sounded like a plunging waterfall as it fell into the deep underground basin, far below the street level. My mother had left for only a few

minutes to go inside our house for something. I am sure she must have panicked when she learned of my narrow escape. The collie barked, yelped and howled. He probably sensed something terrible had happened. I can barely recall anything about that horrible moment. I only remember my mother's terrified look after she learned what had happened to me and being awfully frightened. She said I was very wet and very cold as I was carried into our house by one of our neighbors.

After this unfortunate incident, I was afraid of the collie dog. I would not go near him. Because of my fear of any big dog, my grandmother Richardson gave me a Scotch Terrier puppy. I named her Gypsy. She was a dear pet and I loved to take her in my lap whenever my father took me for a ride in my stroller. He always seemed willing to take both of us. When the weather was nice, I always had this to look forward to.

Some years later, I heard the reason my parents sold their home on Congress Street and moved to Pasadena was because my mother could not forget that I had almost drowned in front of our house. My father chose Pasadena because he said so many people from Chicago, Illinois, had second homes there. He was born and educated in Chicago, as were his eight brothers and sisters. They all attended the University of Chicago, with the exception of my uncle Rob, my father's youngest brother, who became a train engineer.

My grandfather believed that every young person should pursue a career of some kind in order to earn a living. My father chose medicine. After graduation from medical school, he completed his internship at Cook County Hospital. He was then invited to join a group of doctors headed by his uncle, Dr. Robert Tooker, a

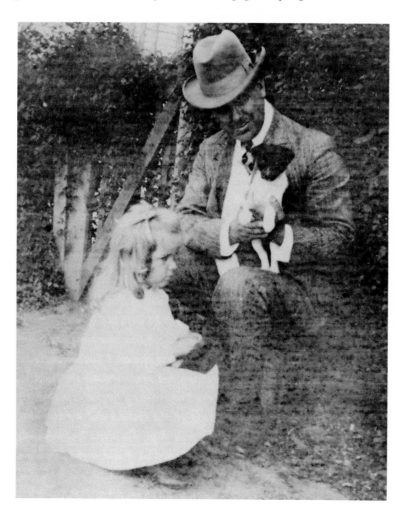

Athalie with her father, George H. Richardson, and Gypsy, circa 1907

famous child specialist in Chicago. Dr. Tooker wanted to finish his career by writing a book on children's diseases. My father was the chosen candidate for this project. I believe he said it took him three years to complete all the necessary research and writing that his uncle wanted. My father could have been an author, he expressed himself so well. I always said he painted portraits with words. After the book was published, my father's declining health prompted Dr. Tooker to persuade him to go to a warmer climate. He was given a leave of absence and went by train to Arizona. My father's older brother William and his eldest sister Winnie had both died of tuberculosis. I imagine that was the reason for concern. In Arizona, he lived in a mining camp. After a brief rest, he started taking care of miners and their families. One of his classmates at the University of Chicago, also a young doctor, had moved west to California and had taken a position on the medical staff at Patton, a large mental institution near Redlands. He persuaded my father to visit him in California before returning to Chicago.

My father left Arizona and went to California. He visited his friend in Redlands. Within a week, he decided he liked California better than Illinois and joined the staff at Patton. His friend had met a young lady by the name of Olive Schimmerhorn. Her family had extensive citrus holdings in Smiley Heights, adjacent to Redlands. My mother and Olive had gone to school together in Los Angeles. My mother was spending Christmas with Olive because my grandparents were going to Wisconsin to visit my grandmother's relatives in Fond-du-Lac. Mother did not want to go with them. This decision was made, I believe, because Olive had sent mother a local publication which had a picture of my father accompanied by an article about him coming from Chicago and joining the medical staff at Patton. I am sure my mother wanted to meet him and declined the trip to Wisconsin. That year, mother spent Christmas at Smiley Heights. Olive gave a Christmas party in her honor, a dinner dance at her home. The two young doctors arrived together. Mother was a very beautiful young lady. I know she must have had a steady stream of beaus in Los Angeles. Mother's impression of my father was one of disappointment. She didn't like his mustache. She told me one time it was awful, it reminded her of bars on a bicycle. But my father was very impressed with her beauty, according to Olive. When it was

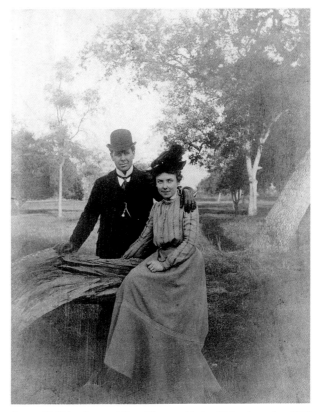

George H. Richardson and Cora Margaret Mather Richardson, circa 1899

time to say goodnight, mother said, he invited her to go for a drive the next day, which was Sunday. She told me because she had nothing else to do, she said she would. Sunday afternoon, he arrived. She said when she saw him at the foot of the stairs, she could not believe he was the same person. He had shaved off his mustache. She said his formal attire of the night before did not become him like the navy blue blazer and the white flannel trousers he was wearing on Sunday.

My mother loved horses. She enjoyed riding whenever she could. My father arrived with his horse and buggy. Mother said the horse was an elegant chestnut. I don't know which impressed her the most, my father or the horse, Penn.

My grandparents returned from their trip. My mother remained on Smiley Heights until after the New Year. I am sure my father saw her as often as he could. Mother said he came to Los Angeles on her birthday, which was April 23rd. At that time, he gave her an engagement ring. They were married on June 14th, 1899, at St. John's Episcopal Church at West Adams and Figueroa. Their wedding reception was in my grandparents' home on West 30th Street.

When we first moved to Pasadena, we took up residence in the Casa Grande Hotel next to the Maryland on Colorado Street. As I remember, it looked something like the Ojai Inn. It was Spanish in style, with beautiful spacious grounds. My father had his office on Colorado Street with a Dr. Haas. It was a great place to watch the New Year's Day parade.

Each year that we lived in Pasadena, I remember going to my father's office on New Year's Day. Both sets of grandparents would join us, as well as aunts, uncles and cousins. Everybody brought something and we had a wonderful time. It would be like a picnic. I can remember one year almost tumbling out of the front window. I guess I just had to see what was going on and leaned too far out of that window. I recall my mother was so frightened and my father gave me such a scolding that I still remember it. He made me go in one of the back offices. I did not get to see the rest of the parade.

Each morning my mother would take me for a walk. I can't remember the exact location but it was near the Green Hotel. Train tracks passed in front of us and we sat on a bench under some trees. I loved to see the big Southern Pacific train go by and wave to my uncle Rob, the engineer. It was a thrilling experience to watch for that big locomotive.

On Sundays, my father would take me along while he made house calls. He still had his beautiful chestnut horse called "Penn" and a buggy. He always held me in his lap and would let me hold on to the reins. I still can remember how I thought I was driving Penn. We would go down Orange Grove Avenue as far as Columbia Street and then turn and go to the Raymond Hotel, which was located on a knoll off Raymond Avenue. The front lobby had large, heavily carved chairs with arms and red velvet cushions. At the corners of the seats, the cushions were tied to the arms of the chairs with cords and tassels. I

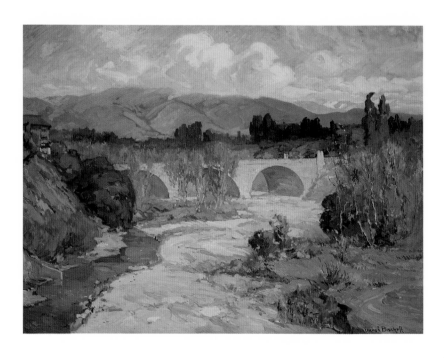

Franz Bischoff (1864–1929), *Arroyo Seco Bridge*, circa 1915, oil on canvas, 30 x 40 inches

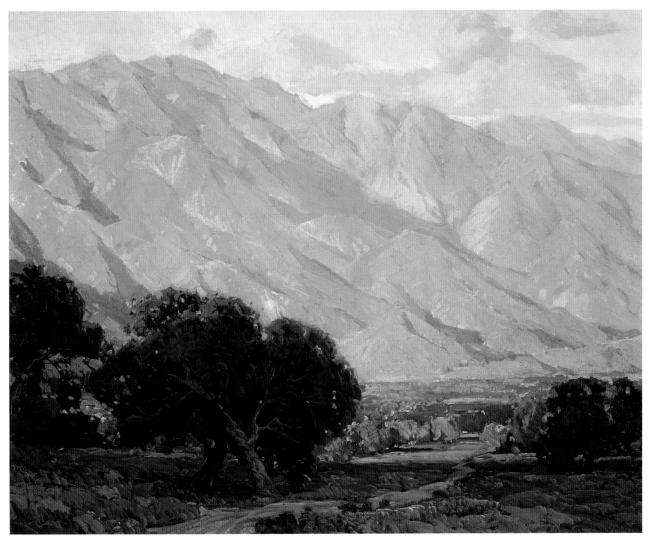

Edgar Payne (1883–1947), *Hills of Altadena,* circa 1917, oil on canvas, 36 x 45 inches

can recall my father telling me, "Now Athalie, you sit there. Don't speak to anyone. Don't you get out of the chair. If you're a good little girl, Papa will bring you again next Sunday." Under no circumstances was I to move until he came back from his rounds. I untied the cords and tassels and tied them up again. I repeated this same performance over and over again. I did not move out of the chair. When my father returned, he was always full of praise and always said I could go with him again.

Across from the Raymond Hotel was a high knoll with a large Victorian house in the middle of an orange grove.

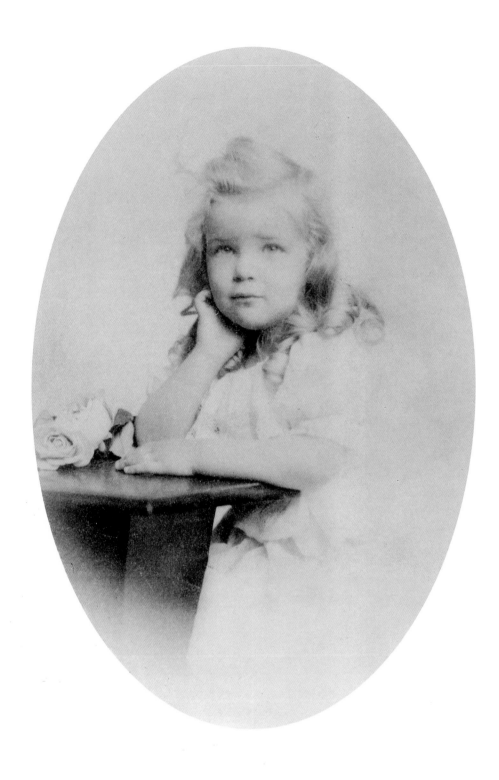

There was a tree-lined driveway leading to the big white frame house. I remember it had two rounded turrets that extended to the roof. I would tell my father I knew Mega who lived in the big white mansion. When we returned to the Casa Grande, I would tell my mother that I saw my friend Mega and I played with her while my father was busy. Perhaps I imagined my play-mate Mega because, at that time, I was an only child.

It must have been spring, about Easter, when we moved to the Huntington Hotel. An Easter egg hunt had been planned for the children at the hotel. Each child was given a small empty basket in which to carry the eggs. There was, of course, a prize. I can remember how fast I scrambled in and out of the shrubbery, looking for those bright colored eggs. After the holiday hunt was concluded, it was announced that little Athalie Richardson had won First Prize. It was a small grey donkey with a pair of round baskets on each side. It was one of my cherished possessions for many years.

My father loved music and my parents loved to dance. Occasionally, there was a dinner dance in the dining room of the hotel. I did not have a nurse. This necessitated my parents taking me with them almost every place they went. This could have been the reason for our very close relationship which continued throughout the years. My father and mother would leave me at the dinner table, but somehow I was able to get down and would join them on the dance floor. Then I would hold on to the train of my mother's dress and have my dance too. After my father danced with my mother, then he would dance with me.

I know my mother disliked the long drive to Los Angeles when she wanted to visit her parents. I remember my father did not especially want to leave Pasadena after he had established his practice there and I am sure it was a real hardship for him to go back to Los Angeles. A house was selected, however, about two blocks away from my grandparents on West 30th Street. My mother was overjoyed to be so near her old home.

I adored my grandmother and I loved to go call-ing with her in her two-horse carriage. As soon as we moved into our new home, I went to call on her. Unfortunately, I had not gotten permission to do this. As I was about to climb the steps leading to the front porch, I heard my father's stern voice commanding me to stop. He didn't say a word during the time he walked me home. It was quite early in the morning and my father was wearing his bedroom slippers and a long dark over-coat. I didn't see my mother anywhere. As soon as my father closed the front door, he took off his shoe and paddled me. I never did that again.

Whenever my parents had an evening engage-ment, I was left with my grandparents, which they always seemed to enjoy. They had a wonderful cook named Rosie. If I spent the night, she always prepared something special and told me she had made it just for a good little girl named Athalie.

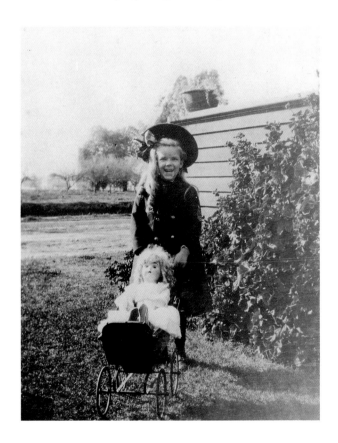

Opposite and at right
Athalie Richardson, circa 1910

So many friends have asked me through the years how I got my name. My mother, who was the eldest of three children, had one sister who died in infancy. She was named Athalie, after the French opera of that name. My mother had promised her mother that if she had a daughter, she would name her Athalie.

Her parents later bought a home on Hobart Boulevard and my mother attended grammar school at the 24th Street School.

When my mother was just seven years old, her younger sister, Jeanne Elizabeth, was born on February 23, 1910. Jeanne developed polio as a small child and required a great deal of care from both of her parents. Her mother kept Jeanne's legs constantly wrapped in hot moist towels, as called for by the Kenny Treatment, which was the therapy used for polio at that time. Jeanne fully recovered from her affliction. However, because of the time and attention devoted to her, she did become quite spoiled.

Athalie with her sister Jeanne

Athalie, Jeanne and their father, circa 1911

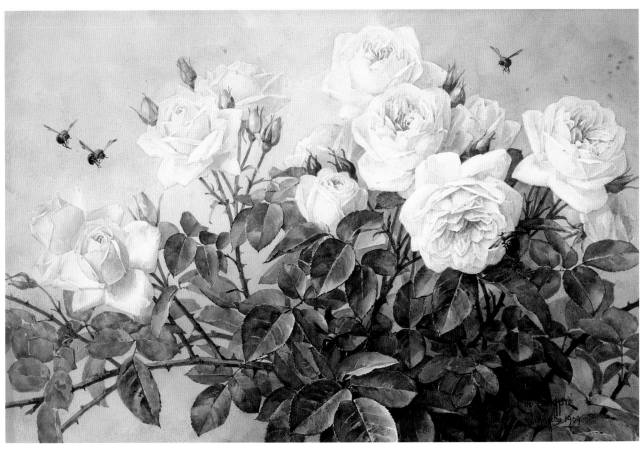

Paul DeLongpre (1855–1911), Roses, 1909, watercolor, 16¹/₂ x 25 inches

My mother had a very special doll named Pink Rose, with a china head, eyes that opened and closed and real hair. It was my mother's most prized possession. One day, when Jeanne was about four or five, the two sisters were posed on the front steps for a photograph with their dolls. My mother had Pink Rose sitting next to her with Jeanne on the other side. They had taken several photographs when all of a sudden Jeanne gave Pink Rose a big shove down the concrete steps. Of course, the china head broke. There was a lot of commotion and my mother was terribly upset. My grandmother tried to console my distraught mother by saying, "Jeanne didn't mean it, dear, Jeanne really didn't mean it" but

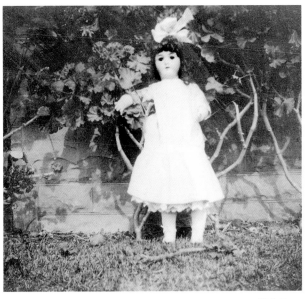

Pink Rose

Athalie and Jeanne with their dolls

Athalie and Pococo,
circa 1913

my mother knew quite to the contrary, Jeanne did mean it! Although they got a new china head for Pink Rose, this was an incident that my mother remembered all of her life, and she used to tell me the story quite often when I was small.

Even though my mother found her little sister a constant irritation when they were children, she and Jeanne eventually became as devoted and loyal as two sisters could ever be.

My grandmother was quite an accomplished seamstress and often would make clothes for her two daughters. One time, my mother was getting ready for a train trip to visit relatives in San Diego. For the occasion, my grandmother had made a middy dress, an overblouse with a sailor collar, and a pleated skirt. Well, my mother didn't like the dress. She went into the kitchen where my grandmother was preparing berry pies, picked up a pot full of berry juice and took a big swallow, spilling it all down the front of the dress. She was determined she was not going to wear that dress to San Diego or anywhere else for that matter!

My mother had a large black cat named Pococo, which she dearly loved and which was her faithful companion until she was in her late teens. As they lived in the West Adams district, my mother attended Los Angeles High School. Every morning she took the Red Car, changing cars four times to get to school. Pococo would walk her to the corner, see her off to school and, everyday, when she would return on the streetcar, the cat would be waiting for her at the corner and walk her home.

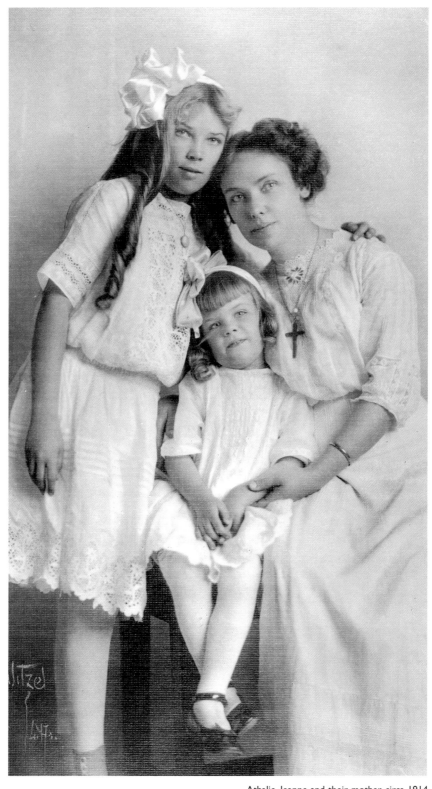

Athalie, Jeanne and their mother, circa 1914

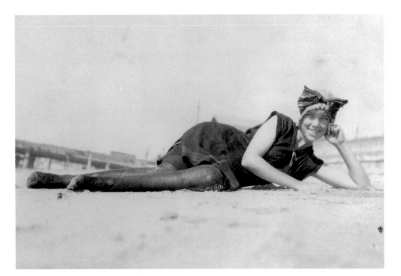

One summer, when the family rented a house at Venice Beach, they took Pococo with them and he disappeared. They looked for him everywhere but he was nowhere to be found. My mother was heartbroken. When they returned to their house on Severance Street, which was seventeen miles away, there he was, waiting for them on the front porch.

Athalie at Venice Beach, circa 1916

At right
Donna Schuster (1883–1953),
On the Beach, Laguna, circa 1917,
oil on canvas, 29 x 29 inches

Opposite
Louis Betts (1873–1961),
Midwinter, Coronado Beach, circa 1907,
oil on canvas, 29 x 24 inches

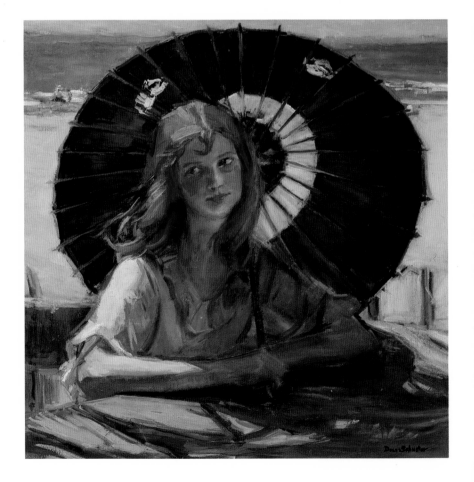

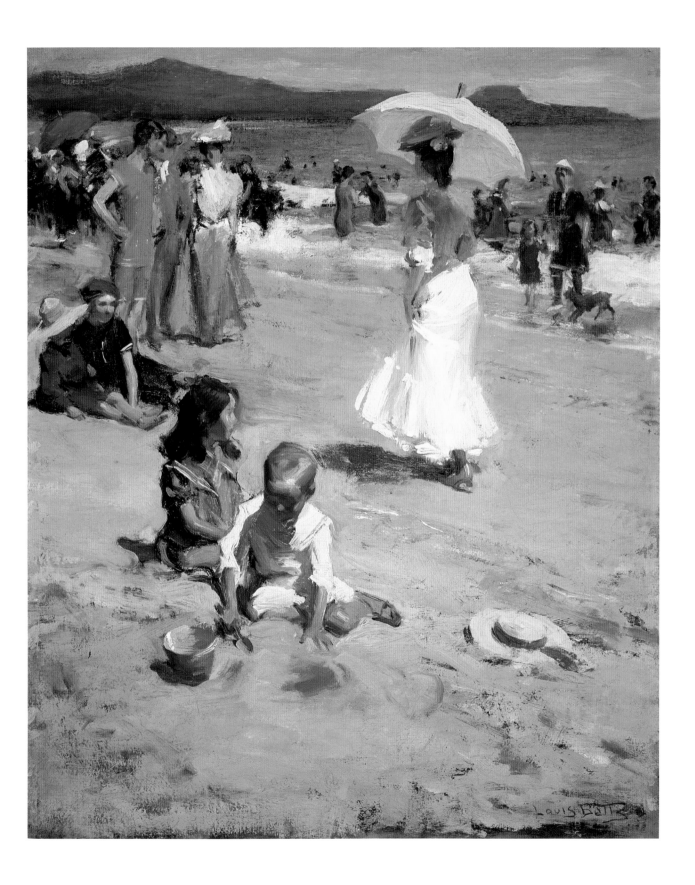

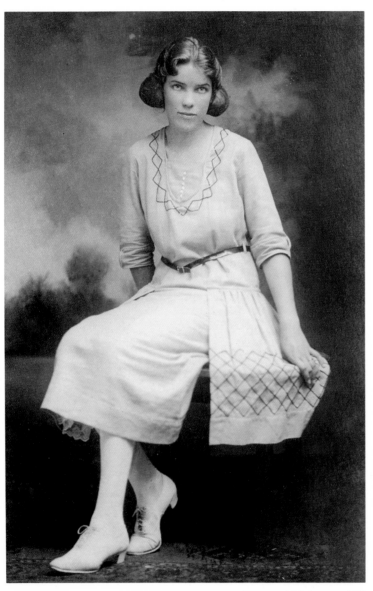

Portrait of Athalie, circa 1921

It was at Los Angeles High School that my mother met Thurmond Clarke, whom she later married. Thurmond was a champion track star at L.A. High, where he held the city and state records for the 440 yard dash in 1920. He also competed at Stanford University where he attended college. My mother had excelled at tennis in high school but was forced to give it up and miss school for one year due to a diagnosed heart condition. When my mother graduated from high school, in 1921, she wanted to attend Stanford, but her family could not afford it. Instead, she went to the old State Normal School on North Vermont Avenue, which later became U.C.L.A. She was dissatisfied with the curriculum there so she transferred to the Otis Art Institute in Los Angeles, where she studied architectural rendering and commercial illustration. E. Roscoe Shrader (1878–1960) was the director of the institute at that time. Two years ago, when I showed her a fine painting of geese by Shrader, she immediately remarked to me that he had been her art teacher.

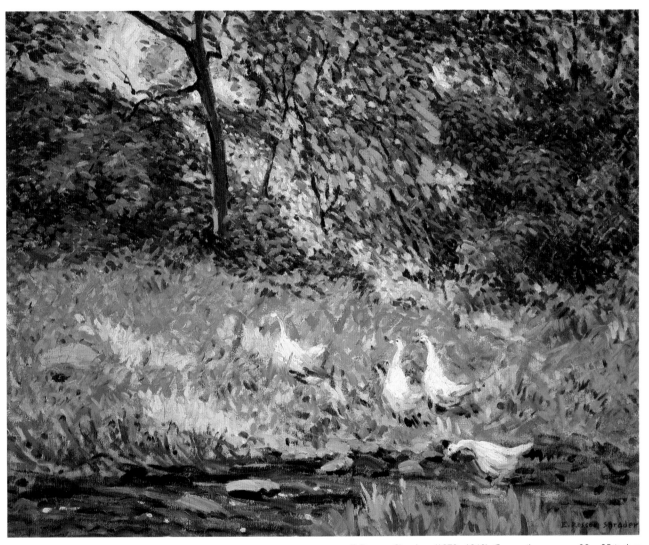

E. Roscoe Shrader, (1878–1960), *Geese*, oil on canvas, 28 x 35 inches

Athalie Richardson's business card, circa 1924

Cinelandia business card, circa 1928

My mother was trained as a commercial artist and became quite successful in that field, keeping an office in downtown Los Angeles in the Story Building at the corner of Broadway and Sixth Street. She did fashion drawings for Bullock's and Robinson's, fashion covers for the *Los Angeles Times,* furniture designs for Barker Brothers, and even the menu for the Coconut Grove, which featured a group of monkeys with coconut bottoms. She would tell me how she would go to the big department stores which displayed clothes by top-flight designers where she would sketch the mannequins in the windows so that the patterns could then be made and copied by local manufacturers.

Cinelandia covers by Athalie Richardson, 1928

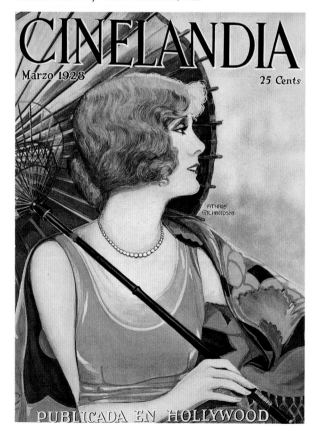

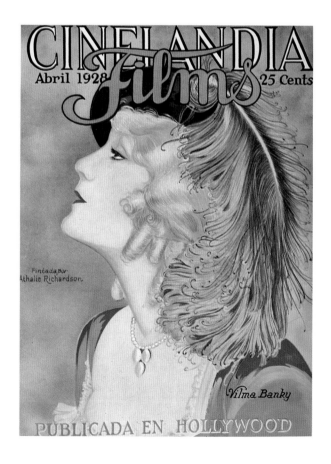

To further her technique in fashion design, she applied for admission as a student at the Wolfe School of Costume Design, which was the leading institution of design in Los Angeles. The school offered classes in fashion illustration and pattern making, as well as designing for the movie industry. She made an appointment for an interview and took along a portfolio of sketches. There was some confusion at the interview because afterwards the reply was, "Well, Miss Richardson, you've got the job." She remarked, "I didn't come to apply for a job, I want to be a student." And they said, "Nevertheless, you've got the job!"

So, she became a teacher at the Wolfe School. Among the students there were Edith Head and "Irene" who was one of her pupils and later became one of the top fashion designers in the country and made quite a name for herself in Hollywood as a film costume designer. I remember vividly, as a teenager, going to the Tea Room at Bullock's Wilshire with my mother for the "Irene" fashion shows. We always had a wonderful time, and afterwards my mother and I would go to the second floor where I could try on the designs that had been modeled that day and sometimes my mother would buy one for me.

My mother excelled at fashion design and many of the magazine covers she did for *Cinelandia,* the Spanish-language Hollywood news magazine owned by my father, James

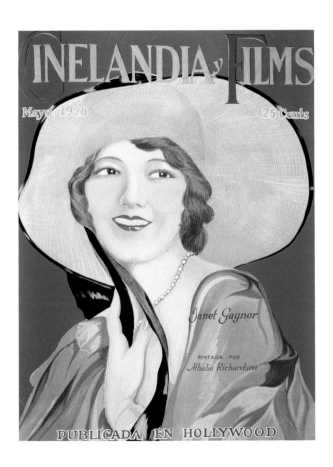

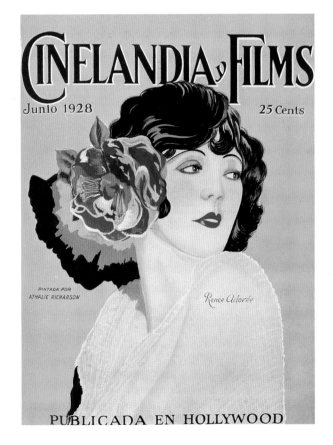

Irvine Jr., clearly show her great ability. The magazine was published for circulation in Spain, Cuba, Mexico and the Latin-American market. My father strongly believed in the potential for future social and commercial

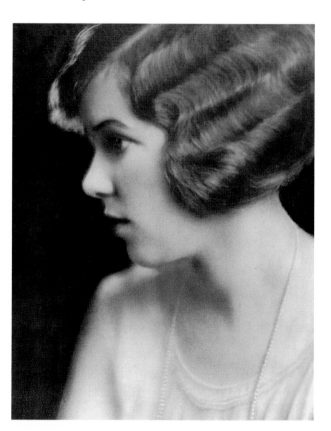

James Irvine Jr., "Jase," circa 1926 and Athalie Richardson, circa 1926

relations with Mexico and other Latin American countries, and I think that by focussing on the movie industry, he showed great foresight in identifying an effective vehicle for improving international relations.

My mother first met my father, who was called "Jase," at the Irvine Ranch in Tustin, California, in the mid 1920s. At that time, the ranch extended over 115,000 acres in southern Orange County. It was originally formed in 1864 by my great-grandfather, James Irvine I, and his partners Llwelyn Bixby and Benjamin and Thomas Flint. They had all

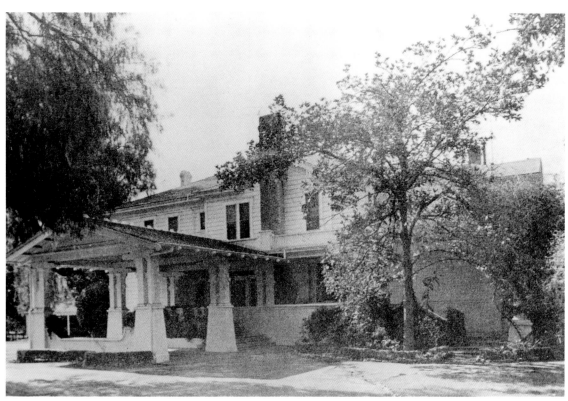

The Irvine Ranch House. Photo courtesy of the Irvine Historical Society.

come to California during the Gold Rush and later pooled their resources and purchased the Rancho San Joaquin as well as two other old Spanish land grants. In 1876, my great-grandfather bought out his three partners' one-half interest in the holdings, which later became known as the Irvine Ranch. On October 16, 1867, James Irvine's only son was born. My grandfather, James Irvine II, was the driving force who guided the ranch into the agricultural empire it became in the first decades of the twentieth century.

My mother recalled, *It was my first visit to Orange County. I had accompanied a friend, Robert Burgess, who had a business appointment with James Irvine. It was an extremely warm day so he suggested that I wait inside the ranch house while he walked over to the ranch office. A mature looking brown-haired woman appeared at the front door and*

escorted me inside. She said she was the housekeeper and would I like a cool drink? I said yes, I would like a glass of water. An enormous mahogany grandfather clock in the living room struck twelve as I entered. It was opposite where I took a seat, facing a doorway and a bookcase. The front door was glass and remained closed to the heat. There was a window directly behind the davenport where I was seated. It looked out on a very large lanai. Lots of old-fashioned wicker furniture embellished the screened enclosure. A dark blue oriental rug covered the parquet hardwood floor in the living room. A somewhat darker wood fashioned the woodwork and staircase as well as the very large fireplace. When I stood up, it was my height. The mantle was plain and a large oil painting of a hunting dog almost touched the shelf. It dominated the scene. The davenport was dark blue velvet. The high covered back was tufted. It had a shiny surface and felt warm.

As I was looking around the room, a tall, very handsome young man descended the staircase. His smiling

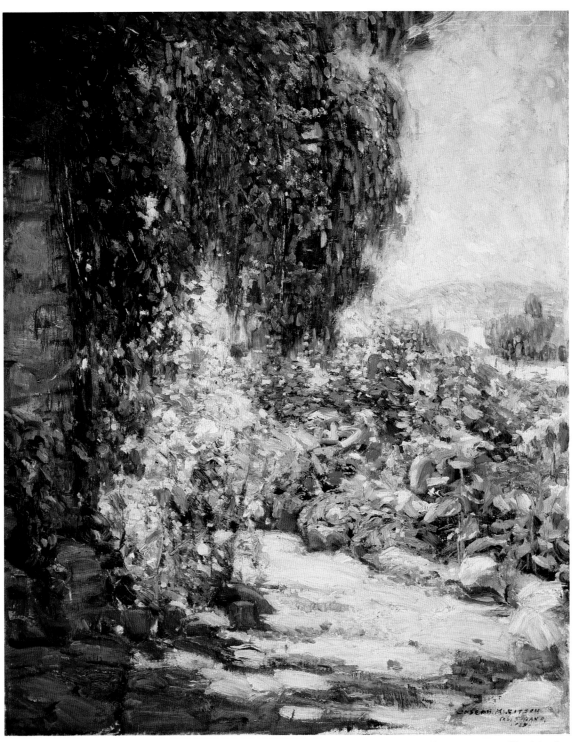

Joseph Kleitsch (1882–1931), *Bougainvillea, Capistrano Mission*, 1923, oil on canvas, 30 x 24 inches

face illuminated the entire room. He paused on the landing. He quickened his steps and when he reached the bottom of the staircase his face greeted me with such a warm smile, and he said, "I didn't know anybody was here." I explained I had driven from Los Angeles with a friend who had business with a Mr. Irvine, and I was waiting for him to return. He then said, "I am James Irvine Jr." It was one of those rare electrifying moments when our eyes met. I remember I could hardly pronounce my name after he introduced himself. From then on, my eyes saw nothing else in that room. I don't think I will ever forget that rare moment.

Jase then opened the door by the grandfather clock and called for Nellie. The housekeeper appeared almost as quickly as she had left after serving me the glass of water. In a pleasant tone Jase said, "Nellie, how many places do you have at the luncheon table?" Her answer, I think, was "five." Jase then said, "Nellie, make it six." His next question to me was, "You will stay and have lunch, won't you?" I said I didn't know if I could, it would depend on when I would be leaving for Los Angeles. I said the friend I came with may wish to leave after his appointment is concluded. Jase then opened the door by the big clock. He held it ajar with his foot. I heard him say as he picked up the phone, "Father, did you ask Bob Burgess to stay for lunch? I have invited Miss Richardson to stay." Apparently the answer was "yes." Then Jase asked me, "Do you like lemonade?" and "you are staying." I answered in the affirmative. The dining room seemed to be around the staircase where Nellie had gone. Jase called her and said, "Have the cook make two glasses of lemonade and bring them right in." Jase then told me he liked the screened lanai. He said, "We have had trouble with the large overhead fan. If I can get it going, we will sit out there."

Roses and bougainvillea were blooming in profusion. The long driveway leading to Irvine Boulevard was lined with palm trees. I could visualize horses and carriages in years past going down that beautiful driveway. The sound of the doorbell brought Jase to his feet. He called, "Marie, George, come this way." Jase then told me it was Supervisor Jeffrey and his wife. Our meeting was pleasant and cordial. She was a lovely looking Spanish woman, I believe in her late thirties. The Supervisor was a very outgoing man, about his wife's age. About a half-hour

Jase and Athalie in pony cart in palm lined driveway leading to ranch house, circa 1929

passed and then Robert Burgess returned with Mr. Irvine Sr. He looked like a very stern, austere man. When he removed his hat, he was completely bald. I had never seen anyone like this before. It seemed to add to his stern, rigid appearance. After our introductions, we proceeded into the living room. The big grandfather clock struck again as we passed into the dining room. A plate rail ran completely around the dining room wall. There were plates of various origin, some large, some small, all of different design and shape. The colors of the plates added a certain interest to the large, plain room. Tall, old-fashioned double-hung windows looked out over the orange grove. We were being seated when the glass front door slammed. A tall, very beautiful blonde woman entered the dining room. Jase said, "Madge, we didn't expect you. Why didn't you phone if you had plans to come down?" Nellie buzzed for the maid and told her to set another place. Jase then introduced me to Madeleine Irvine. I was awed by her patrician beauty. Her long blonde hair was swept to one side and coiled into a bun over her left ear. I didn't know if she was a sister or cousin or Jase's wife. He did not say, he only gave her name. Mr. Irvine Sr. did not speak, but the Jeffreys were cordial in their greetings and so was Mr. Burgess. A long silence prevailed and there seemed to be a rather antagonistic feeling all around the table. After she took her seat, she told Nellie she did not want any lunch, just coffee. She looked to be a woman in her middle thirties. She was very poised as well as very beautiful and seemed very sure of herself. Jase was seated at the head of the table. I was seated on his right. Nellie was at the other end of the table. Mr. Irvine was seated at Jase's left. During the lull he said, "Jase, what time does the game start?" Jase responded giving him the time. Mr. Irvine then replied, "Let's move right along, Nellie, get things moving. I want to see the game on time." He loved baseball and he obviously wanted to be there when it started. Jase invited Mr. Burgess to go, which of course included Miss Richardson. I

was quite concerned as I explained I had so much work to do at home. Jase asked the question, "Is it schoolwork?" I laughed and replied, "I teach school, but I also do commercial art work." His next question was, "Where do you do all this?" I said I had a studio space in the Story Building in Los Angeles. His next question was, "Miss Richardson, where do you live?" I told him I lived with my parents on Severance Street in Los Angeles. He, of course, had never heard of Severance Street.

When we left for the game, Jase asked Madeleine if she would like to go. Her reply was, "No, I only drove down to the ranch to pick up some clothes. I am going to San Francisco in the morning." Without saying goodbye, she left and went upstairs. No comment was made by anyone and we proceeded to drive to the game in Tustin. After the game was over, I told Mr. Burgess I felt I should return to Los Angeles. I knew I had a deadline to make in the morning and I knew I had to finish my pen and ink sketches that night. It was a big order, as I remember. I had to get it done or lose the account. There were no freeways in those days, the trip had to be made on surface streets. Jase said, "I'm sorry you can't stay for an early dinner." I knew I could not, even though Mr. Burgess wanted to stay.

On the way home, I was curious to know who Madeleine Irvine was. Mr. Burgess told me she was Jase's wife. Due to an unhappy marriage, she lived in Los Angeles. They were separated but not divorced. It was a disappointing ending to an otherwise wonderful day because I really felt I would never see Jase again.

I did finish my work that Sunday evening. It was picked up at my little studio at eight o'clock Monday morning, then I left for my day of teaching art classes at the Wolfe School of Costume Design on West 7th Street just above Figueroa Street. My first class started at nine so I had little time to waste. I always walked from 6th and Broadway to 7th and Figueroa. It was

pleasant in the morning before the rush.
This was a new position at the Wolfe School
and I did not want to be late.

Two or three weeks passed. I
returned from Bullock's at 7th and Broad-
way. I had been sketching a layout for
children's clothes. They were going to be
used in a catalogue. I spent a lot of time
on detail, which was what the head of the
advertising department wanted. Whenever
this happened, I had to stay longer. Mr. Van
Slank, whom I rented my desk space from,
told me when I returned that a Mr. Irvine
had come to the office and asked for me.
He also said he left and then came back.
I, of course, was disappointed to learn this.
When I went to my desk, I saw a big box
from the Darling Flower Shop. The flower
shop was on the main floor of the Story
Building. I often stood and looked at the
beautiful flowers as I passed by on my
way to the elevator. I opened the box and
the perfume was overwhelming, but I didn't

Franz Bischoff (1864–1929), *Canna Lilies,* oil on board, 26 x 19 inches

know what the flowers were. I had to go up to 4th and Broad-
way to the Bon Marche to have some sketches approved. Mae
Huseboe, who was in charge of advertising, had become a good
friend. We often went to lunch and sometimes to dinner. I
took one of the flowers with me to show her. I thought she
might be able to tell me the name. It was delicate and so beau-
tiful and smelled so good. I said, "Mae, do you know what kind
of flower this is?" She answered immediately, "Why, don't you
know? It's a gardenia! It's gorgeous! Have you added a florist
to your accounts?" I said no, that a friend had given me a box

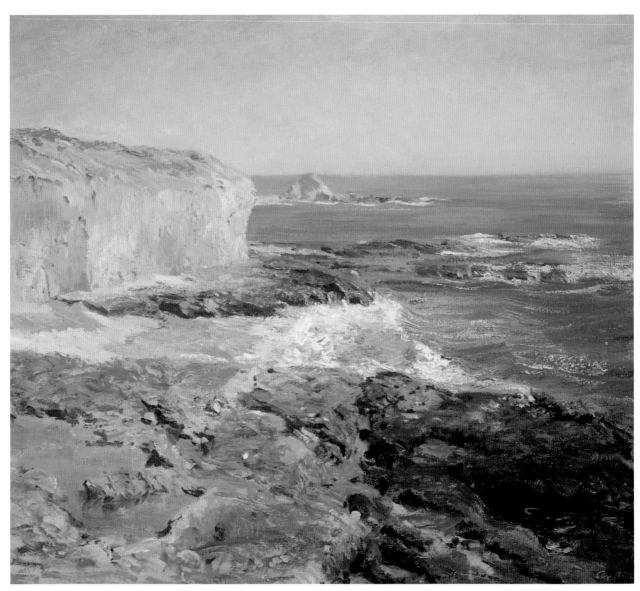

Guy Rose (1867–1925), *Laguna Rocks, Low Tide*, circa 1916, oil on canvas, 21 x 24 inches

of the beautiful blooms. She then said, "A box full? Well, in that case, can I have this one?" I, of course, gave her my gardenia. After Mae gave the green light to my sketches, I returned to my little studio. I kept thinking, "Would I ever see him again?" I read and re-read the enclosed card. It simply said, "Better luck next time."

Some time passed by and again I found another box on my desk, with the same number of gardenias. They perfumed the entire office. Mr. Van Slank was gone. There was a note on my desk that said, "Mr. James Irvine Jr. called." How could I thank him? I didn't know. As I remember, I must have received five or six boxes of gardenias when I decided I had to do something about it. Martha Wright, a friend who worked at the Gillam Advertising Agency, had invited me to spend the weekend at Laguna Beach. At that time, there was no Irvine Bowl and no Art Festival, but I knew there was an art colony, so I decided to go. Martha had a cousin who had loaned her an apartment. It was right on the beach. I loved ocean swimming so it was a real treat. I knew Tustin was in Orange County, but how did we find the Irvine Ranch? After lunch, Martha got directions. I had no idea where we were going. It seemed hours before we arrived at the entrance of the long, curving, palm lined driveway. I was so nervous I couldn't even find the note I

had written and intended to leave for Jase. I kept wondering, "Is he home or isn't he?" Martha's arm accidently hit the horn. I was so embarrassed. The screen door opened. It was Jase. He was quick to recognize me as he said, "Hello, hello!" And then he opened the door of Martha's car. After I introduced Martha, he said, "I am so glad to see you. You're just in time for lunch!" I told him we already had lunch. He then said, "We have a big pitcher of lemonade." Several people were sitting on the lanai eating sandwiches. After introductions, we had a glass of lemonade. Our stay was brief as I knew we had to get home. Again, I had a lot to do. Jase asked us for dinner, but again I had to decline, for the same reasons. I could see he was disappointed, but I knew I had to get back. When we returned to the car, I handed Jase my note. I told him I didn't know where to send it. He responded, "I'm so glad you came." Our eyes met and again we both sensed something we just couldn't express. As we left, I said, "The gardenias were all so beautiful. I loved each one," and once more I wondered if I would ever see him again.

On another occasion, my mother's parents were having the house on Severance Street repainted and all of the furniture was covered with sheets. There was a knock at the door and there stood my father in an elegant camel hair overcoat. He had driven up to Los Angeles with his father, who was waiting in the car. My mother was extremely embarrassed by the state of the house and was reluctant to ask him in. However, my grandmother stepped forward and said, "By all means, do come in and join us for dinner," and motioned him toward the kitchen. My mother was mortified. So my father smiled, waved to his father and called out, "That's OK, Pa, you go ahead. I'm going

Joseph Kleitsch (1882–1931),
Eucalypti, oil on canvas, 16 x 20 inches

to stay here." Later, my father remarked to my mother how that particular dinner had made a lasting impression on him. He said that he had felt a closeness that he had never experienced in his own family. He would tell her, "I've

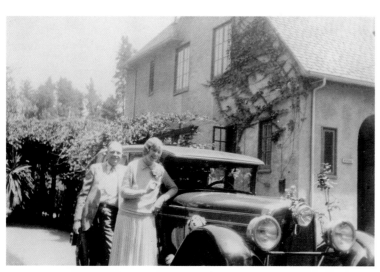

Jase and Athalie in driveway of Severance Street house, c. 1928

never known such loyalty in a family, Athalie. You just live for one another, you and your mother, and your father and your sister." Later, my mother would tell him, "I don't know whether you really married me or my family." My mother said my father never forgot the warmth and informal intimacy of sitting in the kitchen that evening and having dinner with her family.

It was not until 1928 that my father was able to secure a divorce from his first wife, Madeleine Irvine. Although they had led separate lives since 1925, she had been extremely reluctant to give him his freedom. My mother recalls the threat she received the day before her wedding: *The home of my parents on Severance Street was alive with the sound of music. The very joy of living prevailed in every room. The garden had been manicured. The magnificent grand piano which Jase had given me for my birthday was being played by each of the bridesmaids. My mother wanted the*

florist to come the day before the wedding. Flowers were everywhere. My sister Jeanne was giving the rehearsal dinner with Jase's brother Myford at my parents' home. The seamstress who had made my wedding gown arrived with my dress for the final fitting. All of the six bridesmaids came too, for their final fittings.

My sister Jeanne was the maid of honor. The matron of honor was Phyllis Ames, the daughter of my mother's best friend, Katherine Blieker. Her husband, Burton, was one of Jase's ushers. The bridesmaids included Mae Huseboe, Genevieve Young, Evelyn Whittier and Zelpha Young. Jase's cousin Katie Irvine Lillard and my cousin Margaret Mather were the flower girls.

Only one thing marred that beautiful day. Jase's cousin, Mort Plum, told Mae Huseboe, who in turn told me, about the awful letter Jase had received from Madeleine. It stated that I would never reach the altar alive. I would have a bullet through my head before the service began. Jase was furious when I phoned him at the Athletic Club where he and Mort shared a room. He said Mort had betrayed his confidence and he was very upset. I begged him not to chastise either Mort or Mae. I felt sure Mort had pledged Mae to secrecy and she probably thought about it and decided on her own that I should know. Perhaps it was better this way. At least I could make a decision on how we should proceed. Jase tried to relieve my mind of any kind of catastrophe. I remember I asked him if I should call the wedding off. His reply was that was Madeleine's intent, hoping we would do just that. He was convinced it was only an idle threat. He said people do not threaten if they truly intend to act. He told me Madeleine was a coward and would not come near the church. There was nothing to fear and we were going to go right ahead. He said not to mention it to anyone because he did not want our family and friends to worry. He would take care of Mort if I would take care of Mae. The only person I told was our dear Mrs. Scott, the seamstress, who had become such a close friend. When I related the story to her, I have never forgotten what she said: "Clothe yourself safely around with infinite love and wisdom." And then she added, "God will protect you." And this He did.

Our home was lovely with all the flowers. The rehearsal went well. The ushers were all there and so were the bridesmaids and the two little flower girls. Katherine's daughter Katie, who lived with her uncle Jase at the ranch, was spending her time at my house. I remember how excited she was to be a part of our wedding. Myford was Jase's best man. The ushers included Whit Spear, Burton Ames, Mort Plum, Charles Young, Fred Shurtleff and George Maxwell. No one, with the exception of Mort, Jase, Mae and myself, ever knew of Madeleine Irvine's terrible threat.

January 10, 1929, was a beautiful clear afternoon. Our home was bubbling with joy and laughter. The bridesmaids, the ushers and Jase all came to our house after dinner. As was the very traditional custom, the groom did not see his bride until they met at the church. To make little Katie feel she was very much a part of the wedding, she brought me a blue velvet box from her uncle Jase. Much to my amazement when I opened the box I found a magnificent diamond brooch. When the bridesmaids all came upstairs, they all wanted to see the gift that Jase had given me. Each one wanted to try on my beautiful pin.

At the appointed time, the cars pulled in front of the house and we were all driven to St. John's Episcopal Church at the corner of West Adams and Figueroa. We all had entered into the church when uncle Warren discovered that my little cousin Margaret had forgotten her basket containing the rose petals. Katie had hers, so we waited in the lobby for him to return with the basket of rose petals for his little girl. My father seemed grateful for the interlude. I remember he said, "Athalie,

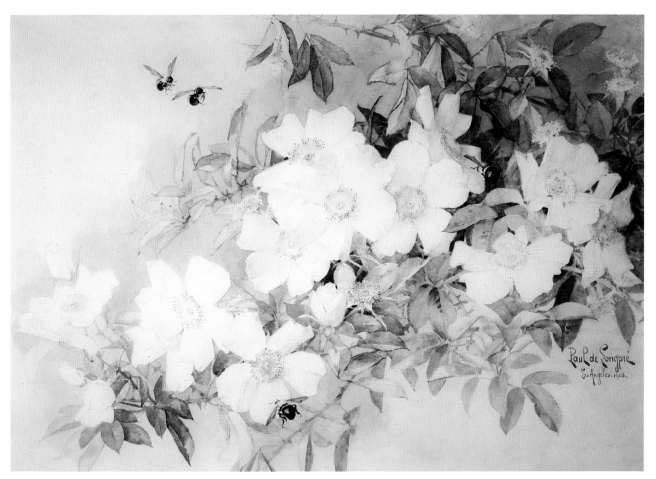

Paul DeLongpre (1855–1911), *White Roses with Carpenter Bees*, 1905, watercolor, 18 x 25 inches

Wedding portrait, January 9, 1929

there will be a great change in your life, don't let it change you. If you always remain the same, some day you can be the channel through which great good can flow." Those were his parting words to me, before he accompanied me, arm in arm, as we walked down the long aisle.

It was a candlelight service and the church was aglow with flickering light. It was a most beautiful sight. I remember so well when my father stepped aside and Jase took my arm.

We walked up the steps to the altar and I handed Jeanne my bridal bouquet. My veil was Belgian lace and was fitted like a delicate cap around my face. The ceremony was especially impressive as we repeated our vows in the glow of so many candles. Myford was so nervous at first. I think Jase thought he had lost the ring. We left to the strains of Mendelssohn's Wedding March. What fear I experienced had completely vanished. The feeling I had was one of complete serenity. I know I repeated those few simple words, "I clothe myself safely around with infinite love and wisdom."

The pictures were all taken before the wedding. We went straight to our home and arrived there first. When the other members of our family and friends arrived, we stood in line and greeted each one. Due to the size of our home, we could only seat about seventy-five or eighty people. Due to the uncertain weather, they had to remain inside. It was Prohibition. Mr. Irvine did not drink. Jase and I had attempted to make our own champagne. We had used our large cellar to try to age it. Fortunately, we sampled a bottle long before the wedding and it was a total disaster. My father was also very strict about hard liquor. He only kept a small amount of whiskey for medicinal purposes. My mother had some kind of sparkling apple cider. From time to time, each of the ushers went out the front door and would return in a very happy mood. They all had bathtub gin hidden in the ferns which bordered the two palm trees in the front yard.

With his drink, Mr. Irvine gave the first toast. He said, "What do you give to young people when they will

have everything they need? This is only for the bride to spend any way she wants." With that, he handed me an envelope with a card which read, "Don't give it to Jase, he will only spend it."

After a wonderful evening, Jase and I went upstairs to my room to slip out of our wedding clothes. My lovely fur coat that he had given me for Christmas was purchased from Colburn's, our finest fur store, which was located on Flower Street. I did the drawings for this exclusive store. One of the times Jase met me, I was completing some sketches there. The magnificent Persian lamb coat was in the window and right away it caught Jase's eye. He insisted I must try it on. It fit perfectly. It was a very light beige. The luxurious fox collar matched the delicate shade of the coat. It was elegantly fashioned and the skins were so soft. My dress was pale beige, the color of the coat. When we said goodbye to our family and friends, Jase opened the front door. It was then that we were showered with lima beans. They came so fast and in such a great quantity that it seemed like a pouring rain of beans. It was my sister Jeanne and Myford who thought this would be quite hilarious. Jeanne and one or two of the bridesmaids made small silk bags and Myford sent the beans. It was quite a surprise as we drove away.

Our destination was the Beverly Wilshire Hotel. I cannot remember the reason the ship The City of Los Angeles was delayed in its schedule for two days and would not sail until the 13th of January. I remember the night was very cold and I was wrapped in my beautiful fur coat. I don't believe I let go of the warmth of its folds until I reached the desk inside the hotel. It was a most embarrassing moment when I let go of my tight hold. A shower of lima beans fell out all over the marble floor. They seemed to fly in every direction. Finally a bellboy escorted us to our room. Upon opening the door, Jase very promptly said, "There has to be a mistake, there is only one single bed." The poor bellboy seemed equally upset. I was still shedding lima beans, much to my total dismay. After a great deal of explaining, we were assigned a different room. It was

Anita Plum Irvine

drive to Santa Ana the next day. He said there was something he wanted to do.

Anita Plum Irvine was the essence of refinement. One only had to look at her beautiful portrait to see she was a lady of the manor born. She had such beautiful features. They looked like they had been chiseled out of a piece of marble. You could see by her pictures the deep spiritual quality reflected in her face.

When Mr. Irvine came to the ranch from San Francisco, his wife always accompanied him. Her health was such that after bearing three children she required nursing care. The problem was her heart, plus a tendency to respiratory attacks. Mr. Irvine was such a rugged individualist that I am sure he had no conception of his wife's frailty. In spite of her bad heart, he would take her on long rides to inspect the ranch, on rough roads, in any kind of weather, even though she pleaded not to go. As a result, the nurse would have to keep her in bed for one or two weeks in order for her to recover.

Jase's love for his mother was very deep. She died in 1909, and I don't think he ever got over her loss. During our drive to Santa Ana, he told me the last time he accompanied her to the train when she left for San Francisco, he felt he probably would never see her again. She gave him a small pocket purse with a ten dollar bill inside. He said, "That was the last thing my mother gave me and I couldn't ever spend it." The purse was in his safety deposit box in the First National Bank in Santa Ana.

Mr. Cruikshank, the president of the bank, was surprised to see us. Jase explained how he wanted now to include my name on his safety deposit box, as well as to open a checking account in my name. I remember I had father Irvine's wedding check. I wanted to share it with Jase but he laughed and said no. He reminded me of what his father had said: "Athalie, this is for you, and don't give it to Jase, he will only spend it."

like the Presidential Suite. As I recall, it had three or four bedrooms, a living room, a dining room, and its own kitchen. At that point, Jase was quite taken aback. He phoned and again talked to the desk. He informed them that the suite was much too big. All we wanted was one nice room with a double bed. The desk responded that it was all they had. Finally Jase made his point and someone came up and closed off the enormous suite.

I have always remembered the very touching thing that Jase said: "Athalie, how much I wish that my mother could have lived long enough to have known you." There was a trace of sadness in his gentle voice. It was then he suggested that we

Before we left the bank, he said, "That was the last time I saw my mother. She died soon after her return to San Francisco. If we ever have a daughter, I would like to name her for the two people I have loved the most, you and my mother."

My parents honeymooned for three months in Hawaii, at the Royal Hawaiian. When they returned, my father continued in his position as Vice President and General Manager of the Irvine Ranch. From 1929 to 1932, they lived in the ranch house.

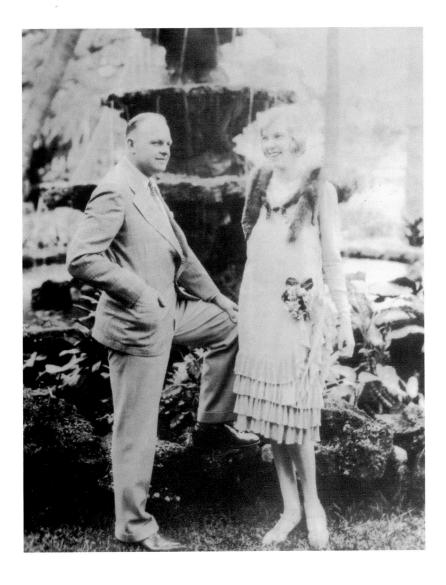

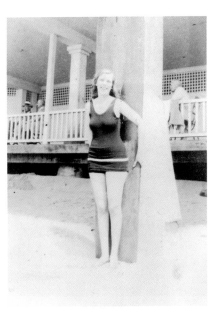

Jase and Athalie on their honeymoon in Hawaii, Royal Hawaiian Hotel

Colin Campbell Cooper (1856–1937), *The Rustic Gate,*
oil on canvas, 46 x 36 inches

*Shortly after Jase and I returned from Honolulu,
our housekeeper Maudie Fassell was stricken with
a severe attack of appendicitis. Father was there
at the time. He asked me if I would take over
and supervise the household. This meant plan-
ning the meals, supervising the staff and taking
care of the needs of his guests. I talked it over with Jase. He
said he knew I could do it.*

*The ranch house was not very attractive when I
first went there to live. Father's room needed refurbishing badly.
This he agreed to let me do. He was very pleased with the re-
sults and said I could remodel the entire house if I would do as
good a job as I had with his room and bath. This I undertook to
do with the help of Mr. Baxter, the head carpenter.*

This is how my mother characterized her fa-
ther-in-law: *My father-in-law was a man who
was big in stature, a monarch in his baronial empire. He always
fought fiercely for what he thought was right. He often regaled me
with stories of his early life. Once he had to mortgage the land to
keep all of his inheritance. Later, with rifle in hand, he kept the*

Southern Pacific Railroad from coming through his ranch. He was a stalwart man, fierce in his convictions, determined always to win his point. He loved the outdoors and he loved his land with a passion. Throughout his lifetime there were two very significant things which motivated him: his family and his ranch.

During each of his visits, my father-in-law would ask me to accompany him on his morning walks. This he enjoyed doing before he went to the Company office, which was near the ranch house. He told me so much about his life and a great deal about the ranch. He was so knowledgeable regarding agriculture. He would describe, in detail, the origin of every tree that was growing on the ranch.

I remember the beautiful walnut trees across from the tenant houses which were on Irvine Boulevard. The tall eucalyptus trees he used for windbreaks between the rows and rows of citrus groves. The giant gum trees were native to Australia. They stood like sentinels in the center of Irvine Boulevard.

James Irvine II, "J. I." (1867–1947) Photo courtesy of the Irvine Historical Society.

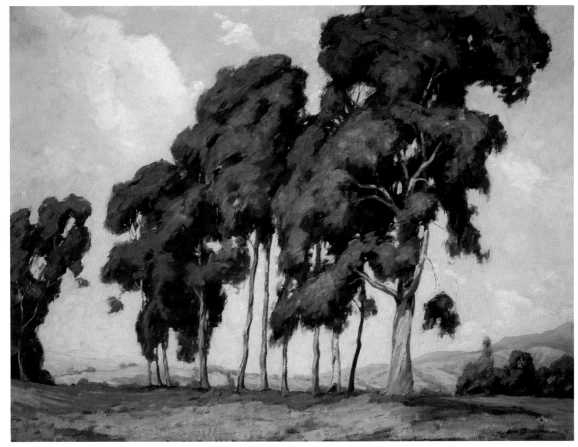

Aaron Kilpatrick (1872–1953), *Eucalyptus*, 1911, oil on canvas, 36 x 48 inches

With sadness, he related the story of each of the Irvine women. He said they had not fared very well. He told me he did not remember his mother, as she died when he was a small child. His beautiful wife, Frances Anita, died when his three children, Jase, Katherine, and Myford were all young. His daughter, Katherine, died during the birth of her only child, Katie. It was the story of a very sad life.

He enjoyed telling me about his travels to foreign lands. He said he always brought back some kind of a plant or a tree, which he hoped would grow in its new environment. That was why we had so many varieties of fruit and unusual plants in the gardens around the ranch house. We would walk, mile after mile, through the extensive Valencia, navel, grapefruit, and lemon groves. The walnuts, citrus, and avocados totaled about five thousand acres of trees. It has left an indelible impression in my memory, the beauty and the nobility of these magnificent trees, planted so precisely in the countless rows of beautiful groves, as far as the eye could see.

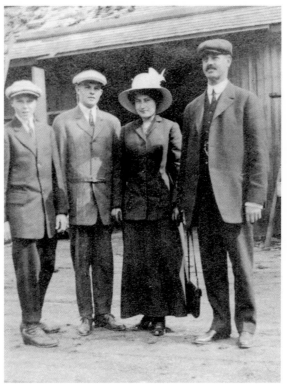

The Irvine Family, circa 1910,
left to right: Myford, Jase, Katherine and James Irvine

My grandfather would show her where they planned to bring in water for irrigation, and she would watch as my father "witched" for the wells. Once they found water, she was shown how they drilled the wells. My father was responsible for much of the development and conservation of the water resources on the ranch, including the Santiago Canyon Dam that forms Irvine Lake, which allowed the Company to become one of the largest single landholdings under cultivation in the United States, maintaining one of the largest Valencia orange groves in the world.

All the agricultural knowledge and experience she acquired from my grandfather was later put to use when she purchased and farmed ranches of her own.

One of the highlights that my mother recalled during her years at the ranch was being present at one of the series of experiments that were conducted by Dr. Albert Michelson, on the Irvine Ranch, to measure the speed of light. She vividly remembered that she was the only woman given the privilege to look into the mile-long tube that was especially built for the experiments.

My father suffered from tuberculosis which he had contracted as a child from exposure to an infected housekeeper. When he was in the service in World War I, he experienced the first severe effects of the disease. While stationed at Camp Meade in Maryland, he fell ill from exposure to extreme cold. They decided to return him to California, and as the train crossed the Rocky Mountains, he experienced a severe hemorrhage. With treatment, the tuberculosis came under control, but it would often flare up when my father was under severe stress.

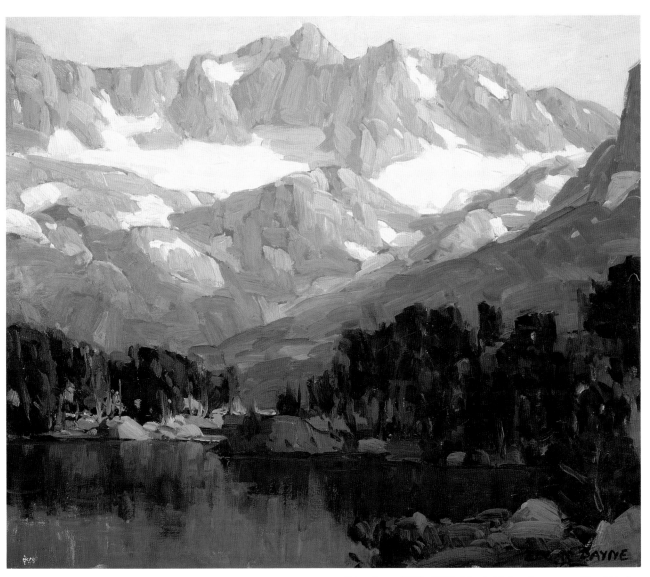

Edgar Payne (1883–1947), *Palisade Glacier,* oil on canvas, 22 x 26 inches

Jase and Athalie on porch swing,
Irvine Cove bath house, circa 1929

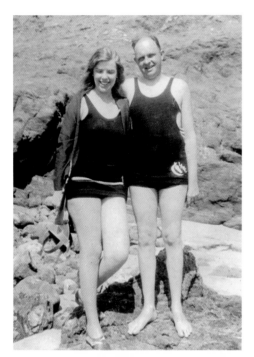

Athalie and Jase at Irvine Cove, circa 1929

My father had always loved the ranch and had wanted to build a home at Irvine Cove. Because of the tuberculosis, he was not sure that he could tolerate the constant dampness of the beach environment. Nevertheless, he had two of the small tenant houses that stood across the Coast Road moved to the cove. One of the houses had the living quarters, and the other had the kitchen, dining room and a small room for servant's quarters. They were placed at right angles on top of the cliff above the beach and connected by a porch. Together, my parents selected some heavy wicker furniture which they bought and placed in the house. My father constructed a series of steps from the cliff down to the beach. At every fifteen steps there was a small landing with a bench, which he had built for my mother's grandmother, who suffered from a heart condition. At the base of the cliff, near the ocean, was a building which housed a large kitchen with a bath house above.

The little green house at Irvine Cove, circa 1935

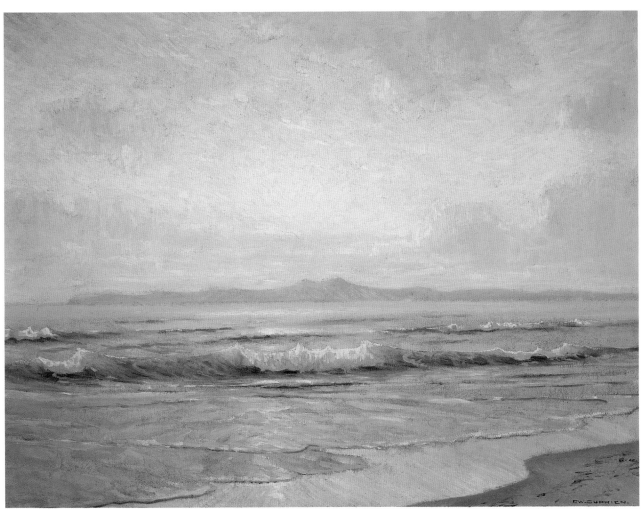

Frank Cuprien (1871–1948), *Tranquil Evening,* oil on canvas, 24 x 32 inches

They loved the little green house at the cove but unfortunately found that my father could not tolerate the damp coastal air. But they still enjoyed going there during the summer months. It was here that they entertained all their family and friends at the beach. My grandfather loved to go there on the Fourth of July.

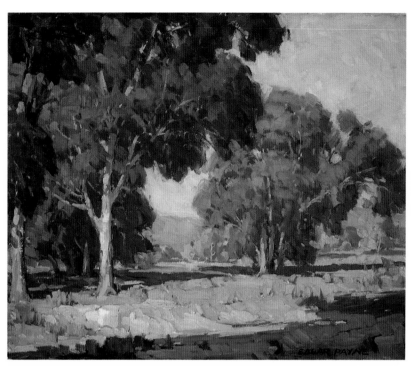

Edgar Payne (1883–1947), *Inland Scene*, oil on canvas, 25 × 30 inches

It was Fourth of July, 1929, my first time to make plans for a big party for my new father-in-law. What a challenge it was!

He told me to count on about twenty-five or thirty people. Jase's brother Myford and his wife Thelma came down from San Francisco. Thelma said she would help me. I told her I had planned steaks, corn, stuffed tomatoes, which I enjoyed making, hot buttered rolls, a green salad and strawberry shortcake that our cook Coco made in individual servings. I wanted it to be just right.

All the ordering had been completed. Jase told me I had better count on some extras, which I did. The evening before the Fourth, during dinner, father Irvine announced he had invited more guests. I knew I could handle about ten. I asked, "How many more, father?" He replied, "I think about twenty-one or twenty-two and I might call some more tonight," and this he did.

Jase left for the cove before breakfast. Picnic tables and benches had to be set up, as well as wood for the barbecue, and umbrellas and chairs for the beach. Checkered table cloths,

napkins and the beach silver all went with Jase. The fireworks were stored in the bath house.

Due to a high tide, the beach had to be cleaned the morning of the Fourth. Jase was very particular about the bath house, the kitchen and the outside johns. Even with help he did a lot of it himself. Then there was the problem of ice. It came from the ice house in Laguna. The ice box would only hold fifty pounds, so food had to come down on the afternoon of the party.

After breakfast Mr. Irvine did some more phoning. I began to worry because the cook was becoming upset with so many changes in the guest list. Fortunately, Jase sent Bob Reed, our ranch sheriff, back from the cove to see if I needed help.

Because the stores were all closed, I suggested to Bob that he might see if the vegetable stand on Irvine Boulevard was open. I needed more corn and more tomatoes. I was so relieved when he came back with both items. Thelma and I were headed for the bunk house when father emerged from the gun room to say he had phoned some additional friends and they had accepted. At that point, I knew I had to change the menu. As soon as Mr. Irvine went upstairs, I went to the gun

room to phone. Fortunately, Mrs. Knott was home. I told her of my predicament and asked if I could pick up about fifteen pies. She didn't have anything like that number but she said she would make them for me. I was so relieved because I had Bob to pick them up.

We left for the bunk house, which was just across Myford Road. On the way over, Thelma said, "Wouldn't you know the old man would pull something like this." I asked her where Myford was. She said he probably went back to bed so he wouldn't have an encounter with his father.

Mort, Jase's cousin, lived at the bunk house. I had phoned him earlier and asked if he could help me get some more steaks. He agreed to tell the cook. When we opened the door to the dining room at the bunk house, the cook was ready to help us. The meat was hanging in a big walk-in refrigerator. He put a large piece of beef on a meat block and simply asked, "How many do you want, Mrs. Irvine?" We left them there to be picked up by Bob after he picked up the pies.

Our next assignment was to inform Coco that he didn't have to make strawberry short cake. At that point there was a big change in Coco's attitude. Thelma and I had another conference. I couldn't possibly bake eighty stuffed tomatoes in that small oven in the cove kitchen. To remedy the situation, I went to the commissary in the basement. Yes, we had plenty of canned crab. This was purchased by the case. It solved our problem. Thelma and I peeled the tomatoes and scooped them out so each one could be filled with crab salad. When I told Coco, he was very pleased with the substitution.

It was a heavenly day, as I remember, guests arrived about 3:00 p.m. Only a few went for a swim as it was an older crowd. The water was cold. Lemonade, soft drinks, fruit juice and Kelso water were served during the afternoon. Myford and Thelma sat with their guests quite a distance from the other guests.

After all of the guests arrived and were seated in the canvas chairs that Jase had set up on the sand, my father-in-law took pictures. He then left the group and went inside the bath house.

When he returned, he was like a small boy with his first firecrackers. As fast as he could break off a half dozen or more, he would light them and toss them under the ladies' chairs. It was hilarious. Some of the women were so startled they jumped out of their chairs. Others just fell out. One or two had to be helped up. Fortunately the soft white sand served as a cushion and prevented any serious accident. My father-in-law was convulsed with laughter. I don't think I ever heard him laugh so hard. It was almost contagious, and some of the men laughed

Beach party at Irvine Cove, circa 1929: Jase (second from left), Athalie (third from left), Mort Plum and Mae Huseboe (couple at front right)

too. For Mr. Irvine this was the best part of the party. I helped some of the guests retrieve their possessions, they seemed to fly in every direction. Mr. Irvine just took more pictures of his disheveled friends. For some, that Fourth of July was a day to remember.

The decision to eat early was due to the fact we only had oil lamps. These were set up and down the long picnic table. Jase presided at one end, I was at the other. He did a fantastic job barbecuing the steaks. Myford remained with his guests. Mort helped Jase, it was a big job. When the coffee came

on with the pie, Jase received many toasts. He said the honor belonged to his bride.

At dusk, Jase, Myford and Mort climbed the steps and found a suitable spot for the fireworks. They were beautiful and more spectacular than any year before.

Father was pleased and I felt rewarded. The pressure was off and now Jase and I could relax. I was so new at this job that I was not too sure of myself but the party gave me confidence.

Every year, in the fall, my grandfather would come to the ranch from San Francisco, where he lived most of the time, and visit his family. This started with the quail hunting season. My father would always go hunting with my grandfather and on many occasions my mother would accompany them.

One morning, my father-in-law asked me if I was going to join them for the hunt. I told him I knew nothing about hunting. He quickly responded that I had better learn or I would spend a lot of my days at the ranch house alone. I did learn and it was my father-in-law who taught me.

We always left early in the morning. Sometimes we would stay all day. Our lunch was in small brown paper bags tied with string to the pommels of our saddles. It was always the same: a sandwich, a hard boiled egg, two cookies and one apple or an orange. We would ride to an isolated hilltop overlooking the great central valley. It would be a spot selected in advance. Here three or four cowboys gave us our guns. They were not invited to do any shooting. Those invitations were rare and only included a few close friends.

After we finished shooting, the cowboys would find the birds and reload our guns. We would then ride on to a new

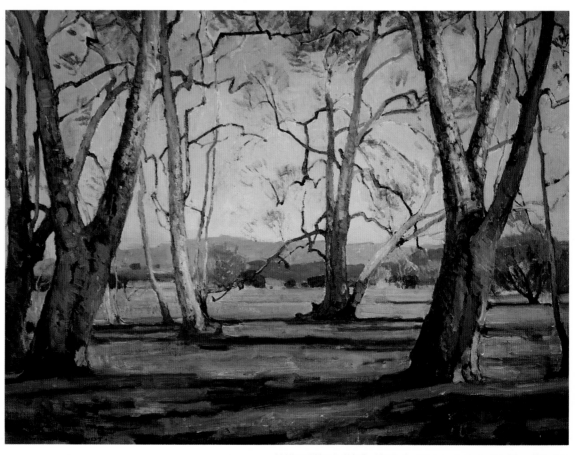

William Wendt (1865–1946), *Sycamores*, oil on canvas, 30 x 40 inches

Hunting on the Irvine Ranch, c. 1929

location. *If the game warden ever asked any questions about the fifteen bird limit, the cowboys made up the difference.*

We had quail for breakfast, lunch and dinner. The broiler had to be timed just right. As a rule, I remained in the kitchen to see they were in the oven for only three minutes, then turned for three minutes more. This my father-in-law said was just right. If it happened otherwise there were bitter complaints and the birds were sent back to the kitchen.

Each time father Irvine came down from San Francisco, he would bring two pairs of shoes to be patched, his

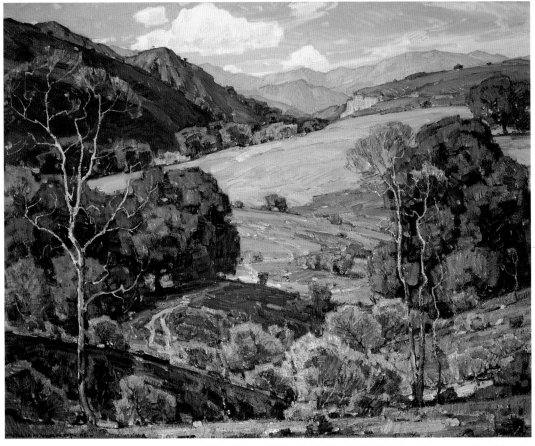

William Wendt (1865 – 1946), *When Fields Lie Fallow*, oil on canvas, 40 x 50 inches

long red underwear to be mended, and his socks to be darned. The housekeepers we had before, Nellie and Maudie, who always tended to this, were gone. I was running the house at the time when he brought them to me. I agreed to darn the socks but I drew the line on the underwear. I will always remember how the long red underwear did play an unforgettable part at one of my father-in-law's dinner parties.

Most of his friends enjoyed duck. Father always liked giving a dinner party or two before the hunting season was over and he returned to "the city," as he always called San Francisco. He would choose his guests and a date would be set. At that time there was no furnace heat.

At the time the night was cold so I had fires going in each of the fireplaces. One was located in the dining room, one in the second parlor and one in the living room. I preceded Jase downstairs so I could check the table and arrange the place cards.

The dining room looked lovely and the embers in the fireplace gave a warm glow to the room. As I went into the living room, my father-in-law was coming downstairs. He had reached the landing. I will never forget his angry voice when he asked, "Who ordered the fire?" I replied, "I had." He then pulled up his trousers and said, "Don't you know better? You know what I wear," as he pointed to his long red underwear. I said, "I was only thinking of your guests." He went straight to the gun room where there was running water. He filled a glass to the brim and tossed it on the fire. Smoke billowed out in clouds all over the living room. I was so horrified I couldn't speak. When Jase came downstairs, he opened the front door. I don't remember where my father-in-law disappeared. Jase opened the windows as the guests began to arrive. There was a lot of coughing and choking. Jase explained the fire was out of control. When Mr. Irvine greeted his guests, everyone told him they were cold. When dinner was served, most of the ladies kept on their fur coats. Jase ordered the fire

rebuilt. By the time dinner was over, the wood was burning and giving off heat.

Coffee was always served in the living room. Everyone had been served when Bob Reed, the ranch sheriff, rang the bell on the front porch. My father-in-law opened the door. Four or five of his pointers and setters dashed in and bounced all over the living room. They were a lively bunch until Mr. Irvine took his seat in his favorite chair.

He stroked each one as it lay down at his feet. He produced a tennis ball wound around with a very strong string and walked to the center of the room where he threw the ball into the fireplace. There was great confusion as lamps turned over, coffee was spilled, and cups and saucers fell on the floor. One of the big brown setters jumped over the davenport. One of the guests looked like she was about to faint. Each one of the dogs tried to retrieve the ball from the fire. One of them always did and brought it to Mr. Irvine. The others barked, yelped and shook their ears. Some of them were badly singed.

It took a few minutes for their yelping to calm down. As soon as it became quiet, the performance was repeated. After a while the repetition became monotonous and some of the guests went home.

After they all said good-night, I told Jase I was going to Los Angeles in the morning and would stay with my parents until his father concluded his visit and returned to San Francisco.

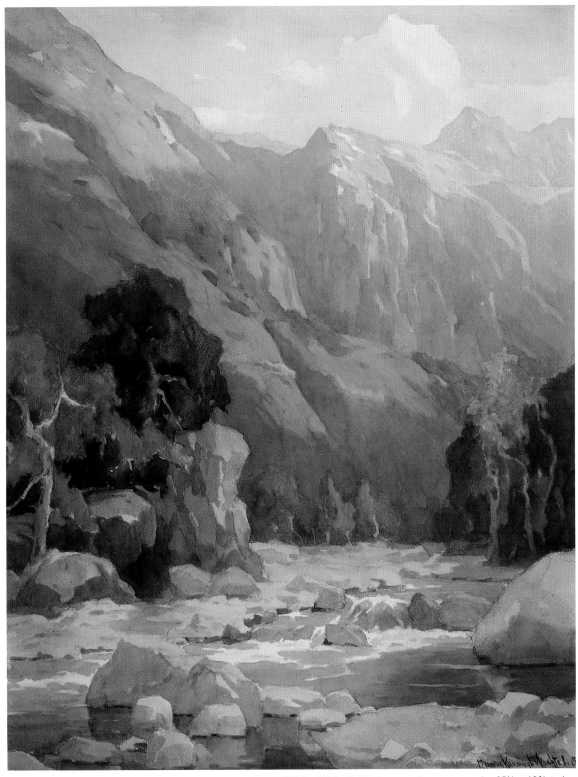

Marion Kavanagh Wachtel (1876–1954), *Matilija Canyon at Sunset*, watercolor, 25¹/₂ x 19³/₈ inches

On January 31, 1931, my grandfather, James Irvine, married Katherine Brown White, his second wife. The new Mrs. Irvine was very antagonistic toward my father. Some months prior to the marriage, my mother recalled: *Father Irvine phoned us one evening to please come to San Francisco right away as he was in trouble. We left and drove all night not knowing what to expect. We arrived in time for breakfast. He told us Mrs. White was going to sue him for breach of promise. He was very upset because Mrs. White had engaged a Mr. Cantillon in Los Angeles as her lawyer.*

Mr. Irvine said, "Jase, we will have to fight fire with fire." He asked Jase to find out everything he could about Mrs. White as quickly as possible. After Jase gathered considerable information, he gave it to his father. In turn, father confronted Mrs. White and in a moment of weakness he revealed to her who his source had been. Mrs. White was furious. Father hated publicity and Mr. Cantillon was notorious for trying his cases in the newspapers. I told Jase that I was afraid his father had met his Waterloo. From that time forward, "Big Kate," as she was called, continually found reasons to criticize Jase on every pretense she could think of.

In May of 1931, Jase and I lost our first pregnancy. I was very upset and very depressed. We had finished refurbishing the ranch house and moved from the north front bedroom to a bedroom on the south side of the house. Father had permitted us to add a bathroom to our new bedroom and enclose the sleeping porch. This we had intended for the nursery. It was so nice to have our own bath as our old room had a bath that we shared with two other guest rooms.

It was the late part of May when Jase told me that his father had asked him to go to Washington to confer with the counsel who was going to represent the Irvine Company in a case which was going before the Board of Tax Appeals. Loyall McLaren, the Irvine Company accountant in San Francisco, had selected the firm because Virgil Moore, a senior partner, was an attorney who had previously worked for the Internal Revenue Service.

Jase urged me to go along. He felt the trip would do me a lot of good. He said after he finished the company business in Washington, we would go on to New York and see some shows. I had never been east so I really wanted very much to go.

Loyall McLaren met us in Washington. I was ill all the way across the continent. Jase was so worried, he had a doctor waiting for me in Washington.

Jase gave me a day by day report as I had to stay in bed and miss the hearings. I was so very proud of him. All the men would come back to our suite and evaluate the progress of the case. June 11th was Jase's birthday. Loyall had arranged a surprise birthday celebration at the Carlton. We were staying at the Mayflower. It was a double celebration as that morning the case was decided in the company's favor. Jase was very excited about his achievement and said he had reached a compromise by promising to make the land which extended from Crystal Cove to Corona del Mar a park. Everybody toasted Jase and complimented him for the fine work he had done. That night he phoned father. After Jase talked with him, I knew he was upset. Jase said his father didn't even say, thank you. As Jase so often said on that trip, "Just one word of appreciation would have meant so much."

One of the highlights of the trip occurred when I accompanied Jase when he met with President Herbert Hoover, in the Oval Office of the White House. He was my ideal. In the 1928 election, Herbert Hoover was the Republican Presidential nominee and New York Democratic Governor Al Smith was his opponent. Jase told me he was going to vote for Al Smith. I could not believe what I heard. I was so mad, I picked up the phone book and threw it at him. I also told him I would not marry him if he voted for Al Smith. Jase then said he would not vote at all because he did not like Herbert Hoover. I remember my father thought my conduct was deplorable. My mother was a Republican, her grandfather was a Republican, and her great grandfather was a Republican. I believe my father voted for the man and not the party. I know this bothered my mother. I can remember her saying the University of Chicago was socialistic. This was my father's alma mater. I can only remember one issue they ever disagreed on: politics.

When we entered the Oval Office, President Hoover was seated at his big desk. He was very sad and drawn. His gray color matched his gray suit. It was tragic to see a man who had disintegrated so much in just three years. It was during the Depression and the President was blamed for the deteriorating condition of the nation. People were out of work, people were

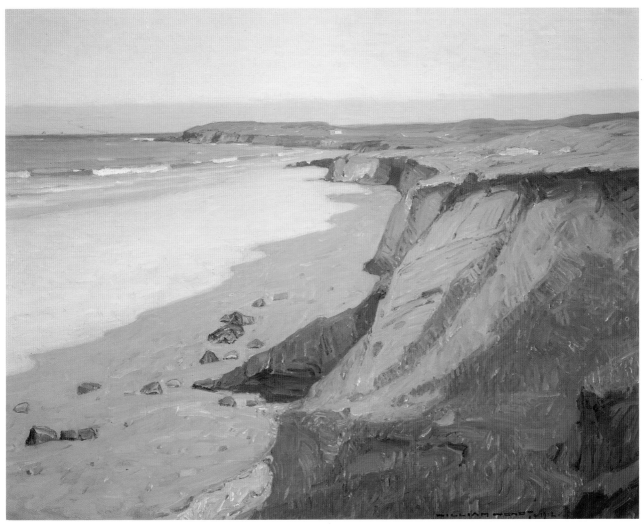

William Wendt (1865–1946), *Crystal Cove*, 1912, oil on canvas, 28 x 36 inches

homeless and people were hungry. This was evidenced at the ranch as more and more vagrants came to the kitchen door asking for food. Our commissary in the basement was always stocked with every kind of canned food. When some poor stranger knocked, I could not turn him away without giving him some of our surplus food. When my father-in-law found out what I was doing, he said I was to stop. He told me I would soon be encouraging a line that would ultimately extend as far as Santa Ana. Later, I could understand what Jase meant when he said, "It is men like my father who brought Roosevelt to power."

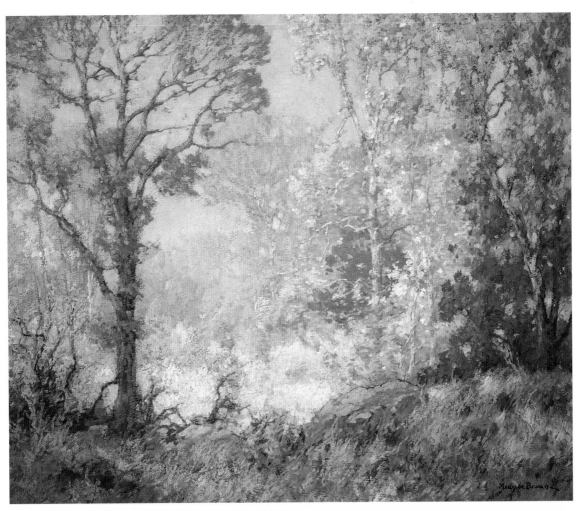

Maurice Braun (1877–1941), *Springtime*, oil on canvas, 25 x 30 inches

We continued on to New York and then to Boston. I became very ill with the heat. Jase was afraid to risk my going across the continent and the doctor suggested we go home through Canada. This we did and had a heavenly trip through the Canadian Rockies. We stopped at Lake Louise and Banff. We both enjoyed it so very much. Jase still hoped that his father would show some degree of appreciation. He said he might give us the cost of the trip when he knew how much we had enjoyed it.

When we returned to San Francisco, we went to the Pierce Street house to see Mr. Irvine. His first comment was he didn't understand why we had taken so long. He wanted a full report. He didn't see why we had to go to Lake Louise and Banff. He wanted to go fishing and wanted us home. Jase said

later, "I saved him hundreds of thousands of dollars on his taxes and he has a grudge because I take ten days off. If only once he would put his arm around me and say, 'Jase, you did a fine job,' it would mean a lot." It would have meant a great deal to Jase, I knew, but I just don't think Mr. Irvine's nature would permit him to do this.

Jase and I departed for the ranch knowing that Kate would be there because she was building a new house for herself in Newport Beach. Father did not seem himself when we left for the ranch.

We took the Lark home and Mullins met us in Los Angeles. It was noon when we arrived. Mullins carried our bags upstairs and said we were to take the room on the left, due to major repairs. Jase could not understand until he opened the door. The furniture was all gone, and in its place were all the new fixtures that had been installed in our new bathroom. Broken tile was all over the floor. The new wall-to-wall carpet had been taken up and rolled over against the wall. It was a tragic sight. Jase was furious. He called Baxter, the head carpenter. He told him to come to the ranch house at once. Reluctantly, we went to our old room. When Baxter came upstairs, he related what had happened. He said that Mrs. Irvine had convinced Mr. Irvine that the new bathroom was built to cut off his view. Father had a small sleeping porch off his bedroom. Our new bedroom was an extension of the sleeping porch and it did not cut off his view. Jase told Baxter to put everything back. He responded by saying that he couldn't do that because father had told him that Mrs. Irvine would give him instructions on whatever she wanted done at the house. We were both upset and did not go downstairs for lunch. Jase wanted to go down and confront Kate. I implored him not to do this. My feeling was this would be just the way she hoped he would react. I told Jase that he could not predict what she would tell his father. I felt she had a very evil intent. I recall so vividly how humiliated Jase felt. He said Kate had made him the laughing stock of the entire ranch work force. We debated the question of what we should do. Jase agreed he would not say anything and finally went to the office. We saw nothing of Kate and finally she left for San Francisco. Jase went about his business as usual. No one asked any questions and eventually Jase recovered from the deep hurt and humiliation.

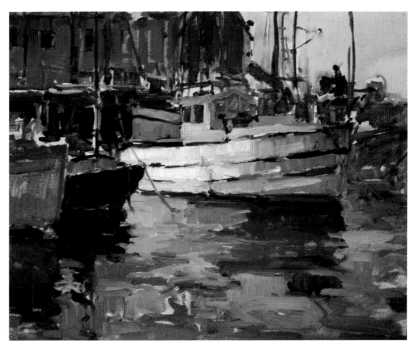

George Brandriff (1890–1936), *Cannery Row, Newport Harbor*, oil on board, 14 x 18 inches

One evening, father called Jase at the ranch. Jase said his father was quite uninformed. His father had just returned from his fishing trip and was unaware of the whole diabolical act. After hearing the facts, Jase said he was very surprised when father said, "Have it put back." A full crew was assigned and in a few weeks the bathroom was put back and the furniture was brought up from the basement. The glass French doors which had replaced the old double-hung windows, were re-installed. When it was finished, we were overjoyed and moved back into our new surroundings.

On the last of these family gatherings at the ranch, in 1931, my mother recalled: *The first of December, father Irvine returned to the ranch for the quail season. It was cold and rainy. The two men would leave at 6 A.M. and return at 6 P.M. Both of them would be soaked. I worried about Jase as he had caught cold but still went every day. He started coughing. Father said there was nothing wrong with him and would be annoyed if I suggested he should stay at home.*

Mrs. Irvine came down the week before Christmas. She was furious when she found the bathroom had been put back and all the furniture returned to our new room. I went to the office to warn Jase that she was there. He asked me to wait and we would go back to the house together, as it was near dinner time. Father was out on the ranch. We reached the house, went upstairs to our room, and Jase showered and shaved, as was his custom before dinner.

It was some time before dawn the next morning that we heard what sounded like bottles, pictures and shoes all being thrown against the walls, as well as the furniture being overturned. Jase and I were both startled as we awakened from our sleep. The battle sounded more intense than it ever had before. We shared a common wall between our two bedrooms. Similar explosions had taken place at other times but this one was by far the worst. As daylight progressed, we heard the bedroom door open and then slam shut with so much vengeance that it shook the wall where our beds stood. Next we heard

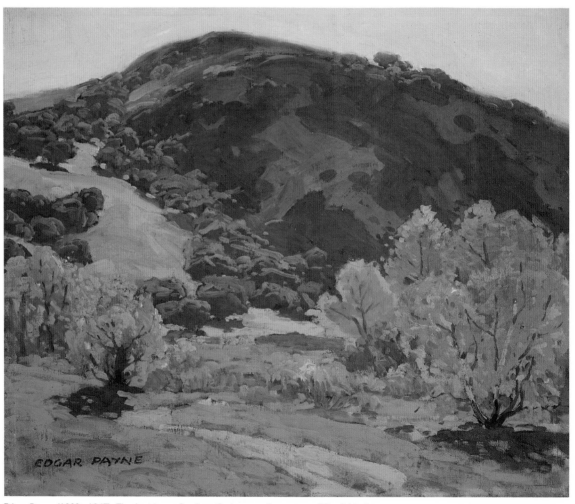

Edgar Payne (1883–1947), *Thanksgiving at San Juan Capistrano*, oil on canvas, 20 x 24 inches

someone pounding on the Shinto gong that stood at the west end of the upstairs hall. The large black gong was metal, and, of course, it would not break, no matter how hard it was pounded with the felt covered mallet that hung by its side.

Jase opened the door and saw Big Kate running downstairs with all five of her Pekinese dogs. They were yelping and barking as she let forth a tirade of profanities. Soon the sound of tires screeching and gravel flying indicated that Kate must have been leaving as the car slid from side to side down the curving driveway.

The gong had accomplished its function at least two hours earlier than it usually did. I could not go back to sleep that morning, so I dressed and went downstairs and took a walk around the garden. There were deep tire marks all over the gravel driveway, which only proved how Kate must have skidded as she tore out from under the porte-cochere and headed for Irvine Boulevard.

I was sitting alone in the living room, wondering how many things must have been broken in that early morning battle scene. I still remember how red-faced Mr. Irvine appeared when he came downstairs that morning. He was very angry and he immediately took it out on Jase. I can't recall the whole story except that he told me Jase had insulted his wife and had called her some names. I asked him when this was supposed to have taken place and he replied it was sometime before dinner. He told me that Jase had to stop it or he had to get out.

Without calling Mrs. Irvine a liar, I explained it could not have happened because Jase and I had left the office together and had come right over to the house. We had gone to our room where we stayed until it was time for dinner. We had not seen Kate until we were seated for dinner in the dining room. My question was if she had been insulted by Jase, why had she joined us for dinner. Nothing had been mentioned at the time.

Father Irvine was frozen in his chair. All he said was, "You mean she lied?" And then he roared, "She lied!"

Mr. Irvine said that Kate had taken the car and was headed for San Francisco. He also stated that they would not be staying for Christmas. I knew this was a real disappointment for my father-in-law. He had been pleased with the Christmas plans because all of the family had accepted invitations for dinner. I suggested that even though Kate had decided to go north, perhaps he might stay. I hoped he would do this because I knew Jase was being unfairly treated and blamed for something he did not do. Without Kate around, it might be possible to solve the problem. There was a long period of silence. Then my father-in-law responded by saying, "I don't know how I can do that."

When Jase came downstairs, his father told him he was going to take the train and go back to the city. He asked Jase to drive him to the station. Jase left with his father and I did not accompany them. I felt Kate had won her point. She didn't want to spend Christmas at the ranch but my father-in-law did. This had been his custom for many years. For her to change his mind was next to impossible, so she had to provoke an incident. She had used Jase to accomplish her purpose in a most underhanded way.

When Jase returned from taking his father to the station, he was crestfallen and looked ashen in color. I will never forget his expression. He stated that his father did not believe him. He told me his father said, "You accept her! If you don't, get out." All that week Jase concerned himself with ideas of what he could do and where he would go. He said he had been thrown out before and had managed.

It turned very cold that winter and the smudge pots burned all night. Jase's cold became increasingly more severe. He said if he could just go to a warmer climate, he knew he would be all right. This had always worked in the past. He said, "If I get where it's dry, I get right over a cold. The desert is my best medicine." He told me he had called Sacramento and been told they would welcome him as a lobbyist anytime. First he wanted to get rid of his cold before going up north. He said he knew he could handle the job and was pleased that it paid more than the two-hundred and fifty dollars a month he received from the Irvine Company as vice president and general manager. His deep cough persisted so we postponed our trip to Sacramento.

At night, I took bath towels and stuffed them under the doors and at the base of windows. I did this to try and prevent the heavy fumes from the smudge pots from coming into our bedroom. Unbeknownst to Jase, I had asked the ranch foreman not to light the pots around the ranch house anymore. Even this didn't accomplish what I had hoped. We didn't go the Rose Parade due to his lingering cold, which seemed to worsen each day. However, we did go into Pasadena to see the Rose Bowl game. On our way driving back to the ranch, Jase complained of feeling sick so I took the wheel. He said, "I feel like I have picked up some kind of bug and it's a good one." I was very concerned and insisted the next morning that he not go to the office and that he remain at home in bed. This he agreed to do.

Our Christmas tree was particularly beautiful that year. We had left it up until after the New Year. Jase rested that morning and I went downstairs to remove the ornaments from the tree. He had gone through a very rough time, coughing most of the night. That morning, the houseboy asked what time he was to serve lunch. I asked him to take two trays up to our bedroom. I explained that Mr. Irvine Jr. was not feeling well. Sometime later he appeared with our lunch. I preceded him up the stairs. When I opened the door, I saw Jase lying in bed, as white as the spread. He was covered with blood. I stood there for a moment, in utter horror. Jase directed me to go quickly and get a big bowl of ice. He also told me to get a spoon and a box of salt. I was so frightened I could hardly get to the kitchen. I phoned my father to come out to the

Marion Kavanagh Wachtel (1876–1954), *Sunset*, watercolor, 24 x 18 inches

ranch as fast as he could. I explained to him what had happened and that Jase had suffered a hemorrhage. I ran upstairs with the salt. My hands trembled so badly that Jase took the box containing the salt and poured it out in large spoonfuls. I insisted on calling Dr. Boyd in Santa Ana as I knew it would be some time before my father could get there. Dr. Boyd arrived shortly after my phone call. He diagnosed Jase's condition as bronchial pneumonia. It seemed like an eternity before my father arrived. There was a difference of opinion in their diagnoses. My father disagreed

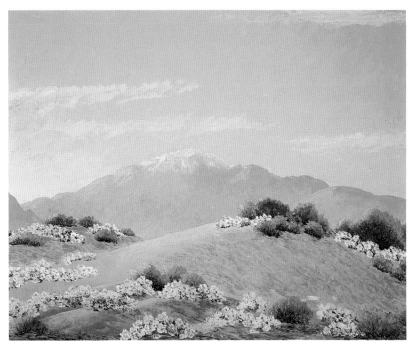

John Hilton (1904–1983), *Dawn of the Primrose*, oil on board, 16 x 20 inches

with Dr. Boyd. They had a discussion in the hall outside our bedroom. My father told Jase he was going to call Dr. Pottinger, who had treated Jase earlier for tuberculosis. Fortunately, Dr. Pottinger was in Fullerton calling on a patient. When Dr. Pottinger arrived, he seemed extremely concerned about Jase. After talking with my father, both Dr. Pottinger and my father agreed on the diagnosis of pneumonia, but they felt the sealed off tubercular bacilli had been activated due to the pneumonia. This they believed was the cause of the hemorrhage.

Dr. Pottinger called an ambulance to have Jase taken to his sanitorium in Monrovia. I was devastated. I couldn't believe what I had heard. When the ambulance arrived, I said I was going to ride with Jase. As we slowly drove down the long driveway, the red poinsettias nestled between the palm trees were waving like pennants, telling us good-bye. As we left, Jase had the ambulance pause as he looked at the house directly across the road. He wanted me to say good-bye to Mrs. Mitchell. Mr. Mitchell, her late husband, had been manager of the ranch for many, many years. When I returned to the ambulance, Jase told me that Mr. Mitchell was the only father he had ever known. I could not hold back the tears. I wondered then if we would ever

return to the ranch again as we turned on Irvine Boulevard on our way to the sanitorium.

I called father Irvine in San Francisco and informed him that we had left the ranch. I told him we didn't leave the way we had expected to leave. I simply said Jase was in Pottinger's sanitorium and I was going to stay there with him. He seemed as stunned as I had been when I first learned of Jase's condition. Mr. Irvine told me he would return to the ranch the following day. This he did and came to the sanitorium. His whole demeanor had changed and he looked like a man who was facing something he did not know how to accept. He saw Jase and how very ill he was. As he stood at Jase's bedside, his face registered both remorse and regret. It was like he realized, for the first time, how wrong he had been. After seeing Jase, he told me he had lost his mother, then his wife, and then his only daughter.

As the days and weeks went by, Jase showed signs of continued improvement. His cough had subsided considerably, his temperature was almost normal and he was eating well. I was thrilled to see his progress. There were so many good signs but Dr. Pottinger wanted Jase to remain for at least a

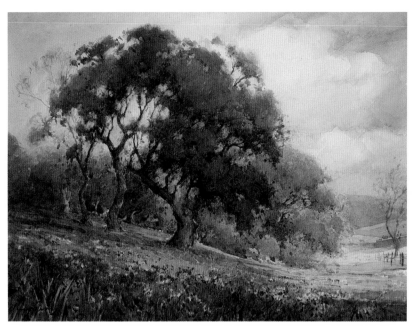

Percy Gray (1869–1952), *Oak Tree and Poppies,* watercolor, 12 x 15 inches

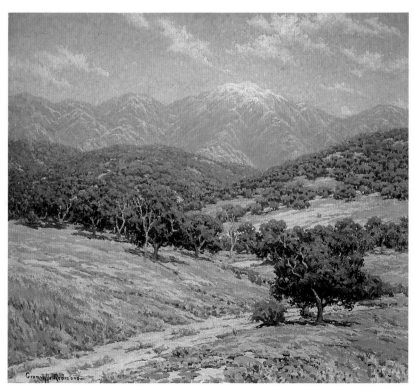

Granville Redmond (1871–1935), *Spring,* oil on canvas, 18 x 20 inches

year. My room was right next to his, so I could be with him during the day as well as at night. I kept a daily record of his condition and I took my meals with him each day.

The sanitorium was located in the center of a large expanse of green lawn. Rose gardens were encircled by magnificent old trees, which all added to the attractive landscape.

Jase rested in the afternoon. During that time, I would take long walks. Friends of my parents, Martha and Lauren Rhoades, lived in Sierra Madre. Occasionally, they would invite me for afternoon tea. It was a pleasant way to spend an hour or two away from the sanitorium.

My father and mother were so supportive. They came every week to see us. My father's great concern was not only for Jase but also for me. I remember him imploring me to come home. He would often say, "If you become ill, Athalie, you could not help Jase. You must keep healthy and strong." I couldn't seem to accept, nor did I realize at the time, that Jase's illness might become a very long ordeal. Being a doctor, my father, of course, knew this was possible. I began to understand a little more after reading books that he brought me. Still, I refused to leave the sanitorium and go home. As I look back now, I can still remember my father's troubled face whenever he told me good-bye.

Jase wanted to return to the ranch but both my father and Dr. Pottinger felt this would be a big mistake. One morning he said, "I want to go back to the ranch, I have to get out of here." Jase felt there was nothing more they could do that couldn't be done at home. It was so hard to see such an active man so confined. I am sure it must have been like living inside a cocoon. Dr. Pottinger was very concerned about Jase's decision. I told Jase and he said he would stay a little longer if I could find a house that we could rent somewhere in the area. He felt he could continue to see Dr. Pottinger by going to his office. Dr. Pottinger didn't approve of this plan. He had prescribed complete bed rest for Jase for one year. For one as active as Jase, this confined existence was a real hardship.

I began looking for a house in the proximity of the sanitorium, hoping that Dr. Pottinger, like my father, would make house calls. As soon as I told people that my husband was recovering from tuberculosis, the reply was, "No, we can't rent to you." I looked in Monrovia, Arcadia, Altadena, Sierra Madre and in the Pasadena area. I finally found a house in Altadena.

It was a small and not very attractive home, very simple in design, with a large front porch. It had a spectacular view of the whole San Gabriel Valley. It was close to the sanitorium, in case I needed help. Jase was so determined to go, I felt this would be an interim rental until I could find something better.

Father Irvine's final visit to see Jase at Pottinger's ended in a heated dispute. The two men reached some kind of an impasse. Jase accused his father of trying to keep him confined against his will. I tried so hard to convince Jase that it was only his father's concern. When I agreed we would leave, Jase wrote his father and said, "You have a string on everything I own, but you don't have one around my neck." I felt when Jase mailed that letter, it was a serious mistake.

I, too, felt very concerned about our almost certain departure. I could not convince Jase to stay. He had made up his mind he was not going to remain at the sanitorium any longer. If I had not found a house, he was going to call a cab and go to a hotel. I knew this time he was very serious and that his decision was final. I had very grave misgivings about going against my father and Dr. Pottinger. Reluctantly, I phoned Mullins at the ranch and asked him to bring my car.

The house in Altadena served a purpose. I became more sure of myself in the few weeks we lived there and I took care of Jase without the help of a doctor or a nurse. Dr. Pottinger advised me, after we moved, that he did not make house calls.

Eventually, I found the perfect home for our purpose in Flintridge. The owner was a widow, a lovely person who understood the situation and was very sympathetic due to the fact that she had lost her husband to the same illness. It was a lovely house, bright and cheery, and it had a large sleeping porch which extended all across the back. Fresh air was an important requirement for the treatment of this disease and I assume this was the reason for the large sleeping porch. I always

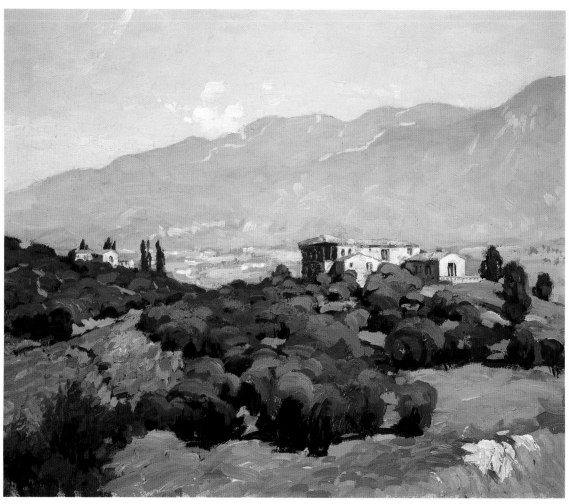

Ferdinand Kaufmann (1864–1942), *Flintridge in Spring*, oil on canvas, 20 x 24 inches

said God had guided my footsteps when I found that home in Flintridge on Meadow Grove Avenue.

It was during our residency on Meadow Grove that Jase decided he would like to buy the house and live in Flintridge. He instructed his secretary, George Harms, to bring all of his accounting books from the ranch. He told me he was going to turn them over to me. I responded by saying I didn't know anything about bookkeeping. He replied that he would teach me. This he did and I soon took over writing checks and keeping books. It was a new experience that I enjoyed.

At that time, Jase was the owner and publisher of the magazine called Cinelandia. He and Antonio Moreno, a famous movie star, had owned it together. When Mr. Moreno

decided to sell his interest, Jase bought him out. It was a wonderful diversion for Jase during his convalescence. Jase would read all the copy each month before it went to press and I would make up the layouts to go to the printers. It proved a happy solution for what could have been very long days. Either the Spanish editor or business manager would often have lunch with us.

George Harms, Jase's secretary, came up from the ranch each week and kept him informed about ranch business. Before long, the sleeping porch had become a busy office. Occasionally, we had Jase's attorney, Randall Hood, and his wife Zelpha for dinner. They lived in La Canada, which was only a short distance away. They recommended a very fine doctor who took over Jase's case. It was very reassuring because he lived in

nearby La Crescenta. Jase's whole attitude changed. He was content and happy. Life again had meaning for him.

Conway Jones, my father-in-law's housekeeper in San Francisco, came south to assist us. This was a big help for me and lessened a great deal of my responsibility. Kate had taken over the house in San Francisco and didn't need Mrs. Jones. In fact, she hated Kate. Mrs. Jones was very pleased to come to us as her family lived in nearby Glendale.

Father Irvine communicated less and less with us after he received Jase's letter. The phone rang one morning and it was my father-in-law. He seemed angry. His question to me was, "Did Jase accept an invitation to be a member of the Board of Directors of the First National Bank in Santa Ana?" I thought my

father-in-law would be pleased, so I enthusiastically told him yes, he had. He then asked me when he did this. I responded that it was sometime before Christmas. With that information, he hung up the phone. Several days later, he called back and asked to speak with Jase. After the conversation Jase called me. He looked ashen, all of the color had disappeared from his face. He told me his father told him he had to resign from the board. I couldn't understand why. I remember the evening the president of the bank, Mr. Cruikshank, called. Jase was so elated when Mr. Cruikshank informed him that he had been invited to serve on the Board of Directors.

Sometime later, his father phoned and talked to Jase. I was stunned when I saw Jase's reaction to the conversation.

I knew something had happened. He told me his father had insisted that he send in his resignation at once. Jase said he also told him if he didn't resign, he would not receive a dividend that year. This was very upsetting because our expenses had gone way over our budget. The Irvine Company dividend was always declared in June and was paid the following December, just before the holidays. This was considered our Christmas present. Jase and Myford always received the same gift each year, a box containing a tie and a handkerchief. Thelma and Myford often joined us for Christmas and Thelma would ask me, "What did the old man give you?" I would respond by saying, "Nothing at all." I then would ask Thelma, "What did father give you?" I will always remember her spicy wit. Her answer came quickly, "The same as always, I got the paper and the string."

Nothing came in the mail and we were financially strapped. Fortunately, I still had, in a savings account, the check my father-in-law had given me as a wedding present. When this was exhausted, I appealed to my father-in-law. His only comment was, "Jase has not resigned from the bank." This was such a hard thing for Jase to do, but in desperation he wrote his letter of resignation. That year, when the dividend arrived, it was paid not in cash but in stock certificates. Jase said they were just cats and dogs that the Company was glad to get rid of. Randall Hood had the stock appraised. It turned out just like Jase had said, we received very little cash when the stocks were sold. It was then we realized we could not afford to buy the home on Meadow Grove. It was a great disappointment to both of us.

Mort Plum, Jase's cousin, and my friend Mae Huseboe announced their engagement. We were the first to know. They drove in from the ranch and we all had lunch in our garden in Flintridge.

It was not surprising when Jase said to Mort during our luncheon at Meadow Grove, "How about having the wedding here?" Mort and Mae were overjoyed at the suggestion. Mort asked Jase to be his Best Man and Mae invited me to be

Meta Cressey (1882–1964), *Under the Pepper Tree,*
oil on canvas 36³/₄ x 40¹/₂ inches

her Matron of Honor. This we agreed to do. Jase was so pleased to be a part of the approaching event. We spent most of the afternoon making plans.

It was not long after this meeting that Mae phoned me in tears. She said Mort's mother, aunt Lilla, had phoned her from San Francisco and said the wedding must take place up north. Mae said Kate had phoned her and it would be a big mistake if it took place at our home. She said if anything happened to Jase, Mr. Irvine would blame them and Mort might lose his job. She said he would not only be asked to resign from the Board of Directors but also as Secretary of the Irvine Company.

After all the planning, I knew how terribly disappointed Jase would be. I broke the news the best way I could. I explained that Aunt Lilla had felt since Mae's parents were dead, that she should give the wedding in her home. Jase said he would call Aunt Lilla. Unfortunately, Aunt Lilla repeated everything Kate had told her in reference to my father-in-law. This only ignited another bonfire. I was convinced Kate had obviously done this on purpose.

I had tried very hard to make the sleeping porch of our home on Meadow Grove as comfortable as possible for Jase. Some of our furniture at the ranch was in the little green house at Irvine Cove. Jase said he would like his wicker chair with the ottoman. I knew this would be more comfortable for him to sit in when he read his morning paper. I suggested also the big wicker chaise lounge with its nice soft cushions. I felt this would keep him from going downstairs where he liked to sit and relax. I phoned Mr. Baxter at the ranch and asked him to go to the cove and to bring our furniture to Flintridge. Mr. Baxter was very glad to do anything for Jase. What I did not know was that Big Kate was entertaining and had planned to put some of her San Francisco guests in the house at the cove. When she discovered the furniture was missing, she reported to Mr. Irvine that it had been stolen. Mr. Irvine called Mr. Baxter and asked him if he knew that the furniture had been stolen. Mr. Baxter replied that Mr. Irvine Jr. had instructed him to take it to our home in Flintridge. When father told Big Kate, she was furious. Thelma was at the ranch. She called me and said there was a terrible fight going on about the furniture. She told me not to be surprised if I received a telephone call. She said Kate was pressing the "old man." Having

been warned, I was not surprised when Mr. Irvine called me. He accused me of stealing furniture that belonged to the Irvine Company. I explained that the furniture did not belong to the Company, it belonged to Jase. We had selected it and Jase had paid for it with his own money. He continued with the tirade telling me I should have called and asked permission before I had anything removed from ranch property. At that point, I hung up and gave way to tears.

Jase must have heard some of the conversation. He said he knew it was his father and wanted to know what he wanted. I knew it would upset him so I just said, "Nothing." Jase was very perceptive. He replied that he heard me talking about the furniture and insisted that I tell him what was said. This was very difficult for me to do, but he guessed right and he reacted accordingly. He felt it was Big Kate. He was right but I didn't want him to know. Jase quickly returned to the sleeping porch and opened two large glass windows at the end of the sleeping area. I was speechless when I saw him push, shove and then pick up the chair, the ottoman and then the chaise lounge, and throw each of them out the upstairs window. I watched in horror, not knowing what this would do to him. Complete exhaustion followed this unfortunate episode. It was like a nightmare. Finally, Jase spoke and asked me to call Mr. Baxter to come and pick up the furniture. His concluding remarks were, "Tell Baxter he will find the furniture at the back of the house on the lawn." I was very apprehensive as he did not go downstairs for dinner that evening. I didn't sleep any that night. I continued keeping a very close watch until it was almost daylight. Sometime before morning, he had a violent coughing seizure which brought on another hemorrhage. This time I didn't panic. I instructed Mrs. Jones to bring me cracked ice quickly.

The salt was upstairs. This time, Jase was more frightened than I was. At daybreak, I called his new doctor and also my father. When they arrived, I explained what had happened. My father's only remark was, "This is not good." Both doctors then went upstairs. When they returned they both said Jase would have to curtail his activities and remain in bed.

My father asked my permission to call Mr. Irvine. I welcomed his help. He called my father-in-law and told him, in no uncertain terms, exactly what he thought of him. It was something my father-in-law never forgot. It took a lot to anger my father, but when he did become angry, it was like a volcano erupting. Mr. Irvine said he had never encountered anything like it. I believe my father made his point very clear, the result being that neither of them spoke to the other for over a year. My father informed me that stress was the worst thing that Jase could have. He told me he would never get well if the present conditions continued.

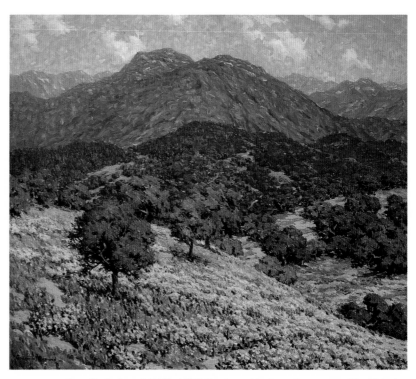

Granville Redmond (1871–1935), *Poppies and Lupines*, oil on canvas, 25 x 29 inches

I can recall my mother telling me that my grandfather Irvine called her and was very upset over my father's condition and asked to come to Flintridge to see him. Of course, my mother said certainly he was to come. But when he arrived, he had Big Kate with him. This my mother had not expected and she was taken by surprise. She asked them both to come into the house. Then my grandfather went upstairs to see my father, leaving my mother to sit in the living room with Kate. My mother said, "*As soon as we sat down, Kate started to criticize Jase. I simply responded that she go outside and wait in the car. When Mr. Irvine came down, I told him Kate was waiting in the car.* My father-in-law's concern for his son that day was very obvious. He seemed like he wanted to stay. It had always been difficult for him to express his feelings. His emotions came to the surface, and his eyes betrayed what he felt as he lingered, before saying good bye.

The late spring drifted into summer. Warm days made it necessary to increase the sprinkling on the golf course which surrounded our home. This produced a heavy humidity. As summer advanced, the humidity in the atmosphere worsened. It was almost like the tropical moisture in the Hawaiian Islands. My father's concern prompted me to tell Jase we might have to move to a drier climate. Randall Hood had told me that Palmdale was an excellent area for the treatment of tuberculosis. He knew a doctor who had recovered his health while living in Palmdale. He lived in a double bungalow which was located in front of the county sanitorium. Randall made the contact for me. The three of us, Randall, Zelpha and I, drove to Palmdale. We met with the doctor. He felt Jase had an excellent

chance, if he made up his mind to stay. He also agreed to rent one half of his modest home to us. It was a very simple home, a wood structure with a wide porch overlooking the railroad tracks. It was a hard decision to make but it did seem best. We would have to break our one year lease before we could move. This we did by paying for six months of the rent. We then said good bye to our very understanding landlady.

Jase and I drove to Palmdale and took up our new abode in that warm, dry climate. Jase's improvement was miraculous. We did our marketing in Lancaster, a small town to the north. Our tiny kitchen sufficed for the simple meals I prepared. Often we took a picnic lunch to some secluded spot in the desert. At other times, we drove at sunset and took a picnic supper and enjoyed the magic colors of the ever changing shadows of the desert landscape. Sometimes we enjoyed our evening meal on the front porch of our small cottage. Here, we would make bets on how many boxcars a minute would be going south.

The same was true going north. There was nothing else to do in the evening, and we had many good laughs at the thought of counting boxcars as our only entertainment.

One night, after a group of vagrants attempted to break into my parents' cottage to steal food, my mother and father decided to look for a house in a less isolated area.

Randall felt we should look in Palm Springs. We looked at some rentals and found one which really did seem right in every respect. It was owned by a Mrs. McManus, and I immediately signed a six months' lease. We spent the night in Palm Springs, across from the Desert Inn.

The desert was a vast lavender carpet as far as the eye could see. It was spring. The yellow acacia trees waved their golden tassels in the wind. Slender stalks of yucca, laden with delicate white buds and blooms resembled bells on a candelabra silhouetted against a pale blue sky. There were not many homes in Palm Springs in 1933. No bulldozers and no concrete jungles spoiled the vast vistas of the desert landscape. Sometimes, in the mornings, I would go for long walks. The early mornings were particularly beautiful. The evenings were too, just at sunset, with the changing shadows drifting over the mountaintops.

Granville Redmond (1871–1935), *Hazy Day in Antelope Valley*, oil on canvas, 20 x 25 inches

On March 6, 1933, President Franklin D. Roosevelt declared the "Bank Holiday." Without warning, the banks were closed for five days, leaving us without any cash. So I drove over to see Mrs. Kauffman, who owned the Desert Inn. She always cashed a check for me whenever the need arose.

On the evening of March 10th, we were looking at the newspaper after dinner. A terrible roar, followed by a trembling and then a violent shaking, interrupted our quiet evening. It resembled the sound of hundreds of oil wells on fire. Large cracks opened in the cement floors and also in the walls. Having gone through the San Francisco earthquake in 1906, when he was about twelve, Jase knew this one was very severe. Later, we learned about Long Beach, which was hit the hardest. Mort and Mae Plum were living there, and I remember they said it was completely demolished.

Severe sandstorms followed the earthquake. Tumbleweeds raced across the desert like they were in a contest to outdo one another. The expansive lavender carpet that had so brilliantly spread across the desert disappeared under the drifts of sand.

John Frost (1890–1937), *Mount San Jacinto*, 1926, oil on canvas, 24 x 28 inches

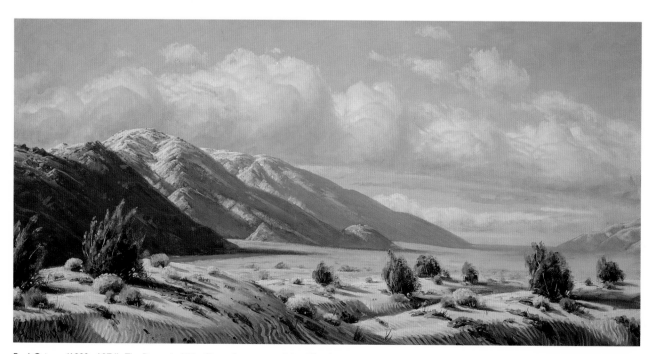

Paul Grimm (1892–1974), *The Desert in All Its Glory*, oil on canvas, 24 x 48 inches

When Jase became dissatisfied with his doctor in Palm Springs, I drove him to Loma Linda Sanitorium for x-rays and check-ups. It was here that we met a wonderful doctor, whose name was Dr. Alfred Roos. It was he who said that Jase was suffering from a viral infection rather than tuberculosis. He called it streptococcus hemoliticus. He said there was also a strain of stephlacoccus. Dr. Roos felt this resulted from the pneumonia he had struggled through the previous year. Jase's condition became more acute as his coughing spells increased in severity. I felt this could have been caused by the very bad weather we had just experienced.

Easter was late that year and the pounding sandstorms finally changed into showers. The pungent smell of the earth, the sand and wet sagebrush was very refreshing after the hot, dry winds. When I knew Jase was sleeping, I would often slip out on our porch and look at the heavens bedecked with millions of stars. Sometimes I could not hold back the tears. However, I would always find solace whenever I repeated the 23rd Psalm. It was my strength and my comfort for so many nights when I was alone with my thoughts.

I attended Sunday services at a small Episcopal church close to our house. On Palm Sunday, Jase accompanied me to church. I was so happy he felt able to go. An Easter Sunrise Service was planned on the mountain behind the Desert Inn. I felt so much the need of that spiritual rejuvenation. Jase felt it would be too much for me, as I was into the seventh month of my second pregnancy, and he said I should only go halfway. I drove the car to the Desert Inn where Mrs. Kauffman said I was welcome to park. When I left our house, the night was gently and quietly slipping into the gray mantle of dawn. Many people had started to walk up the steep, winding path on the mountainside. As I remember, I had to stop quite a few times to rest, but I did make it to the top. It was only a matter of minutes before the vast panorama below burst into soft shades of pink and gold. A rich crimson glow heralded in the new day. I will never forget that magnificent sunrise.

Something seemed to touch my very soul on that particular Easter morning. After the service was over, I waited for people to leave. I just wanted to be alone and continue to pray.

Athalie Irvine with baby Athalie Anita, 1933

While my mother and father were living in Palm Springs, my father suffered a spontaneous pneumothorax and was taken to The Good Samaritan Hospital in Los Angeles. Shortly thereafter, my mother went into labor and entered the hospital. When I was born, on May 29, 1933, my mother only wanted to know if the baby was perfect. Her father spoke first. He smiled and the answer was, "Yes, you have a beautiful baby girl."

Baby photo of Athalie Anita

The next morning Jase sent me a note, telling me how happy he was to know we had a daughter. We both had agreed on a name long before she was born, Athalie Anita Irvine.

Jase was so ill following his spontaneous pneumothorax that his phone was removed from his room. The only communication we had was writing notes to one another. There was so much that was missing. The closeness of being together and sharing in the miracle of birth was something we had to forego.

My strength was diminished to the point where I could not sit up. Each time the baby came in for her feeding I was enraptured. So quickly she became endeared to my heart.

All my family came to see her, including father Irvine. I recall, whenever there was a knock on my door, how much I wished it was Jase. My father, my mother, my sister and Randall Hood came to see the baby, but it wasn't the same. There was no substitute for the one I longed to see so much. I experienced a feeling of great loneliness.

Everything went according to schedule that first day after the baby was born. Dr. Slemons came to see me and said that I had suffered far more than I should have. I told him it didn't matter as long as we had a perfect baby girl.

I vividly recall it was the following morning when my nurse did not appear. I was told she was in the nursery.

I asked for Dr. Slemons and I was told he was in the nursery. Intuitively, I knew something was wrong.

Eventually, Dr. Slemons and Dr. Dietrick came in my room together. Dr. Dietrick was the pediatrician who Dr. Slemons had selected to take care of the baby. After he was introduced, he spoke in a very solemn voice and said, "Mrs. Irvine, I know you are a strong woman." I can still recollect the anguish I felt when he told me my baby was not going to live. Both doctors explained it was "bleeding of the newborn" and showed me the evidence. They said the only thing that might save her was an immediate blood transfusion.

I have never forgotten the finality of their words. They were like a knife that had suddenly pierced my heart. I think I must have temporarily gone into shock.

My father was called and he selected Dr. Hammer from the Children's Hospital to give the transfusion. Dr. Hammer worked diligently to find one of her tiny veins. Because he was unsuccessful, the transfusion had to be given intramuscularly. Nevertheless, her condition began to worsen. I remember how frantically I pleaded with him to try one more time to look for a vein. There was a lengthy silence before anyone spoke. Dr. Hammer finally said he would try again. After another period of silence, there was great rejoicing. It was then I knew Dr. Hammer had been successful and found one of the tiny veins he had so diligently searched for.

I knew it was nothing but a miracle that she had lived. My prayers were filled with gratitude as we began each new day. It was then I promised my father I would always do whatever I could for the medical profession for as long as I lived. I have tried to fulfill that promise whenever I could. I have been asked many times why I have so much interest in anything medically oriented. I have not shared the real reason before. It was too personal and too close to my heart. The gratitude I felt will always remain as long as I live.

I could only talk to Jase on the phone. It was so

hard because each day he wanted to see the baby. Finally, it was decided we could both see him outside in the fresh air. His bed was moved onto the hospital terrace and it was there he saw his infant daughter for the first time. Athalie Anita and I left the hospital with a nurse and returned to my parents' home. Dr. Dietrick warned me before I left that if I returned to visit my husband I could have no contact with my baby, but as time went on, Jase became more and more depressed. I was completely torn between the two: my husband and our baby.

When he told me he no longer could endure the hospital, I decided I must be with him, wherever he wanted to go. At that point, the wonderful bond between mother and child had to be broken. The baby was moved from my bedroom into what had been my grandmother's room.

Several weeks after Athalie Anita was born when I was visiting her father, he told me he wanted to see the ranch once more. I felt he knew he was going to die when he said "once more." He asked me to phone his father, which I did. After I explained the circumstances, Mr. Irvine was very concerned and a date was set. I made a trip to Palm Springs to close our house and pack up our things in preparation for the move back to the ranch.

When I returned to the hospital, everything was ready and Jase was waiting to leave. He told me his father had called and wanted to talk to me. I returned the call and I could hardly believe what I heard. Mr. Irvine said there had been a change in plans. Kate had come down from San Francisco and would be staying at the ranch. I asked why that should make any difference. He had promised

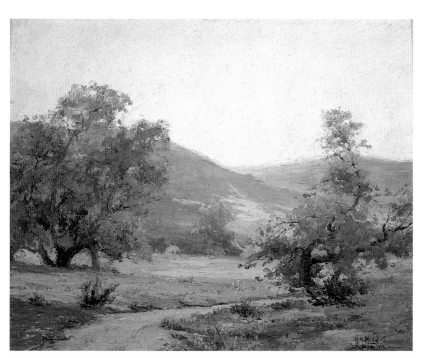

Anna Hills (1882–1930), *Fall, Orange County Park*, 1916, oil on board, 14 x 18 inches

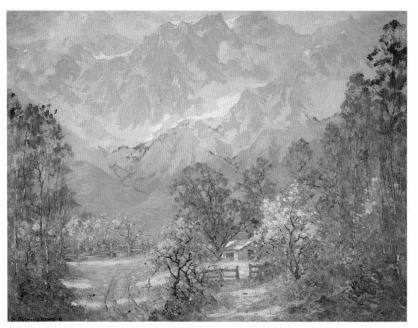

H. Raymond Henry (1882–1974), *Blossom Time, Mt. Langley, High Sierras,*
oil on canvas, 30 3/8 x 40 1/4 inches

That same day we left for Banning. Fortunately, one of the nurses had planned to go with us.

I contacted Dr. Roos at Loma Linda and he immediately came to see us after we arrived. Father Irvine also came to see us the first week we were there. We told him about some new research that was going on at Loma Linda. He became very interested in the program, and he phoned Dr. Roos, stating that he would like to give Loma Linda all the financial help they needed to speed it along. Dr. Roos was delighted and the work proceeded at a much faster pace.

Mr. Irvine came often. Sometimes we met at Loma Linda. He was fascinated with the work that was going on. If Jase was not too tired, we would all have lunch at the Glenwood Mission Inn in Riverside. He kept Jase informed of what was going on at the ranch. All during his long illness, Jase's interest in the ranch was always a top priority. They would talk at great length, and I would walk around in the hotel courtyard and talk to the colorful parrots, cockatoos and macaws. The birds' brilliant color always fascinated me.

Mrs. Kauffman lived only one block away from our house in Banning. When Mr. Irvine came to visit, he enjoyed going to her home. She would often invite us for tea whenever I let her know he was coming to visit. Lazy Acres, as she called her beautiful country estate, was located in a setting of cherry trees. Many beautiful antiques and Chinese porcelains embellished her home. She lived there during the summer months when the Desert Inn was closed. It did not open again until late fall.

Jase that he could go back to the ranch. I realized he was very upset. His reply was he could not risk having his marriage broken up. A few minutes later the phone rang again. The nurse said it was Mr. Irvine. He told me Kate wanted to speak to me. She was adamant. She said Jase could not return to the ranch house under any circumstances. If he did, she would have to have the house burned down. There was no doubt who was in control. Jase was heartbroken. All he said was, "To think a woman like Kate has taken my mother's place."

I knew I had to act fast. I phoned Mrs. Kauffman and inquired if she knew anyone in Banning who might have a house we could rent. She told me she had two homes. One she called Lazy Acres, which she used when she wanted to get away from the heat in Palm Springs, and one she rented, which was just off Mount San Gorgonio. I asked about renting her other house. She said she would be happy to do this for us.

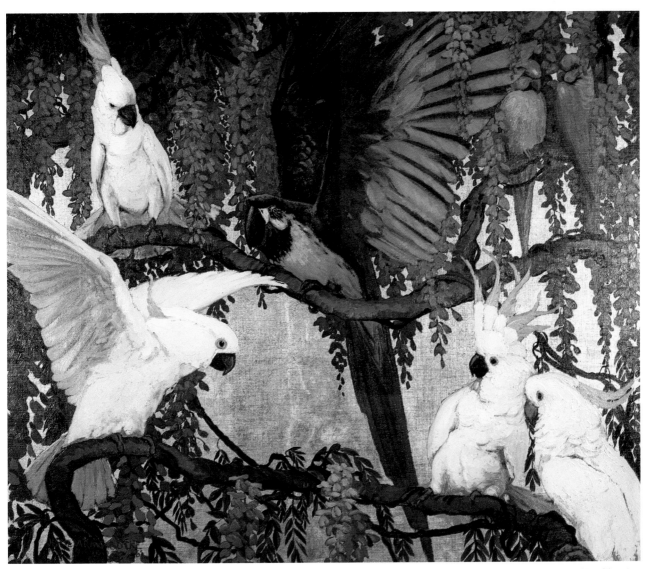

Jessie Arms Botke (1883–1971), *Macaw and Cockatoos*, 1926, oil on canvas on board, 25 x 30 inches

I was content and so was Jase to leave Athalie Anita with my parents. We knew she had all the love that we could not give her at that time. Needless to say how much my mother and father enjoyed having this happy experience with their first grandchild. My mother sent lots of photos but it was not like seeing the baby. Whenever I felt I could leave Jase, I would take the train to Los Angeles and my sister Jeanne would meet me. This way I could spend the night with my family and return the next day. I followed Dr. Dietrick's instructions to the letter. I looked at my baby only from the nursery door. It was so hard, but as my father explained, as long I as continued to live in a house with tuberculosis, I had no choice. Sometimes, the nurse who lived with us would call and ask me to come right back because Jase had taken a turn for the worse. I knew how difficult the spells of depression could be. I would then take the evening train back to Banning, which arrived quite late. When he knew I was there, it seemed to comfort him and he would finally go to sleep.

Baby photos of Athalie Anita

Athalie Irvine with Athalie Anita, 1934

and make up a foursome. This I did occasionally. Jase urged me to go and enjoy an evening, knowing how much I liked the game. All he would ask was to have someone call for me and bring me home early. I had never had time to learn how to play. It was my father-in-law who taught me after Jase and I were married. Mr. Irvine loved to have a game after dinner. When he was at the ranch, he would always want me to arrange a foursome. In the morning, before he left for the office, he would say, "Call Cogan. If you can't arrange it with Cogan, get Mitchell. If you can't get Mitchell, get Browning. If you can't get any of them, phone Mort over at the bunk house. He'll do." This was because Mort was not a very good player. Poor Mort knew his uncle James was an excellent player and was always nervous.

Jase met a doctor with tuberculosis who lived a few houses down the street. He was a very pleasant man who had been in bed for ten years. He enjoyed seeing Jase, who would walk over to his home, which like ours was set back in several acres of cherry trees. The two men would talk and I would visit with his wife. One day, he told us about a new operation. It was called a thoracoplasty. The doctor told Jase there was only one doctor he knew who was capable of doing this kind of surgery. He said his name was Dr. Samuel Mattison. His office was in Pasadena. The doctor down the street said if he was young like Jase, he would seriously consider having a thoracoplasty. Supposedly, it was said to be an immediate cure.

Jase continued to visit with his new friend. At one time, he discussed it with Dr. Roos, although I believe he had made up his mind. One day, Jase asked me to go to Pasadena to meet Dr. Mattison. I called Dr. Mattison and made an appointment to see him. I arrived in Pasadena with all the x-rays and charts. I liked Dr. Mattison and he agreed to come to Banning and talk to Jase. This he did soon after my trip to Pasadena. He wanted more x-rays so we all went to Loma Linda and saw Dr. Roos. Jase hoped the surgery would be performed there but Dr. Mattison said no. He said he did all of his surgery

I met many wonderful people while we lived in Banning. A huge engineering project was underway at Whitewater. Many engineers and their families lived in Banning on a temporary basis, the same as we did. Our neighbors were all very caring people. Many came to call, and some I met through Mrs. Kauffman when I went to her home for afternoon tea. Everyone was so friendly and so willing to help in any way they could. Each week someone would bring cookies or a cake and all kinds of different soups. No one ever came to see us empty handed. I have never lived in a community where people thought so much about the welfare of one another.

Several wives of the engineers enjoyed playing bridge. Their husbands worked late. Often, I was invited to play

at the Huntington Hospital in Pasadena. The decision was made and Jase went into the hospital.

The final conference between Jase, me and father Irvine concluded with the unanimous decision to go ahead and schedule the surgery. Dr. Mattison was contacted, and the arrangements were made for Jase to enter the Huntington Memorial Hospital on a Sunday afternoon sometime in June of 1934.

Jase had a pleasant room assigned on the second floor. It looked out over an area of the grounds that was all in a garden. As I recall, it had quite an expanse of green lawn which was bordered with varied-colored seasonal flowers.

Dr. Mattison had requested a conference with father Irvine and me. The meeting was to determine how the hospital costs would be taken care of and also Dr. Mattison's fee was to be discussed. He said it was necessary to perform the surgery in stages. There would be a waiting period of four to five weeks in between before it was completed. It might take seven or eight stages or it might require ten. First he wanted to close the open wound in Jase's back. This was our one great concern. It was paramount in our prayers.

Dr. Mattison was virtually certain he could achieve this before he went ahead with the thoracoplasty. This angry open wound continually drained month after month and was the cause of so much anguish and pain. There were times that his deep depression was almost beyond his ability to cope. It was a situation that at times looked hopeless.

Athalie Anita was always Jase's great desire to go on fighting. Plans for her future were paramount in his mind. He was confident once the surgery was completed he would be able to take her horseback riding, fishing, hunting, swimming and share with her all the sports he loved so much. His hopes were very high ever since we left Banning. Dr. Mattison firmly

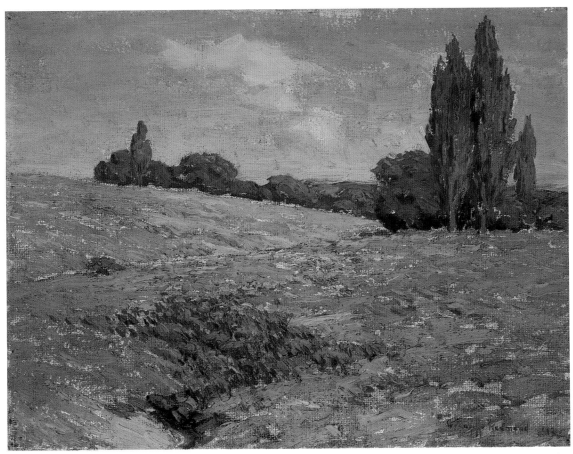

Granville Redmond (1871–1935), *Lupines*, oil on canvas, 9 x 12 inches

believed he could accomplish this miracle for us. It seemed indeed the answer to our prayers. Hope had never faltered with either of us. Jase entered the hospital with such an optimistic feeling and high hopes for a bright future.

When any discussion took place, Dr. Mattison had been advised that my father-in-law would be taking care of the costs. Our funds had been completely depleted by this time. When Dr. Mattison told father Irvine the cost would be ten to eleven thousand dollars, my father-in-law bellowed out, "The cost is too high!" At this point Dr. Mattison replied, "There is no reason to talk further, Mr. Irvine, because there will be no surgery." Father Irvine left and made a phone call. When he returned, he said he had phoned Kate and she had agreed with him. I can remember so well telling my father-in-law, "You can have your wife but you will not be able to keep your son." At that point my own father arrived and the two doctors left us. I was so emotionally upset that I remember I burst into tears. When my father returned, he simply stated that everything would remain as scheduled and Jase would go to surgery as planned at seven o'clock the next morning. I can't remember just how Dr. Mattison and my father worked things out. I do recall he cautioned me to say nothing to Jase about the incident.

The next morning, I arrived at the hospital with my father. When Jase left his room, he said, "We are going to win this time."

The outcome was a victory. The operation was successful. The wound closed and the incision healed and there was no more drainage. Jase and I were overcome with joy. It was as if God had truly bestowed His blessings on one who had endured so much. It was like a new beginning. A new hope was born with a much brighter future.

My next conference with Dr. Mattison and my father-in-law was in Dr. Mattison's office. Father's whole attitude had changed. When we departed he said, "Dr. Mattison, I will give you my entire ranch if you can just save my boy." Tears filled

his eyes as we left to go and see Jase. It was very hard for Mr. Irvine to express himself or show affection. When he left the hospital, I remember walking down the hall with him and he said, "Stay with him, Athalie." My reply was, "Father, I always will."

The weeks that followed were agonizing. I was not aware that morphine could not be given on account of risking pneumonia. It was a vicious circle. It was horrible the way Jase had to endure such anguish and suffering. My father was with him during each stage of the thoracoplasty. I can still hear Jase screaming from the intense pain after each of the surgical procedures.

How Jase ever endured ten of those surgical procedures, I will never know. After each stage his strength would return only after four or five weeks. Then he would face another operation. For a long time I could not erase from my mind the terrible pain and the suffering he so bravely endured. All I could do was to be at his side during those long weeks of recuperation. It was heartbreaking, he wanted so much to live a normal life again.

Athalie Anita was such a joy. I could see her each day when I returned from the hospital. We continued to live with my parents on Severance Street in Los Angeles. Weeks passed by. The same awful aftermath of each stage of the thoracoplasty was repeated. The healing process also continued after each stage. This of course was what we anxiously waited for. To keep nurses around the clock was difficult. After so many weeks they wanted to be relieved. It was a continuous source of worry. I could well understand their concern and I often took a nurse's place until a relief could be found. Jase's morale was a marvel to everyone.

Dr. Mattison permitted his bed to be taken into the garden so he could see Athalie Anita. These were days he so looked forward to. He had a bright red rubber ball which he would toss on the lawn and loved to watch her scramble to pick it up. The minute she retrieved the ball she would toss it towards his bed. This was repeated time after time until the nurse

felt Jase should return to his room. Many times father Irvine brought friends with him to visit with Jase and to see Athalie Anita. His name for her was "Scooks." It was always a very happy occasion and something for Jase to look forward to. I do believe it was the one way God sustained him and gave him the will and the courage to go on.

I took most of my meals at the hospital with Jase. Occasionally, Randall and Zelpha invited me for dinner. The afternoons were spent planning layouts for Cinelandia or reading. George Harms, Jase's secretary at the ranch, still kept him updated with Irvine Company business. He brought leases and mail each week.

I continued to look after the business at Cinelandia. It became increasingly difficult to collect money from South America. My sister Jeanne, who was managing the magazine office, would come for dinner and bring us up to date. She was very efficient and kept a close watch on the money and all of the outside activities. The magazine sales in Cuba, Spain, Portugal, Mexico and Latin America all fluctuated at a very alarming rate. After a great depression set in, the money market caused a lot of concern.

Jase's exchange program for Latin American students continued. As I look back, he was a pioneer in the program at that time. He felt it was one way to cement relationships between our two countries. Education was a paramount concern with Jase.

During the difficult days that followed each operation we often read the Bible. Many chapters became very meaningful. It proved a source of great strength for both of us. My father had also been my strength.

Finances became more and more a problem and finally we found ourselves totally dependent on father Irvine. My only expense was the nurse for Athalie Anita, which was seventy-five dollars a month. The nurse lived with my parents so I had no other expenses. After a kidnapping threat, father Irvine insisted

Jeanne Richardson, circa 1930

"Dear-Dear" and baby Athalie Anita, 1933

that I keep a driver with me at all times. His name was Harry. He remained with us long after I moved to Beverly Hills.

Before the final stage of the thoracoplasty was completed, Jase asked me to look for a house. He was so eager to leave the hospital. I found one in La Crescenta. It was located not far from Randall and Zelpha Hood's home. This I knew Jase would enjoy because of the very close friendship we enjoyed. La Crescenta was only a few miles from Pasadena. It would be close to Dr. Mattison's office.

As I remember, there was about half an acre of garden. This was just right for a small guest house and would be perfect for Athalie Anita and "Dear-Dear," her nurse. The main house was two story. It was furnished and had a

guest bedroom and bath downstairs. It was ideal for our needs. Jase was able to drive with me for a preview. This was his first outing since entering the Huntington Hospital for the surgery. He was very pleased and told me to see if I could lease the house with an option to buy.

We moved into our new home. We said we were going to get along without nurses, which we did. Jase occupied the guest room downstairs. There were two nice rooms upstairs. One was mine and one was occupied by our housekeeper, Conway Jones. It was the middle of May and the garden and the flowering trees were in full bloom.

Sometimes we took our meals on the terrace overlooking the garden. The guest house was a topic of conversation. Jase had an architect submit a set of plans. My father seemed so anxious for us to wait and see how Jase adjusted before moving Athalie Anita and "Dear-Dear" into new surroundings. I told him it would be a while as we had to wait for our dividend.

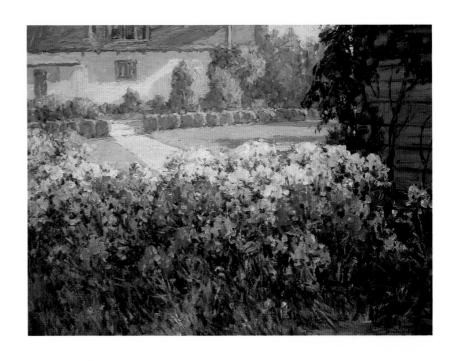

Benjamin Brown (1865 – 1942), *The Joyous Garden*, oil on canvas, 30^1/$_2$ x 40^1/$_2$ inches

For a few weeks all went well, and then something happened. Jase told me he could not breath. I called Dr. Mattison. He came to the house immediately. It was the only time I ever knew Jase to panic. Dr. Mattison ordered a tank of oxygen. He insisted that Jase should have a nurse. After a short time Dr. Mattison wanted Jase to return to the hospital for more x-rays, but he could not face going back to the Huntington.

Dr. Roos came often to visit Jase. He told us St. Vincent's Hospital had the finest x-ray equipment of any hospital in the area.

On one of the days when I visited the magazine offices, I also visited St. Vincent's Hospital. There was a beautiful suite overlooking Third Street. It had two rooms and a private bath. It seemed like a small apartment rather than a hospital suite. We could have lunch or dinner in the lounge area. Jase decided he would go.

It was apparent that the many months of being confined after surgery had taken its toll on his heart. Dr. Mattison, Dr. Roos and Dr. Bennett felt he should remain for a short time at St. Vincent's. Each day I brought Athalie Anita to the hospital. The roof garden served as a perfect spot for Jase to see her. On her second birthday we had a roof garden birthday party with ice cream and cake. Myford and Thelma were at the ranch. They came, and father Irvine also came. My father, mother and sister Jeanne came, as well as my aunt Martha and my uncle Warren. It was a happy occasion and Athalie Anita tossed her little red ball back and forth. With so many admirers she had a wonderful time. Because there were no chairs, we always brought Jase up in a wheelchair. There was a fire escape, and when Athalie Anita continued to throw the ball down the opening, it would bounce down the steps. Jase did not like her to do this and continued to remind her if she did not stop he would spank her. Why this fascinated her so, I don't know. Jase would say to me, "You must take control now. Otherwise it will be too late." I knew he was right. "Dear-Dear" thought it was

amusing and would run down the steps and bring back the ball in spite of Jase's ultimatum.

Our next celebration was Jase's birthday, June 11th. Father Irvine said he would drive in from the ranch. Dr. Roos, Dr. Bennett and Dr. Mattison were also invited, along with the rest of the family.

I had a beautiful cake with forty-two candles. Everyone was there with the exception of father Irvine. Jase did not want to cut the cake until after father arrived. We waited for some time, the doctors departed. I said I would go and telephone the ranch. When I asked to speak to Mr. Irvine, he picked up the phone. He had completely forgotten about Jase's birthday. I knew this would be a big disappointment to Jase. When I returned, I simply stated that his father had been unavoidably detained, but he would try to come the following day. I made some kind of a facetious remark. Jase replied, "But Athalie, he is my father."

I had been unable to throw off a lingering cold. Jase felt I should take a brief holiday while he was in the hospital. Bertine Treat, a dear friend, had gone through a divorce and had invited me to spend the week with her in Santa Barbara at the Santa Barbara Biltmore. Jase insisted that I go. He did seem very content at St. Vincent's. He enjoyed the sisters and also a young Dr. Ed Boland, who used to visit with him at night.

After a great deal of urging by Jase and my parents, I did reluctantly decide to accompany Bertine to Santa Barbara. The old Biltmore was a favorite of mine. That night

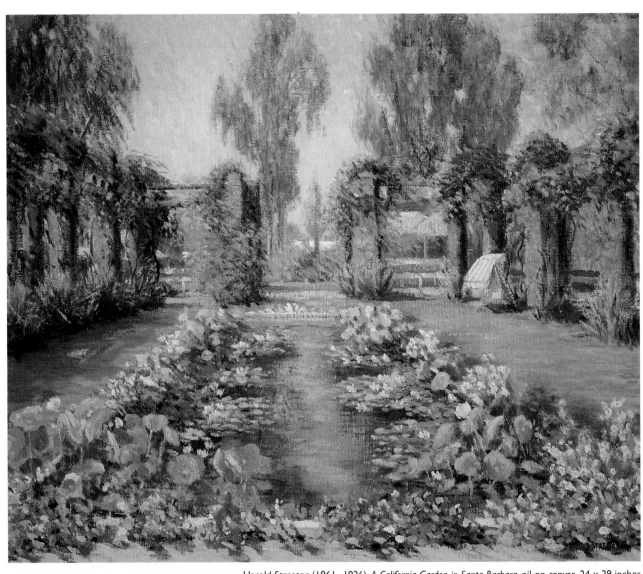

Harold Streator (1861–1926), *A California Garden in Santa Barbara,* oil on canvas, 24 x 29 inches

for some reason, I could not go to sleep, I felt I should not have come on the trip. After breakfast the following morning I told Bertine I had to return home. I felt so strongly that I should not have left Jase. I phoned him, and even though he urged me to stay, I knew I could not. Something just told me I should return. Harry, the driver, came to Santa Barbara and drove me back to Los Angeles. I went directly to the hospital. Jase was reading the Sunday paper when I arrived. I told him how wonderful he looked, all shaved and dressed in his light blue pajamas. The sun was shining very brightly that morning. You could feel the warmth as the rays seemed to dance through the glass window panes, sending showers of sparkling sunbeams all around the room. There seemed to be a light which encircled Jase's head. I remember I exclaimed, "Jase, you look exactly like you did when we first met!" That wonderful smile lit up his countenance. It was a moment in time which had recaptured the past. He was so pleased and we reminisced about many happy occasions.

Finally he told me what he had decided to do. He said Dr. Bennett had urged him to try pneumothorax. The x-rays had indicated a spot on his right lung. He felt it was his only chance. He said I had been through so much he found it difficult to tell me of his decision. I knew then why he had been so insistent that I take a holiday.

I was, of course, bewildered because Jase had always been so opposed to pneumothorax. When Dr. Bennett first became Jase's physician, he had urged him to try this treatment and Jase had been adamantly against having it done. Somehow Dr. Bennett had now talked him into it. I was very upset and could not understand why Jase had changed his mind. Dr. Bennett, Dr. Mattison and Dr. Roos arrived together. It had been planned to take place just before lunch on that Sunday morning. When I saw the size of the syringe, I knew I could not remain and witness the procedure. I told Jase I would wait outside the room.

Jase loved humor. Dr. Bennett told a funny story, followed by one from Dr. Mattison. As I left, the room rang with laughter.

I was very troubled and I went down to the first floor. There was a beautiful chapel. Mass was over, only one sister had remained. I was not a stranger to the chapel, having knelt in prayer there many times before. Bells were chiming and I could only think of Hemingway's book, For Whom the Bell Tolls.

Why, I don't know, but I remember bursting into tears. I could not stop. The dear sister came close to me and put her arms around me. She asked if I had lost a loved one. I told her no, but it seemed like I had read the last chapter in a book and closed the cover.

I hurried to the elevator and went quickly to our floor. All the doctors were chatting at the information desk. I

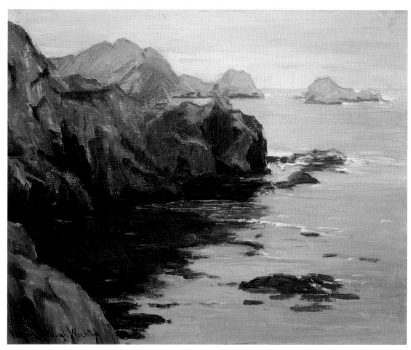

Marion Kavanagh Wachtel (1876–1954), *Monterey Coast,* oil on board, 16 x 20 inches

was surprised they were not with Jase. They said he was in good shape and for me to go down to his room and go in. The minute I saw him I knew he was not fine. I rushed out and down the hall to where the doctors were all chatting. I told them Jase had advised me that something had gone wrong. Dr. Bennett's reply was, "He only wants me to draw off the air, and if I do, he won't submit to having another pneumothorax. I have already scheduled another one for next Sunday." Not one doctor would grant my request.

I turned in my despair and ran down the long hall back to Jase's room. I would not leave him like I found him, alone. At some point I passed young Dr. Boland as he came out of another room. He immediately saw my grave concern and accompanied me to see Jase. In just seconds he produced an oxygen tent which he rolled into his room. The tent completely covered his bed. Dr. Boland told me to call the other doctors. It was then that they all went in. Dr. Boland came right out and broke the news that Jase had suffered a spontaneous pneumothorax and he implored me not to go in. I waited in such anguish which I have never experienced since. It was Dr. Mattison who came out and told me that Jase was dead. The shock was horrendous.

As I reflect, God must have prepared me for that final hour, when I entered that quiet chapel on the main floor of the hospital and knelt for some time in prayer.

Dr. Mattison called my father. He arrived at the hospital as quickly as he could. It was his strong comforting embrace which brought the tears again. I could not hold them back. We had both shared so much during this long tragic ordeal which lasted for over three years.

I could not understand what had happened. My father conferred with the doctors. No one seemed to know. My father's conclusion was that a post-mortem should be performed. He said, "I know there will always be a question in your mind,

Athalie. If you will execute the papers, we will go ahead." It was very hard for me to do this. Just the thought of any more mutilation being inflicted on his poor body was almost more than I could endure. I couldn't bear the thought of his being hurt anymore. I had quite a debate with my conscience before I said yes. When I made peace with my troubled mind, I knew my father was right.

When it was over, my father explained to me what had happened. When Dr. Bennett inserted the needle which was to go between the pleura and the lung, the needle accidently punctured the lung. Jase had laughed heartedly at one of the stories which was being told at the time. The real heartbreak came after I learned what the post-mortem revealed. The lesions in the good lung proved only to be the old scar tissue. It was devastating news when Dr. Roos explained this tragic situation. It was then that the human frailty of my spirit was revealed and all of my strength was gone.

Dr. Mattison insisted that I go and lie down in one of the empty rooms. I still remember that wide hospital door. When it closed, I was quite alone with my thoughts. Perhaps that avalanche of tears which I could not control as I sat

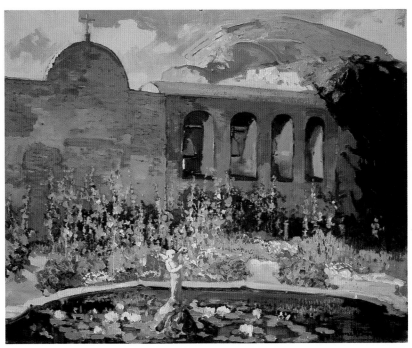

Franz Bischoff (1864 – 1929), *San Juan Capistrano Mission Yard*, circa 1922, oil on canvas, 24 x 30 inches

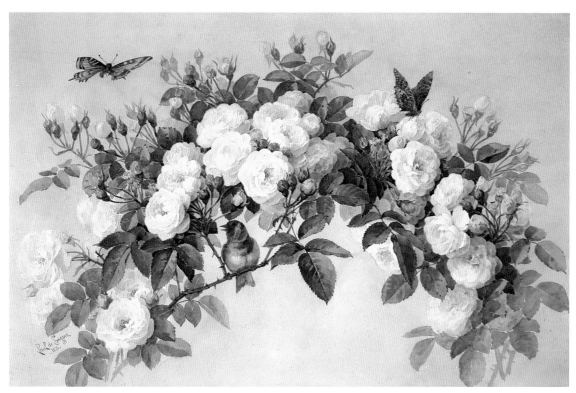

Paul DeLongpre (1855–1911), *Wild Roses,* 1898, watercolor, 15 x 24 inches

in the chapel earlier that day prepared me for the end. It came so quickly. I had no chance to even say good-bye. All four doctors refused to let me go in Jase's room. I didn't know what they were talking about when they told me his cyanotic condition had so drastically changed his appearance that they did not want me to see him that way. I have told myself so many times, "Perhaps it was better that way." I remember Jase just as I saw him that bright Sunday morning when I left his room and went to the chapel and prayed.

The only memories I have of my father are when I saw him, in a bed in a garden or on a hospital sun deck, wrapped in a blue shawl and wearing a grey felt hat.

After my mother died, when I was going through a box of her old cards and letters, I found a small white envelope containing a lock of light brown hair tied with a blue thread. The envelope was identified in my mother's handwriting as, "Jase's hair, June 23, 1935." Not a thread of gray marred the silken strands, as fine as a child's. At that moment, I was suddenly deeply moved by the great tragedy of my father's untimely and unnecessary death.

My father was vice president and general manager of The Irvine Company until he died in 1935. His death was a great blow to my grandfather, not only because of the close relationship that existed between them, but also for the reason that my grandfather had depended upon my father for the management of the Irvine Ranch and had expected my father would succeed him as president of The Irvine Company. Had my father lived, how different our lives would have been.

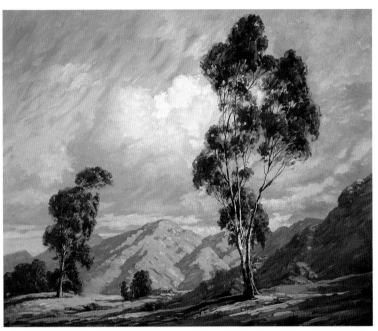

Paul Grimm (1892–1974), *Eucalyptus and Clouds*, oil on canvas, 25 x 30 inches

Sometime during the afternoon, my father-in-law phoned from up north. He said he and Kate were making plans for Jase's body to be shipped to San Francisco, and he wanted it entombed in the family vault in Cypress Lawn, a very beautiful cemetery just outside the city. Jase had taken me there when he took flowers in memory of his mother. I said I could not agree to that and did not tell him why. When the conversation became very heated, I told him I would have to call him back. My next phone call was to Randall Hood, Jase's attorney. He was quick to explain that the widow was the one who always made the final choice. It was not the father or the mother of the deceased. Randall told me that was one call he would like to make. I granted him permission to go right ahead.

All of Jase's things were at our home in La Crescenta. Randall and Zelpha said they would go over to the

house and bring me whatever I needed. Before they arrived at my parents' home, Mr. Irvine had phoned again. I told him what I had found out. When he became more demanding, I told him my decision was final and Jase would remain in the south. It was very difficult for me to take this position against my father-in-law. I still could not think of Jase as dead. It seemed more important for me to carry out Jase's wishes than those of the living and that was what I did. Jase wanted to be cremated. He did not wish to be buried and he did not want his remains placed in the vault at Cypress Lawn. When I had finished making the final plans, my mother suggested I place the urn containing his ashes in their crypt. This I did until I could make a choice for the final resting place.

The crypt was in Daffodil Court, in the new mausoleum at Forest Lawn, located in the city of Glendale. I knew my mother wanted to make it as easy as possible because I was so unprepared. How much I appreciated all of her help at this difficult time in my life.

That evening, I could not join my family for dinner. Uncle Warren and Aunt Martha and my cousins were there. I knew I had to be by myself, alone with my thoughts. I excused myself and I went upstairs to the nursery. I remember I wanted to be close to my little girl. I forgot all the rules, I took Athalie Anita in my arms and rocked her to sleep. Then I gave way to tears. I have never experienced anything like it since. I cried and I cried and I could not stop. I looked down into the face of my sleeping child. She was an ethereal looking little girl, and she was so much like Jase. For the first time, I realized how much I had missed not being with her during those first two years of her life. It was then I seemed to be lifted out of my grief. A door had closed and a new one had opened. I have heard it said, "God never takes anything away that He does not put something back in its place."

The next day, my mother and father went with me to visit Jase. I dreaded going, but they felt I should. As it turned out, I was thankful I did. I didn't believe I could witness the change. I had been told, only the day before, how he had turned completely black. That was the reason I didn't believe I could go. I longed to remember him the way I had seen him on Sunday morning, with the sunbeams dancing all around his bed. It was not at all like I had imagined and dreaded so much.

There was no change. I was greatly comforted as I looked at his peaceful face. I realized, as I said good-bye, that the long hard struggle had come to an end, and Jase was at rest. I left with an inward peace and quoting the beautiful verse from the Bible, "The peace of God, which passeth all understanding."

Dr. Davidson, the minister who had married us at St. John's Episcopal Church, officiated at the funeral. He spoke of our beautiful wedding in 1929 and then said, "Only six years later, I find myself delivering the funeral service for this fine young man." The service was very impressive. I was deeply moved when the American flag, which was draped over the casket, was folded and placed in my lap. I could not take my eyes off the inscription above the arch in the church. It read, "In my Father's house are many mansions: if it were not so, I would have told you. I go to prepare a place for you."

There were flowers everywhere, in the church as well as outside on the lawn. Both sides of the walkway which led to the chapel were lined with floral arrangements. They extended as far as the street. The church was crowded to the point that many friends were standing outside. I have always said Jase built his own monument during his lifetime on this earth. This was

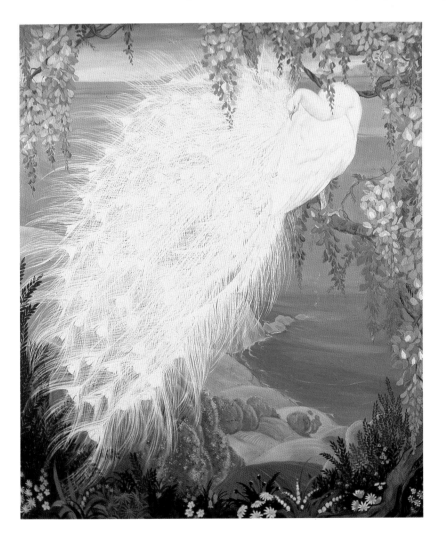

Jessie Arms Botke (1883 – 1971), *Wisteria*, oil on masonite, 40 x 34 inches

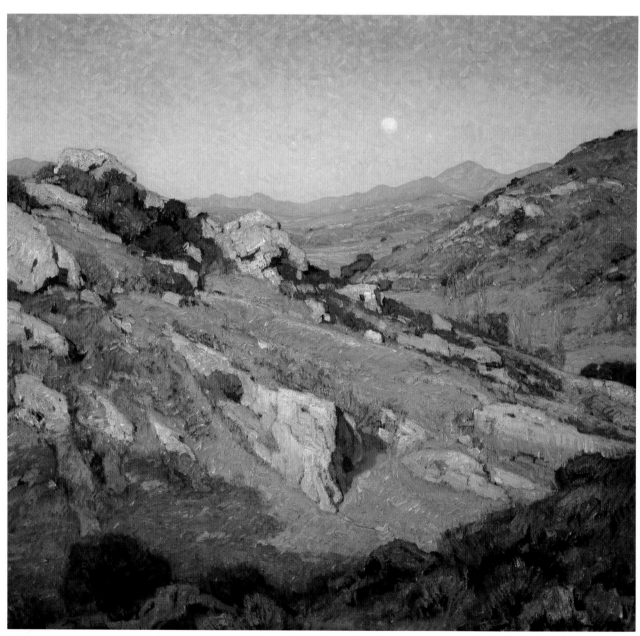

William Wendt (1865–1946), *There Is No Solitude, Even in Nature,* 1906, oil on canvas, 34 x 36 inches

evidenced by the deep affection that was shown for him when he was alive. Numerous telegrams and letters of condolence arrived, more and more with every succeeding day.

I left the church with my father and mother. There were many friends who wanted to speak with me and I remained until my father insisted I had to leave.

Sometime during the drive from the church to my parents' home, I related this story to my mother and father. One day, when Jase and I were riding horseback and enjoying the beauty of the ranch, he pointed to a mountain off in the distance. He wanted me to see how much it resembled a saddle. He told me he had climbed the mountain to the top, when he was a very young boy. He explained in such a proud manner that he had always claimed that mountain as his because he had climbed it to the highest peak. I asked him what he saw when he reached the top. He told me he could not believe the ranch was so big. He said he knew it was more than 100,000 acres but he didn't realize how far it reached. From the mountains to the sea, it followed the coastline for miles before it was lost from view. I asked him if he had climbed it alone and he said he had. He told me he just kept on climbing, he was so determined to reach the top. It was then he understood what his father meant when he said, "This is a great ranch. It includes far reaching valleys, high mountains, forests, streams and rivers that empty into the ocean." He told him, "You can only see part of it from the top of a mountain." I always felt it was his father's description of the ranch which had given Jase the desire to climb Saddleback to its highest peak. Everyone on the ranch called Jase, "Mr. Jim." Saddleback became, "Mr. Jim's Mountain."

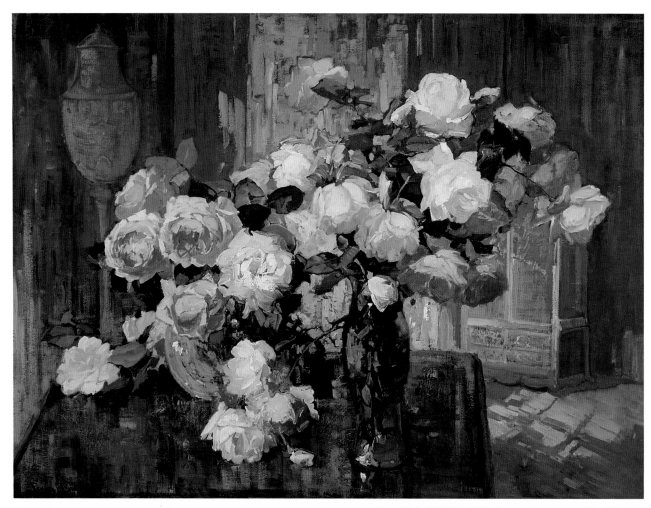

Franz Bischoff (1846–1929), *Roses,* oil on canvas, 30 x 40 inches

My parents' home was a haven of peace and tranquility. I knew I did not want to return to La Crescenta to live in the home Jase and I had leased. I could not, at this point in my life, face living alone. I felt the need of my family. My mother, my father and my sister Jeanne were all so thoughtful and caring. My parents could not have been more understanding. My father had assured me that their home was my home as long as I cared to stay. This was very supportive and so reassuring.

Jase and I had visited the giant redwoods together so many times. We had taken walks along the Irvine Trails, through the tangled vines and flowering shrubs and the giant trees. If I had tried to find my way back alone, I could not. I would have needed a helping hand to show me the way. After Jase died, my prayers were answered and I was given the courage and vitality with which to carry on. I had to draw a new set of plans for my life. When I accepted the challenge, I seemed to be given a new kind of strength. I was no longer caught in a web of indecision. Instead, I charted the course and was able to move ahead. I had many obstacles placed in my path. In each instance, I remember how I was reinforced with the strength that was needed whenever I thought of those giant redwoods.

It was just after lunch when a caller came. It was my father-in-law. I remember during the first part of our conversation he said he would like Athalie Anita to visit him as soon as I could arrange to bring her down to the ranch. This I agreed to do, and I assured him I would always be happy to share Jase's child with him, whenever he wanted me too.

He then told me he had left his copy of Jase's Trust Agreement, concerning his twenty percent interest in The Irvine Company, in San Francisco and he wanted to borrow the one that Jase had. He said it was necessary for him to have it right away. I told him I did not have it at home. He wanted to know why and also where it was. I told him Jase always kept it with him until the time he entered St. Vincent's Hospital. I also told him Jase had instructed me to rent a safety deposit box in Los Angeles and to deposit the Trust Agreement there. I did not give him the name of the bank.

My father-in-law was a very demanding individual. Finally, I had to tell him that Jase had instructed me never to let anyone have his copy of the Trust Agreement. This made him quite angry. He turned very red and then he decided he would leave. I knew I had carried out Jase's instructions the way he wanted me to, whatever the reasons might be. As my father-in-law left my parents' house, I saw Big Kate outside, sitting in the car. I had been warned, now that Jase was gone, that I would have to be very careful of Big Kate. It was not very comforting but I knew it was true.

The following day, I received a most disturbing telephone call. It came from Jase's longtime friend Charles Swanner. He was an attorney. Jase had told me how much his father disliked Randall Hood. He said his father's feeling was so intense, just the mention of his name was like waving a red flag in front of a bull, and that was why he had asked Charlie Swanner to substitute in Randall's place.

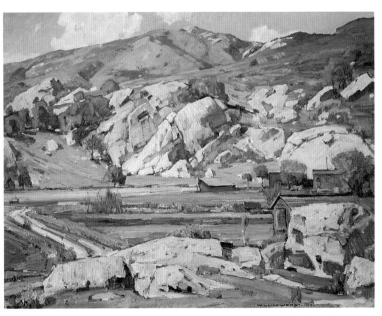

William Wendt (1865–1946), *Sermons in Stone*, 1934, oil on canvas, 28 x 36 inches

Charlie informed me it was necessary for me to accompany him to court the next day. Those were the instructions which Jase had given him just before he died. He explained that it was for Athalie Anita's protection. He also told me, the last few stressful weeks Jase had given the matter a great deal of thought and attention. He said I would have to sign a document which Jase had instructed him to prepare. He brought this to my parents' home. After I read it, I realized how Jase was taking care of us even when he was facing death.

It had only been two days after the funeral, which was why it was so difficult for me to go. The last place I wanted to be was in court. I asked Charlie Swanner why I had to do this so soon. He told me Jase had said not to wait, to file right away. And this is what we did.

Charles Swanner had given Mr. Irvine a copy of the petition the day we filed it in court. The guardianship proceedings he had prepared petitioned for both the person and the estate of Athalie Anita Irvine. It was granted immediately and the judge moved quickly onto another case.

Charlie took me to lunch and I told him what Jase had related to me at the hospital. He had said, "If I can't be with you, I don't want you to be alone. You can't be mother and father both to our little girl. I don't want to think of you going through your life alone. You have been my sweetheart, my wife and my mother. I want you to marry again." I was heartbroken and I could hardly wait to go home. When I told my father what Jase had said, I will never forget his response. He said, "Athalie, can't you understand how unselfish Jase is? His love and concern is only for you. It takes a very big man to say what he said." As time went by, I knew my father was right.

Charlie agreed with my father and said this was further proof of Jase's love and how much he cared. It was then I began to see that, even in death, his plans were for me and our child.

Shortly after the court appearance, my father-in-law phoned. From the tone of his voice, I could almost picture how he looked. I had seen him many times when he was angry. He wanted to know if it was true that I had gone to court. My answer was, "Yes." He asked if I actually filed for a guardianship. Again my answer was, "Yes." He told me he didn't care anything about Athalie Anita's person, I could handle that, but he was going to handle her estate. The ensuing argument continued until I told him the petition had been granted and there was nothing he could do. It was not only for her person but also for her estate. It was then I understood why Jase had instructed Charlie to go forward with the court proceedings as quickly as he could.

The words I had inscribed on the bronze urn containing Jase's ashes I believe symbolized his life. "To live in the hearts of those you love and leave behind is not to die."

All of the employees at the ranch loved him. To them, Jase was always "Mr. Jim." Whenever a grievance arose, he always had time to listen. No one was ever denied an audience in his office. A ranch foreman would be given the same amount of time as the president of a bank, and he was always fair.

For years, many of these employees came to see me and to see Mr. Jim's little girl. They never came empty handed. Sometimes it was a loaf of homemade bread, a glass of jelly or perhaps a bouquet of garden flowers. It didn't matter because each gift brought a deep sense of true affection. It was the thought that meant the most.

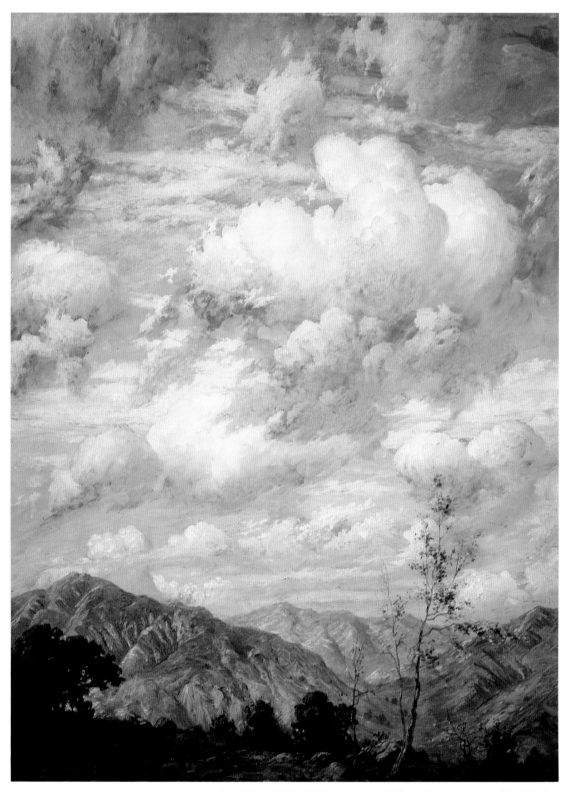

Paul Grimm (1892–1974), *Landscape with Cloudy Sky*, oil on canvas, 40 x 32 inches

George Maxwell, Jase's close friend who lived on the ranch, never forgot a holiday or a birthday. He always sent beautiful long-stemmed roses and he always brought something for Athalie Anita. Sal Saunders, Jase's mother's nurse, and Edna Price, Mr. Irvine's secretary, would come down from San Francisco. They both loved Jase and always called him Mr. Jim.

For at least six months after Jase's death, Dr. Bennett came to my parents' home every Sunday morning. He always told me he granted Jase his wish. He said Jase didn't want to live if he had to be an invalid. Dr. Bennett said he could never have lived an active life again, "So, I gave him his wish." This was of little comfort. Perhaps what he had to say lessened his feeling of guilt. Young Dr. Boland was a frequent visitor. He gave Athalie Anita her first tricycle.

My mother, my nurse Dear-Dear and I continued to live with my mother's parents and her sister Jeanne in their home on Severance Street. I was devoted to my grandmother and grandfather Richardson, who still continued to care for me, as my mother immediately became immersed in the details of my father's estate and in acting as my guardian. She also became Managing Director and Publisher of *Cinelandia* and spent a great deal of time running the magazine with my aunt Jeanne's help. Just as the magazine had been a wonderful therapy for my father during his long illness, I am sure it was an equally good therapy for my mother, as it enabled her not only to carry on my father's work, but to bury her grief in that work as well.

I was trying hard to put the magazine on a paying basis. Mr. Irvine had backed Jase with money to offset the continuing deficit all through the three years of Jase's illness. It did amount to thousands of dollars. I was very proud and I did not want his father to feel I had not tried to repay this enormous debt. I gave the Eagle Rock property, which I had inherited in Jase's estate, to my father-in-law. He accepted it as payment for some of the loans. To me, the whole debt was staggering, but I was determined the pay back all I could. After a few years of hard work, I sold the magazine to a young French entrepreneur.

In 1936, President and Mrs. Franklin D. Roosevelt invited my mother to a luncheon at the White House to receive a posthumous award for my father's participation in Latin American affairs.

Every week, my mother and Dear-Dear and I would go to Forest Lawn to put flowers next to the urn that held my father's ashes in Daffodil Court. There was a large pond with a lovely fountain just inside the

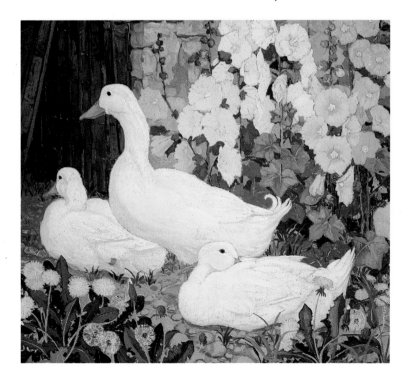

Jessie Arms Botke (1883–1971), *Ducks,*
oil on canvas, 24 x 27 inches

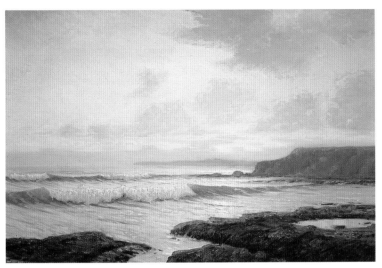

Frank Cuprien (1871–1948), *Evening's Iridescence,* oil on canvas, 32 x 48 inches

grandmother Richardson. I always remember her telling the story that, as a young girl, she sold all of her mother's beautiful cut crystal perfume bottles to buy a buckskin horse when her parents were away.

We spent part of the summer at Irvine Cove. My aunt Jeanne would stay with us. As soon as we arrived, my grandfather Irvine would come to see me and stay for dinner and bridge. He always brought Charlie Cogan, the Irvine Company purchasing agent, with him to make a foursome so he could play bridge with my mother and my aunt after I went to bed. They kept a running score and before my grandfather would leave, he would want to know about the next night. My mother and aunt Jeanne were always happy to see him enjoy the evening so much.

I loved our summers at the cove. At low tide, my mother would take me to search for sea shells and starfish in the rocks and tide pools around Abalone Point or in the caves at

cemetery gate where white swans and ducks always swam. After we visited the mausoleum, we would return to the pond where I could feed the swans and ducks. Once in a while, a plane would fly overhead and descend quite low in the sky. My mother would tell me that my father was up there and I would always point to the sky whenever a plane flew over.

Sometimes, we would drive out to Eagle Rock, where there was a pony ring, and I would be allowed to ride one of the very quiet ponies around and around the small dusty ring. This was something I truly looked forward to, and I would always cry when I had to get off my pony. I am sure I inherited my great love of horses from my

My mother and I at Irvine Cove, circa 1935

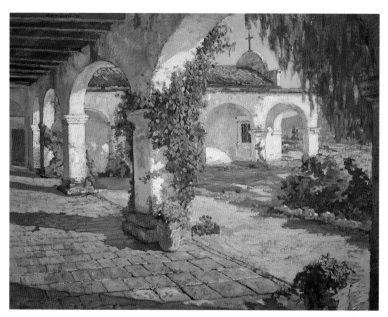

Alson S. Clark (1876–1949), *San Juan Capistrano Mission,* 1921, oil on canvas, 35³/₄ x 46 inches

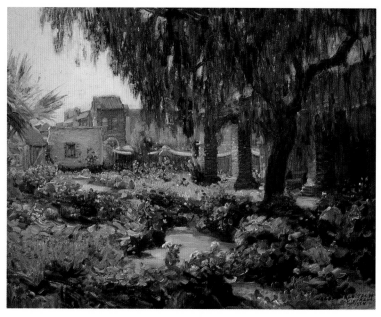

Joseph Kleitsch (1882–1931), *San Juan Capistrano,* 1924, oil on canvas, 24 x 30 inches

the other end of the beach. She showed me how to press my fingers against the moss-green sea anemones that covered the rocks, until they squirted streams of salt water, and to catch the tiny sand crabs that scurried into the wet sand when the waves receded into the sea. When the tide came in, she would hold my small hand tightly in hers, and we would splash in the frothy white water that swirled along the edge of the pounding waves. Sometimes in the evening, she would read me stories about the sea shells and creatures we had encountered during the day. My room would become filled with many of these treasures as the summer wore on.

As there was no electricity in the little green house, we had gas lights and had to go to Laguna to get ice for the ice box. My mother had a beautiful light blue Cord convertible with a white top and a rumble seat, and I loved to ride in that rumble seat when we went to town.

Occasionally, my mother and grandmother and I would go to the mission in San Juan Capistrano, where I loved to feed the white pigeons that would flutter around me and then land on my head and shoulders when I fed them the grain we could buy at the mission entrance.

Granville Redmond (1871–1935), *River with Oaks,* oil on board, 5¹/₂ x 7¹/₂

Joan and her mother in front of Oakhurst Drive house, Beverly Hills, circa 1938

During the years she lived on the Irvine Ranch, my mother became very interested in farming. One of the first investments she made after my father's death was the old Simms Ranch in Visalia, in the San Joaquin Valley. She acquired the property in 1937 and held it until 1977. The ranch was the setting for *The Grapes of Wrath* and John Steinbeck lived there while he worked on the novel.

When I was four years old, my mother, my nurse and I moved from my grandparents' home on Severance street to our new home at 632 North Oakhurst Drive in Beverly Hills. My mother continued to devote a great deal of time to my guardianship and to the publication of *Cinelandia.* It was at this time that I became very taken with a Mother Goose nursery rhyme that went:

"Here I am, little jumping Joan,
When no one is with me,
I am always alone."

I told my mother that I wanted to be called Joan instead of Athalie Anita.

Joan and Athalie, circa 1939

123

My mother always insisted that I wear my hair in shoulder-length sausage curls that were secured with a large bow on the right side of my head. How I hated standing in front of the bathroom mirror each morning while my nurse brushed in each of those sausage curls. In looking through old photographs of my mother as a young girl, I can see where she got the idea for those curls and that big bow.

My grandfather Irvine would often drive up from the ranch and visit my mother and me at our new home. He played the piano by ear and loved to sit and improvise at our grand piano in the corner of the living room. My grandfather wore high-top shoes, which always fascinated me. As soon as he would sit down, I would get down on my hands and knees to inspect the laces on his shoes. As soon as I did this, he would put his heavily shod foot on my hand so I could not get away. The harder I tried to get free, the more pressure he would put on my fingers. My mother would wince visibly at this performance, but I would never cry. As a child, I knew instinctively that he was just playing a game with me. After dinner, he would sit with my mother and talk, long after my nurse put me to bed.

Not long after we moved to Beverly Hills, my mother received a letter from Big Kate inviting me and my nurse down to the ranch for a visit. Of course, she did not include my mother in the invitation. My mother wrote to Kate, on April 11, 1938, saying: *"Your cordial invitation to Athalie Anita and her nurse is appreciated. It is gratifying to me that Jase's father and stepmother should be so interested in his child.*

"Much as I should like to have Mr. Irvine and Athalie Anita enjoy each other's companionship, I must remind you both that the child now is only four and a half years old,

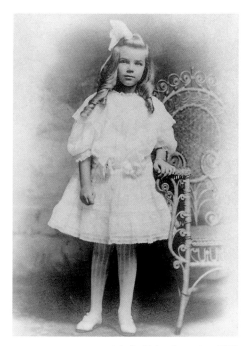

Athalie Richardson, circa 1910

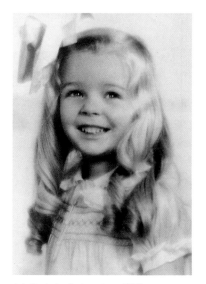

Athalie Anita Irvine, circa 1938

124

and that she has never yet been separated from me or members of my family with whom she has always lived.

"I cannot bring myself to subject her at this tender age to the unhappiness she most certainly would suffer under such separation, irrespective of the kindness I know she would receive at the ranch. Your reluctance to invite me to your home does not necessitate the apology or explanation you offer. I understand that reluctance as clearly as you must understand that I could not have accepted such an invitation, even if it had been tendered.

"Not that I bear you any malice. On the contrary, I had hoped that the sorrows we have all endured and the years that have passed since our unhappy association, would serve to obliterate any bitterness that either of us may have once felt.

"I am sorry you feel that my attitude has not been right and that I have said scandalous things about you. I have never intentionally said anything untrue about you, and in recent years I have not even discussed you.

"While I can understand your feeling so in your own case, I cannot share your opinion that I owe Mr. Irvine 'everything.' My allegiance is wholly to his son and namesake, who made the supreme sacrifice for me and his daughter, and who would be unhappy indeed if he felt that his child were obliged to accept a hospitality which was denied to him and which now is denied to her mother.

"I have made it very clear to Mr. Irvine in the past, and I now reiterate, that the child is being brought up with admiration, respect and affection for her grandfather who has been, and is, ever welcome to visit her at his own convenience."

Tom Mitchell, Joan Irvine
and Athalie Irvine Mitchell, circa 1939

On April 12, 1938, my mother married Thomas Hampton Mitchell, manager of Radio Corporation of America in Southern California, and a graduate of the United States Naval Academy at Annapolis. On May 26, 1938, Tom wrote to my grandfather Irvine saying:

"Ever since my marriage to Athalie, I have wanted to write to you and to say some of the things I had hoped to discuss personally with you before that event occurred. I regret that the opportunity has not presented itself before the present time.

"While I appreciate that social custom did not require that I approach you in exactly the same manner that a man approach the father of his prospective bride, I have long recognized the sincere affection which Athalie holds for you, and from the many things she has told me, you appear to reciprocate.

"Then too, as Athalie Anita's grandfather, you have a very valid right to know

something of the history and character of the man who is to be her stepfather."

Tom proceeds with a lengthy biographical account, then continues:

"In November of 1935, one of our now mutual friends, Margaret Johnson Wells, invited me as dinner partner and/or escort for Athalie on the occasion of the Junior League Ball at the Ambassador Hotel. Neither of us had ever heard of the other prior to that time, and even then I was not aware of her widowed status, nor the fact that this was to be her first party in years. On the way home, she informed me of these circumstances and confessed that she had gone solely upon the insistence of her family

and friends who, doubtless, were anxious to distract her mind from her sorrows.

"At infrequent intervals thereafter, I called and escorted her to the theater or took her and the baby for Sunday rides. After months of this association, there developed a deep and sympathetic friendship between us which time and propinquity ripened into love. Not the kind of love she felt for Jase, perhaps, for I'm told that occurs only once in a lifetime. But a mature and sincere affection based on mutual respect, admiration, and sympathetic understanding.

"As for the baby, we have seen so much of each other in the last two and a half years

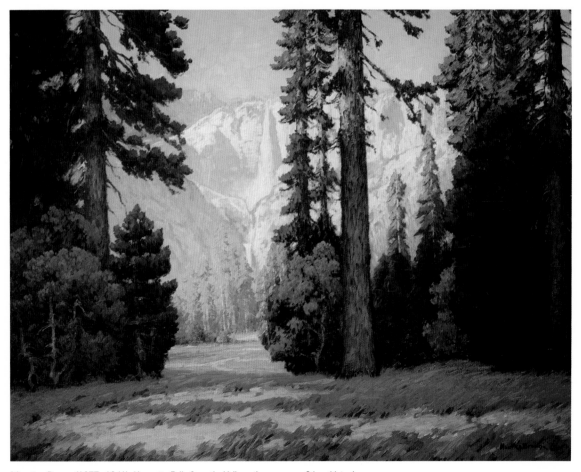

Maurice Braun (1877–1941), *Yosemite Falls from the Valley,* oil on canvas, 36 x 46 inches

After I commenced school at Marymount, my mother allowed me to go with my nurse to visit my grandfather at the ranch on weekends and during my vacations. I spent my days there, playing with the dogs, fishing with my grandfather or riding with the cowhands at the cattle ranch.

One of the Irish Setters my grandfather had was named Mike. He was so old that his face was completely white and he had a white bandage on the end of his tail. He moved so slowly that he had lost the tip of his tail getting it caught in the swinging door between the dining room and the pantry. One morning, when I came out of the ranch house, I saw my grandfather and several of the men who worked on the ranch standing at the edge of the goldfish pond across the driveway. When I went over to my grandfather, I saw a tear on his cheek. One of the men told me Mike had tried to get a drink of water at the pond and had fallen in and drowned. Later, when I went home, I told my mother what had happened and she told me Mike had been

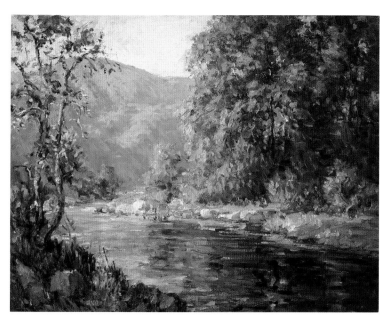

Benjamin Brown (1865–1942), *A Quiet Reach, Matilija Creek,* oil on canvas, 28 x 36 inches

that I believe I already fairly fill the void which occurred so early in her lifetime. I know I love her as much as I could possibly love my own flesh and blood, and if it is within my poor power to do so, I shall make her a stepfather of which, at least, she will never be ashamed."

In the beginning, Tom was a good husband and stepfather. We went to Yosemite and Catalina and spent a happy summer at the cove. When my mother would go to visit her cotton ranch in Visalia, we would go to Sequoia, and Tom would spend hours sitting with me while we fed the chipmunks and the deer.

William Wendt (1865–1946), *Landscape with Cattle Troughs,* oil on canvas, 25 x 30 inches

My mother with Buster the coyote,
Beverly Hills, circa 1939

my father's dog. It was the only time in my life I ever saw my grandfather show any tender emotion.

My mother always allowed me to have an assortment of pets, including dogs, cats, pigeons, a rabbit and a mouse. On one of my visits to the ranch, I saw an orphaned baby coyote which, of course, I wanted to take home. My grandfather said I could not have it because it was a wild animal and would bite me. But I wanted the coyote anyway. So, I pleaded with my mother and Tom, and unbeknownst to my grandfather we got the coyote and took it home with us to Beverly Hills. I named him Buster. The next day, I remember, my mother was ill when I left for school. When I returned from school, I found my mother in bed with Buster beside her. She had been feeding him warm milk with an eye

Bette Davis and Joan

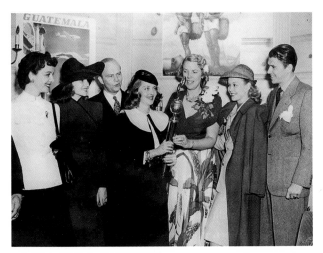

Bette Davis receiving the First Cinelandia Pan-American Award, as Hollywood's outstanding contributor to the cause of Pan-Americanism, at a reception given in Athalie Irvine Mitchell's home (left to right: Mona Maris, Rita Hayworth, Edgar Bergen, Bette Davis, Athalie Irvine Mitchell, Jane Wyman and Ronald Reagan)

Roi Clarkson Colman (1864–1945), *The Opal Sea, Laguna Beach,* 1941, oil on canvas, 22 x 30 inches

dropper. As time passed, Buster grew quite large and all went well until we tried to take him with us to the cove for the summer. As soon as we drove out of our driveway, Buster panicked and started running around inside the car. Before we could catch him, Buster threw up and relieved himself all over the back seat. We found an empty rabbit cage and left Buster in care of our gardener, but he eventually got loose. Buster only liked women. He did not like men at all. He probably got away from the gardener the first chance he got and that was the end of my pet coyote. I'm sure he had a good life living in the mountains above Sunset Boulevard and rummaging through all the garbage cans in Beverly Hills.

My mother continued to publish *Cinelandia* and it was at about this time that she presented the Pan American Award to Bette Davis at our home in Beverly Hills, and I had my picture taken with Bette Davis too.

When I was growing up, I was often subject to colds. Because of this, my mother bought a small house in La Quinta, near Palm Springs, where she and Tom and I would go on weekends during the winter. In later years, her great love of the desert prompted her to buy the house that President Eisenhower had used for a time as the Winter White House, in El Dorado Country Club in Palm Desert.

When I was about seven, my mother sent me for riding lessons at the Riviera Country Club in West Los Angeles. One day, when I was having my lesson, my horse stumbled and I fell off over his head, knocking out four of my front teeth. I will never forget the look on my poor mother's face when she came to pick me up, as I had blood all over the front of my shirt. My enthusiasm for my riding lessons was not dampened but my mother's certainly was. After that, Tom would take me riding at a stable near our house and he also taught me to shoot during our summers at the cove. He, my mother and I would practice shooting with a .22 at cans that we would set up along the edge of one of the cliffs next to the little green house.

After Pearl Harbor, my trips to the Irvine Ranch were less frequent because my mother

did not have the gasoline coupons that were necessary to drive that distance. If you were engaged in farming, you were entitled to more gasoline. She felt if she could find a ranch close enough to where we lived, I could keep a horse, and she would have more coupons which would enable me to make more trips to the ranch to see my grandfather.

Grandfather Irvine came less frequently into Beverly Hills to see us due to the gasoline shortage. Mullins would drive him in and he would have dinner and spend the night with us. In the morning, he would have my mother drive him to the Chancellor Hotel, which he owned. By doing this, he could save his gasoline. It was on one of these visits in 1942 that, my mother recalls: *I told my father-in-law I had read an ad in the* Los Angeles Times *regarding a ranch in the San Fernando Valley. I had seen the property. It was located on the corner of Tampa and Nordhoff Avenues in the San Fernando Valley and it was planted with Valencia and navel oranges and walnuts. The owner had told me the ranch was in probate estate and he had to have all cash. I was $10,000 short*

of the asking price. I was hoping Mr. Irvine would loan me the money. I remember how he twisted and puffed and his face turned crimson red when he said, "With a war going on, you should not be buying a ranch. How do you think you could operate one with thousands of men going into the service?" I responded by telling him the ranch manager was not that young and would not be drafted. He felt I should know better than to think that this man would work for a woman. Mr. Irvine seemed very concerned and told me in a very positive manner I should not make that kind of deal.

Later, when I informed Mr. Irvine that I had purchased the ranch, he was quite displeased and said I had paid too much. The price was $500 an acre, which came to $40,000. I told him my Federal Land Bank loan was approved for twenty years at three percent. He told me he would come up and take a look. We had a picnic lunch. There was an old house on the property which must have been built before the turn of

William Wendt (1865–1946),
California Landscape, oil on canvas, 24 x 32 inches

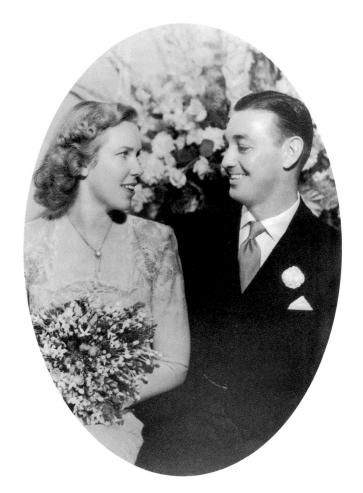

the century. Adjacent to the back of the house was a wide pergola covered with Concord grape vines. Father Irvine was very fond of those grapes and we had a wonderful picnic. He was impressed with my purchase and said I had a very fine ranch.

My mother eventually sold this ranch in various parcels. One part was traded for Byrnely, her farm in The Plains, Virginia, in 1969. Another part of the property was sold to a Dr. Gladstone, who developed it into a major shopping center. Dr. Gladstone devised a plan whereby all the income was to be given for medical research. My mother assisted Dr. Gladstone in accomplishing his goal, and as a result of their generosity, the University of California Medical School, San Francisco, today has one of the largest cardiovascular research centers in the United States.

Although Tom was a good stepfather to me, he did not remain faithful to my mother and the marriage ended in divorce in 1944.

My mother married Judge Thurmond Clarke on September 11, 1944. At that time Thurmond sat on the Superior Court bench in Los Angeles. Although they had known each other in high school and Thurmond would often brag about how he used to hold her hand at school, he actually never paid any attention to her at that time. My mother would

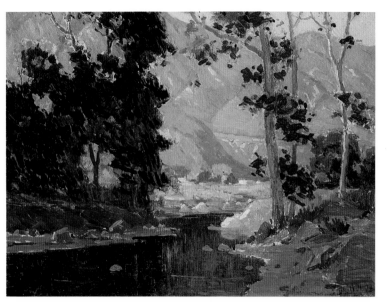

Elmer Wachtel (1864–1929), *In the Arroyo Seco,* oil on board, 9 x 12 inches

always say, "Thurmond couldn't see me for dust. No Junior could see a Freshman!"

Thurmond attended Stanford University and then went on to the University of Southern California School of Law. He began his law practice in 1927 in the Los Angeles County District Attorney's office and was appointed a Municipal Judge in 1932. He served as a Judge of the Superior Court from 1935 until 1955, when he was appointed United States District Judge for the Southern District of California by President Eisenhower, a position he held until he retired.

John Gamble (1863–1957), *Morning Mist, Wild Lilac,* oil on canvas, 20 x 30 inches

Granville Redmond (1871–1935), *Tending the Flock,* oil on canvas, 12 x 18 inches

Thurmond did not like Beverly Hills. He said he drove into the sun going to work in Los Angeles in the morning and had the sun in his eyes coming home. He preferred Pasadena so we moved to a new home there on Landor Lane. His fourteen year old daughter Frances attended Miss Branson's School in Marin County north of San Francisco, and I remained at home and attended Polytechnic and later Westridge in Pasadena.

Thurmond belonged to the California Club in Los Angeles, and my mother and I would often join him there for lunch. This was where I first saw examples of California Plein Air art, as the California Club owns a significant collection of this type of art and it is always on display. One of the clubs my mother and Thurmond joined after moving to Pasadena was the Flintridge Riding Club where I could keep my horses.

Two years after my father's death, my grandfather's accountant and tax advisor, N. Loyall McLaren, convinced my grandfather to sign the 1937 indenture of trust which was the basis for the holding by the James Irvine Foundation of the controlling stock interest of The Irvine Company.

From 1937 to 1947, when my grandfather died, he still maintained absolute and complete control over the Company. Only upon his death did the title of his stock pass to the James Irvine Foundation as trustee for the people of the State of California.

My uncle, Myford Irvine, president of the James Irvine Foundation, succeeded my grandfather as president of The Irvine Company in 1947 over the vocal protestations of Mr. McLaren and other foundation trustees.

My mother became a member of the Board of Directors of The Irvine Company in 1950 and remained there until I succeeded her in 1957. She was also a member of the Board of Directors of the Irvine Industrial Complex from the time of its inception until the company was sold to eastern investors in 1977.

My mother always said one of her greatest attributes was her ability to bring together the right people at the right time. One of these circumstances resulted in the National Boy Scout Jamboree, which was held on the Irvine Ranch in 1953. She said there was nothing that she could remember that compared to the magic of that evening when Myford Irvine welcomed 52,000 boys to the Irvine Ranch. The event made history for Orange County.

In 1957, after I became a member of the Board of Directors of The Irvine Company, my mother and I instituted legal proceedings against the Company, which were the first in a series of legal actions we were forced to bring in order to protect our stock interest in the Company. Thurmond's vast legal knowledge and excellent counsel proved invaluable to my mother and me during the long years of litigation that followed. This litigation was on-going for thirty-two out of the past thirty-seven years.

One day, I showed my mother a newspaper article about famous historical lady pirates and laughingly told her, "They must be referring to us." From that time forward, my mother always referred to us as the "Lady Pirates."

After Myford Irvine's death, on January 11, 1959, the Foundation gained absolute domination and control over The Irvine Company. N. Loyall McLaren succeeded my uncle as president of the Foundation and was elected vice president of The Irvine Company. A. J. McFadden became vice president of the Foundation and was elected president of the Company. I was to be the only Irvine Company stockholder of record to sit on The Irvine Company Board of Directors for the next fifteen years.

In December of 1959, with my mother's assistance, I won a two year battle to convince my fellow directors to make a gift of 1,000 acres of land to the University of California for a new campus on the Irvine Ranch. In December of 1960, again with my mother's assistance, I won a three year battle with my fellow directors for a master development plan for the Irvine Ranch lands.

On April 14, 1963, The Irvine Company Board of Directors adopted a resolution for the implementation of a master plan for the Irvine Ranch. On October 10th of that year, Mr. William Pereira outlined to the Company board what steps would be taken in general land development planning for the Irvine Ranch lands. The Pereira concept envisioned the university campus as the focal point for a "city of intellect." When the first section of the Company's master plan was

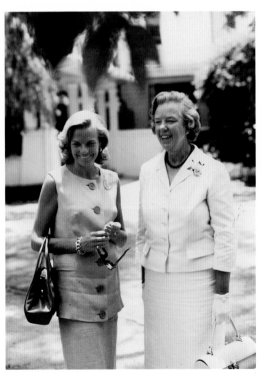

Joan Irvine with Athalie R. Clarke at the Irvine Ranch house, circa 1964. Photo courtesy of *Fortune* magazine.

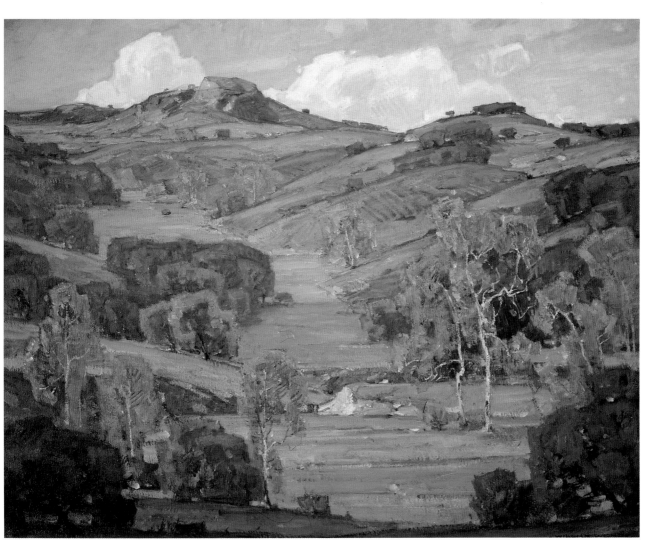

William Wendt (1865 – 1946), *Autumn Sycamores,* oil on canvas, 40 x 50 inches

Thurmond and Athalie, Corona del Mar, 1970

Maurice Braun (1877–1941), *The Oak,* oil on canvas, 14 x 18 inches

presented to the Orange County Planning Commission in 1963, the commissioners and the spectators who crowded the room rose to their feet and applauded.

My mother and Thurmond remained in Pasadena until he retired from full-time judicial duties on the Federal Bench in the early 1960s, when they moved to Newport Beach.

In 1964, I purchased my farm, The Oaks, in Middleburg, Virginia. A few years later, my mother purchased Byrnely Farm in The Plains, not far from Middleburg. She restored the main house, one of the oldest Federalist houses in the area. Records revealed that George Washington took surveying lessons from the original owner of the land.

Thurmond was a history buff, in the true sense of the word. His family was originally from North Carolina and he was an authority on the Civil War. He and my mother loved taking my sons James Irvine Swinden and Russell S. Penniman to visit the various battlefields in the area, which is steeped in Civil War history.

Both The Oaks and Byrnely Farm are located in the best fox hunting country in America, and although they did not ride, both my mother and Thurmond enjoyed the colorful spectacle of the hunt as well as the hunt breakfasts and other social events that were part of our community life. The rest of the family all rode to the hounds, and my husband, Morton W. Smith, was Master of the Orange County Hunt in The Plains, Virginia, for many years.

The Orange County Hunt, Byrnely Farm, The Plains, Virginia, 1969.
Photo courtesy of Marshall Hawkins.

Our years in Middleburg were a very happy experience for my mother and me. It was a family-oriented period in our lives. My sons Jim and Russell, my youngest son Morton Irvine Smith and my stepdaughter Alletta Morris Smith lived on the farm and were in school on the East Coast, my husband Cappy and I were breeding and training horses on the farm, and my mother and Thurmond were living close by.

Even after the adoption of the Master Plan for the Irvine Ranch lands, self-dealing, conflicts of interest and acts of mismanagement persisted within the Company. Although the Irvine Ranch lay directly in the path of urban development, former Company management allowed a major "opportunity to achieve our golden destiny" to pass us by for more

than ten years. As urban development leap-frogged over the ranch, developers like Mission Viejo in the southern part of Orange County reaped the rewards. The Irvine Company gradually developed an infrastructure of water and sewage facilities and appeared to remain a sleeping green giant.

Over the two and one-half decades that I served on The Irvine Company Board of Directors, my mother and I were forced into more than a dozen lawsuits, and I appeared before the House Ways and Means Committee and the Senate Finance Committee in order to protect both our vested interest in the Company and the financial well-being of my grandfather's charitable legacy.

After having lobbied for six years in Washington, D.C., I was instrumental in getting legislation passed in 1969, which, by 1974, required the James Irvine Foundation to diversify its investments by disposing of its 54 percent controlling interest in The Irvine

Left to right: Morton Irvine Smith, Athalie Clarke,
James Irvine Swinden, and Russell S. Penniman

Jessie Arms Botke (1883–1971), *Demoiselles Cranes and Lotus,* oil on canvas, 40 x 30 inches

Company. This legislation also required the Foundation to make a 5 percent payout to charity, based on the value of its assets each year. These two changes in the tax laws governing private foundations went far in bringing to fruition the benefit of my grandfather's legacy to the people of California.

Thurmond died from cancer in 1971, after a very long and painful illness, and my mother's sister Jeanne also was ill for a long time and died of cancer in 1974. For a while my mother was taking care of both Thurmond and my aunt Jeanne.

My mother and I had hoped The Irvine Company would go public. However, the Foundation trustees secretly made a "sweetheart" deal to sell the Company to Mobil Oil for $200 million. In December, 1974, my mother and I filed litigation here in California to enjoin the proposed $200 million merger between Mobil and The Irvine Company and became embroiled in the bidding war and public controversy that followed. In 1977, in an effort to stem the takeover of The Irvine Company by Mobil, we joined a group of financial giants to outbid Mobil and buy the Company for $337 million. Our group consisted of people like investment banker Charlie Allen, shopping center magnate Alfred Taubman and auto heir Henry Ford II. Also part of the team was local home builder Donald Bren.

In the same year, during a trip reminiscent of her honeymoon with my father to the Island of Kauai in the Hawaiian Islands, my mother fell in love with and acquired Olu Pua Gardens and Plantation. This world-renowned botanical garden and historical estate, developed for the Alexander Baldwins, proved to be the ultimate garden for one who loved horticulture, as she did. With over twelve acres of exquisite orchids, exotic heliconis, delicate hibiscus, flowering ginger and stunning vistas, my mother spent many enjoyable hours refurbishing and maintaining this magnificent garden.

While on Kauai, she also became associated with the National Tropical Botanical Garden and later served as trustee for many

years, helping to formulate the development of the gardens.

Her love of the Hawaiian Islands was not limited to Kauai. In 1978, she purchased a second magnificent estate known as Baldwin Manor, on Maui. This ancestral home of the Baldwin family had special meaning for her, for it reminded her of the original Irvine Ranch house and it was here that my father and grandfather had visited in the early 1900s. In 1985, she donated this extraordinary property to the Crystal Cathedral and entrusted it to Dr. Robert H. Schuller to be used and held as a retreat for years to come.

Our last battle with The Irvine Company began in 1983 when my mother and I became engaged in litigation with Donald Bren concerning the evaluation of our shares of Irvine Company stock. In 1991, when the final settlement was made, it marked the end of an era, the end of any substantial Irvine family financial interest in the land empire that was established in the 19th century and still bears the family name. However, it did not mark the end of our interest in Orange County.

In 1985, my mother and I began acquiring the property which today comprises The Oaks, my private equestrian training facility in San Juan Capistrano, California. From 1986 until my mother's death in 1993, she and I hosted The Oaks Classic and The Oaks Fall Classic, two Grand Prix jumping events at The Oaks. In recent years, these competitions have been held for the benefit of the National Water Research Institute and the U.C.I. College of Medicine. Since the founding of The Irvine Museum in 1992, The Oaks Classics have also featured an exhibition of California Plein Air art from the Museum as well as from prominent art dealers from across the country.

William Wendt (1865 – 1946), *Quiet Brook*, 1923, oil on canvas, 30 x 36 inches

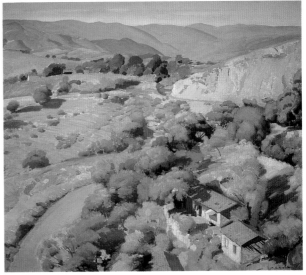

Arthur Rider (1886 – 1975), *Ortega Highway*, oil on canvas, 30 x 35 inches

After the settlement with Donald Bren, resolving the value of our stock in The Irvine Company, my mother and I were able to proceed with a new phase of the philanthropic efforts in which she had long been involved. We formed the Joan Irvine Smith & Athalie R. Clarke Foundation to provide continuity and centralized management for those efforts. As its first effort, the foundation provided the funds to launch the formation of the National Water Research Institute (N.W.R.I.).

My father and grandfather believed that nothing was more important to the well-being of the Irvine Ranch and Orange County than careful stewardship and development of water resources. When I was a girl, my mother told me stories of their legendary abhorrence of any waste of water, a sure ground for dismissal of any employee on the ranch. Long interested in local water matters, we concluded that the research efforts of local agencies could be more effective in the expenditure of their existing budgets and more successful in obtaining

financial and other assistance from other public and private sources if they coordinated their efforts. Through the Joan Irvine Smith & Athalie R. Clarke Foundation, we provide continuing funding for initial development of the N.W.R.I.

The N.W.R.I. is a unique public-private partnership effort dedicated to identify, coordinate and support research that will lead to improved water quality and supply. Formed as a joint powers authority by five Southern California water and sanitation agencies, it is governed by a board of directors selected by them and funded by a combination of public and private funds. After only three years, the N.W.R.I., with its public and private research partners, has become one of the principal water research sponsors in the nation. Its research priorities include membrane research and development, health risk assessment, water quality improvement, water recycling, watershed management, and public policy and institutional development. N.W.R.I. projects now represent a major source of the scientific literature being published in the field,

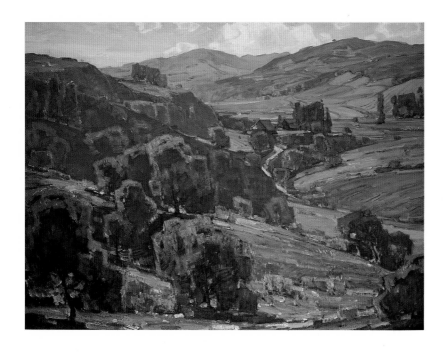

William Wendt (1865–1946), *Ranch in the Valley (Santa Ana River),* oil on canvas, 30 x 40 inches

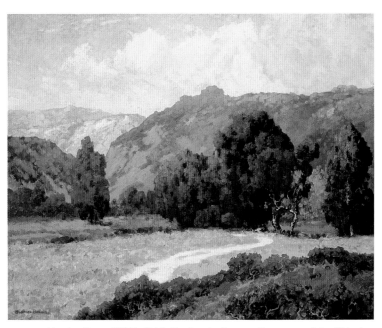

Maurice Braun (1877–1941), *Road to the Canyon,* oil on canvas, 24 x 30 inches

Frank Cuprien (1871–1948), *The Golden Hour,* oil on canvas, 20 x 26 inches

and its workshops and seminars are beginning to affect public policy at the national level. My mother took great pride and felt a great sense of accomplishment as she watched this new agency grow.

The Joan Irvine Smith & Athalie R. Clarke Foundation has also provided substantial continuing support for U.C.I. The foundation was able to provide the private funds necessary to acquire the first building in the development of the Center for the Health Sciences. Now known as Joan Irvine Smith Hall, because my mother was too modest to have a building named after her, the building houses faculty offices, research facilities and administrative offices for the medical school. Since then, the foundation has been able to support visiting scholars and senior scientists in the university's world-renowned atmospheric research and chemistry program. U.C.I. held a special place in my mother's heart and she was enormously gratified by the success of its first quarter century.

The third principal focus of the Joan Irvine Smith & Athalie R. Clarke Foundation had been to support, directly and indirectly, the efforts of The Irvine Museum. With grants to the Laguna Art Museum, The Fleischer Museum, The Oakland Museum and public television KOCE, the foundation has funded several projects related to California art. Through the foundation, my mother and I wished to provide continuing financial support for The Irvine Museum and its goals.

My mother and I founded The Irvine Museum in 1992 to share our love of the California Impressionist school with others. Paramount was our mutual conviction that the paintings are significant and representative of the highest standards of American art. The lives of all who view them will be enriched by

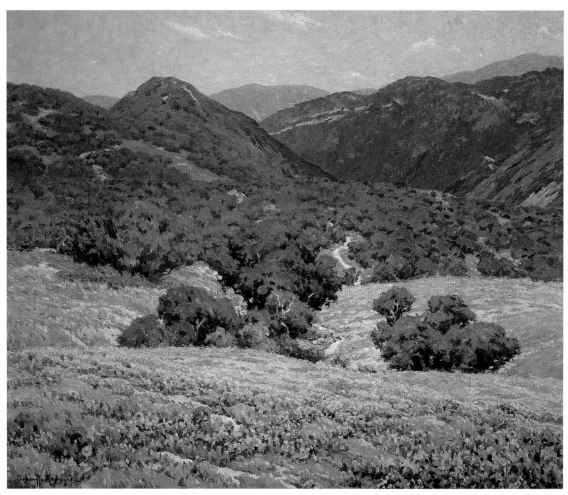

Granville Redmond (1871–1935), *Southern California Hills,* oil on canvas, 25 x 30 ¼ inches

their beauty. Moreover, both my mother and I felt that these paintings have a cultural significance and importance even beyond the aesthetic pleasure they bring.

The California of our respective youths needs to be documented, preserved and shared with future generations. This art is an outstanding way to experience the exhilaration and vitality of the natural beauty of California. Each of us spent a great deal of her formative years outdoors and developed a strong love and respect for nature and its inextricable bond to the human spirit. Our environment is a part of our essence and it can

never be removed from our lives. Of late, and hopefully not too late, many of us have become increasingly concerned about our environment's fragile and impermanent structure. We abuse it at our peril.

The California Impressionist paintings, with their beauty, their significance as both art and historical record, and the reverence for nature they memorialize and communicate, have had a deep and abiding impact on both my mother and me. They stand as a silent testament to our regard for the environment, and their account must not go unheeded. I trust that all who see these magnificent paintings

firsthand will be as moved by them as my mother was and as I have been.

One day, when my mother and I first started looking at California paintings which we were considering purchasing, she turned to me and said, "Now dear, you must be very careful when you are buying this Plein Air art as it could become addicting."

As long as I can remember, my mother had been involved in philanthropy. She was very good at raising money for worthwhile causes. When we first moved to Beverly Hills, my mother became a member of the Beverly Hills Auxiliary to the Children's Hospital and also a member of the Board of Directors of the Los Angeles Assistance League Day Nursery. During the Second World War, when we lived in Beverly Hills, she was Chairman of the Los Angeles Chapter of the Home Nursing Division of the American Red Cross, and she was one of the founding members of the Home Nursing Association of Los Angeles County. She was also a founding member of the Pasadena Guild of the Children's Hospital and served two terms as president.

Athalie Clarke with Anita Jeanne Ziebe

My mother loved people and was very gregarious. She truly enjoyed being with people and helping people. As a young girl, she had wanted to be a nurse, which I think probably came about from the fact that her father was a doctor. I think a lot of her interest in medical causes resulted not only from the fact that she had promised her father, when I was born and nearly died, that she would always do whatever she could for the medical profession for as long as she lived, but also because my father had suffered so much during all of his treatments for tuberculosis.

With the establishment of the new campus of the University of California at Irvine, my mother took an active interest in ways to develop the school into the first rate institution that it is today. Of course, she was very concerned with medical causes.

My mother served as a member of the U.C.I. Foundation Board of Directors and the U.C.I. College of Medicine Board of Trustees. She founded the U.C.I. Research Associates in 1983 and the Brain Imaging Committee in 1987.

My mother and her sister Jeanne were inseparable as adults, and when my aunt Jeanne died, my mother promised her she would always watch over her only child, Anita Jeanne Ziebe. With her support, Anita pursued the nursing profession. When she began her career in nursing management at the University of California at Irvine in 1987, Anita asked my mother if she would assist other nurses wishing to continue their education. Shortly thereafter, my mother founded the Associates for the Advancement of Nursing Science and Research, an organization dedicated to promoting nursing within Orange County.

For all her dedication and hard work, she was awarded the U.C.I. Medal of Honor

Athalie R. Clarke with Dr. Walter Henry and his wife, Maria del Carmen Calvo, 1989

Athalie Clarke and Dr. Howard P. House at The Oaks Classic, 1990

in 1987, the highest recognition the university can bestow. In 1990, she received the U.C.I. Lauds and Laurels Extraordinarius Award in appreciation of her efforts at fund raising.

Dr. Walter Henry, Vice-Chancellor for Health Sciences and Dean of the U.C.I. College of Medicine, said, "The thing that always struck me about Athalie was the depth of warm feeling that everyone I knew felt toward her. She was very gracious, thoughtful and kind toward everyone she met. She always had time to listen and offer words of encouragement. She will be sorely missed by people in this community. It is like losing somebody in the family."

One of my mother's special causes was the House Ear Institute in Los Angeles. She suffered from inner ear problems in her later years and was treated by Dr. Howard P. House, founder of the institute and her long-time physician and one of her closest friends. She served as a trustee of the institute in Los Angeles and formed the Associates of the House Ear Institute in Orange County, dedicating her vast fund-raising talents to this cause. In 1983, she was the recipient of the House Ear Institute Humanitarian Award.

My mother was particularly touched when the American Jewish Committee awarded her its Human Relations Award of the Western Region. Shortly after her death, Howard Friedman, her long-time friend and legal counsel, who presented the award in 1980, recalled that "she is the paradigm of a vanishing generation."

My mother was active in her support of other institutions as well. She was appointed by Governor Goodwin Knight to serve on the Board of Trustees of the Los Angeles Museum of Science and Industry and was a charter member of the President's Circle of the National Academy of Sciences and its Institute of Medicine. She was a trustee of Chapman University for almost twenty-three years, where the library is dedicated to the memory of Judge Thurmond Clarke. Pepperdine University awarded her an honorary doctorate for her service to the community at large and to that institution in particular. She was a regent of Loyola Marymount University in Los Angeles and a trustee of California State University at Los Angeles.

Athalie Richardson Irvine Clarke, circa 1952

In addition to philanthropic fund raising, my mother became active in Republican Party fund raising. It was sometime in the late 1940s that she got involved, and this is how she said it all began:

I became involved in politics at Thurmond's urging. A friend whom I have known since elementary school, Margaret Martin Brock, asked me to attend a luncheon she was giving at the California Club. Margaret had obtained one of the private dining rooms and asked about twelve ladies to join her.

It was my first experience with a Republican fund-raising event. The place cards were small white envelopes which contained ten $100 dinner tickets. Margaret explained how Norman Chandler of the Los Angeles Times, *had called her and asked her to help with the $100-a-plate dinner to be given at the Shrine Auditorium. She said Senator Knowland, who was the Majority Leader of the Senate, would be the speaker. Charlie Thomas was the dinner chairman.*

We met again, two weeks later for the follow-up luncheon at the California Club. I was the first one Margaret asked to report. I handed her the envelope containing the thousand dollars in checks. She didn't say thank you, she just handed me another envelope with ten more tickets and said, "I know Thurmond won't mind if you sell another table." The second table was easier than the first.

After that, my mother became very active in political affairs in California. With Margaret Brock she founded the Women's Division of United Republican Finance for Los Angeles County. She was co-chair of the Eisenhower/Nixon campaign in Los Angeles County in 1952 and represented California as a delegate or alternate to the Republican National

The Eisenhower campaign, 1952

President Ronald Reagan and Athalie R. Clarke

Convention on three occasions. Mrs. James Roosevelt, a close friend and no stranger herself to politics, noted that few women could claim the distinction of having living room chats encouraging two men, General Dwight D. Eisenhower and Richard M. Nixon, to seek the office of President of the United States. In fact, a good part of Richard Nixon's inaugural address was written in my mother's living room in Newport Beach, California.

In 1960, my mother spent five weeks travelling in Iron Curtain countries. It was a small group which was headed by Congressman Patrick Hillings. They traveled under the auspices of the State Department, visiting Moscow, Leningrad, Kiev, Rostov on the Don, Yalta and Odessa. Also included were cities in Romania, Czechoslovakia and East Germany. My mother was Congressman Hillings's appointee to the California State Central Committee. She was appointed by the Chairman, Casper Weinberger, to serve as Assistant Treasurer. Later on, when Ronald Reagan was Governor of California, my mother served on the State Board of Agriculture. For many years, she served as a member of the Fine Arts Committee of the United States Department of State.

President Richard M. Nixon and Athalie R. Clarke

She was appointed by President Nixon to the Committee for the Preservation of the White House. When she was called by Rosemary Wood with the news, she originally turned it down because Thurmond was confined to the hospital in Winchester, Virginia, and my mother didn't think she could devote the time required by the assignment. After talking to Thurmond over the weekend, she called Rosemary Wood on Monday

The Vermeil Room at the White House

President Gerald R. Ford with Athalie R. Clarke

to see if the President had filled the post. "No, as a matter of fact, Athalie, he has not, because his reply was, 'I'm going to let it go over the weekend. Thurmond will change her mind.'" She was re-appointed by Presidents Ford and Carter.

In 1975, President Ford appointed her to represent the White House at the 37th International Conference on Education held in Geneva, Switzerland. Later, she served as a director of the Richard Nixon Library and Birthplace Foundation.

President Jimmy Carter and Athalie R. Clarke in the White House

Athalie R. Clarke in the Vermeil Room at the White House in front of the Claude Monet painting, *Morning on the Seine,*
a gift of the Kennedy family in memory of President John F. Kennedy

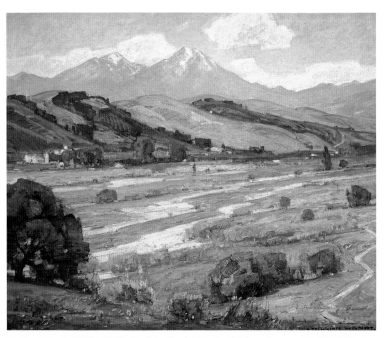
William Wendt (1865–1946), *San Juan Creek Near the Mission,* oil on canvas, 30 x 36 inches

On the week of May 17, 1993, I was busy preparing for the Oaks Classic, and my mother was making plans with my children for my 60th birthday party, which she was going to have at her home in Newport Beach on May 29th. I was at The Oaks in San Juan Capistrano when I received word from my son Jim, on the afternoon of Saturday, May 22nd, that my mother was gone. She had died peacefully, in her sleep, while taking her nap. As we drove north toward her home, through the great central valley of the Irvine Ranch, I felt the presence of both my mother and my father beside me, and I was suddenly enveloped with a tremendous sense of peace and well-being.

When I reached her home, I went to her bedside and looked down into her sleeping face. To my amazement, the years and the pain had vanished from her countenance and she was once again my beautiful young mother I remembered when I was a girl. I felt in my heart, my mother was with my father and that was where she truly wanted to be.

Upon hearing of my mother's death, Dr. Howard House recalled my grandfather Richardson's charge to her, just before she married my father: "Her father told her that her new life would be considerably different, that in her new life, she would have the opportunity to help many people have a better life. When I spoke with her not long before her passing, she asked me, 'Do you think I've done well?' She wanted to feel that she had done all she could to help people, especially children, and satisfy her father's wishes. It's hard to imagine that anyone could have done more."

Athalie R. Clarke and Dr. Howard P. House, Easter 1993 at The Oaks, San Juan Capistrano

EPILOGUE

From 1957 to 1991, except for a period of two years, my mother and I were continually involved in litigation with the Irvine Company both in California and in West Virginia, where the Company was originally incorporated. Our close friend and attorney, Howard I. Friedman of Loeb and Loeb, remembers this period with these words:

"In her remarkable and diversified 90 years of life, Athalie Clarke was involved in a myriad of activities to which she devoted her talent, her intelligence, her grace, and her energy. A major portion of those 90 years was devoted to her active and constructive involvement relating to the Irvine Company, where she served as a major shareholder and, for a time, as a director. She viewed that Company, as did her daughter Joan, as a patrimonial legacy for the Irvine Family and for the citizens of Orange County. Accordingly, she regarded the affairs of the Irvine Company and her own involvement in the Company as one of her primary responsibilities in life.

It was in the context of Athalie's Irvine Company activities that I came to know her and Joan. Initially, I met them in approximately 1957 when Judge Thurmond Clarke referred them to the law office with which I was associated and to Herman Selvin, a litigation partner of that firm, to whom I was, in a manner of speaking, an understudy. Our initial engagement for Athalie and Joan was to investigate a series of circumstances relating to the activities of the General Manager of the Irvine Company and a real estate broker with whom he had an association which seriously affected the Irvine Company. My association with Joan and Athalie continued thereafter until Athalie's death early in 1993. Hence, my perspective on Athalie and Joan was that of an attorney representing them in numerous litigation matters as well as counseling them in connection with policy decisions placed before the Board of Directors of the Irvine Company for action.

Among the litigation matters which occupied the attention of both Athalie and Joan over the years were the initial proceeding involving the former General Manager of the Company, proceedings relating to certain real estate transactions with several developers with close relationships to the management of the Company, efforts to assure the right of a director to be accompanied by counsel at board meetings, litigation relating to the circumstances under which the Irvine Foundation acquired 51% of the stock of the Company, and litigation over the proposed sale of the Irvine Company to Mobil Oil

Athalie Richardson Irvine Clarke.
Photo courtesy of *Newport Beach (714) Magazine*

Corporation in the middle 1970s. These litigation matters culminated in the appraisal proceedings commenced in 1983 on behalf of Joan and Athalie to secure the fair value of their shares in the Company. That proceeding was a preoccupying concern to Athalie and Joan for approximately eight years until it was settled in the summer of 1991.

Among the non-litigation matters in which I provided counsel to Athalie and Joan affecting the Irvine Company were the decisions involving adoption of a master plan for the Company, the decision to convey undeveloped acreage to the University of California for the construction of what became U.C. Irvine, the opening up of the Company to a broader range of developers for the development of the Company's properties, the organization of the City of Irvine and numerous other major policy matters which came before the Board of the Company.

I believe that when the history of Orange County is written covering the past 40 years, the roles of Athalie and Joan in influencing the Company toward constructive citizenship and effective planning will be among the highlights recounted in such a history. Their influence was a product of their farseeing vision for the Company, their steadfastness of purpose in asserting their points of view and in maintaining appropriate litigation strategies designed to accomplish constructive ends.

Athalie and Joan manifested an intelligence and a devotion to hard work not characteristically part of the popular perception of the role of women during those years. They were the vanguard of non-confrontational feminism in the best sense of the phrase. Though encountering repeated rebuffs and scorn for not maintaining a more passive feminine role, they were ultimately able to command attention and respect for what they were seeking to accomplish.

I have represented numerous companies and individuals faced with major challenges over the years. I have never encountered any clients, male or female, with a better capacity to understand issues, to do homework, and to maintain prudent postures. It was not as though Athalie and Joan were pursuing what was popular among their colleagues in the Company. Quite the contrary. But with it all, Athalie never lost her cool, never compromised her sweetness of disposition, her generosity of spirit and her friendly mien.

Athalie Clarke was a singular person in so many ways. But I think of her primarily as a person with enormously good judgement and a compassionate personality which made it a pleasure and a privilege to act as her counsel. All who knew her will treasure and nourish their own memories of her in whatever settings they knew her. In the context in which I knew her for nearly 40 years, she occupied, and will always occupy, a special place for me of nostalgic fondness and affection."

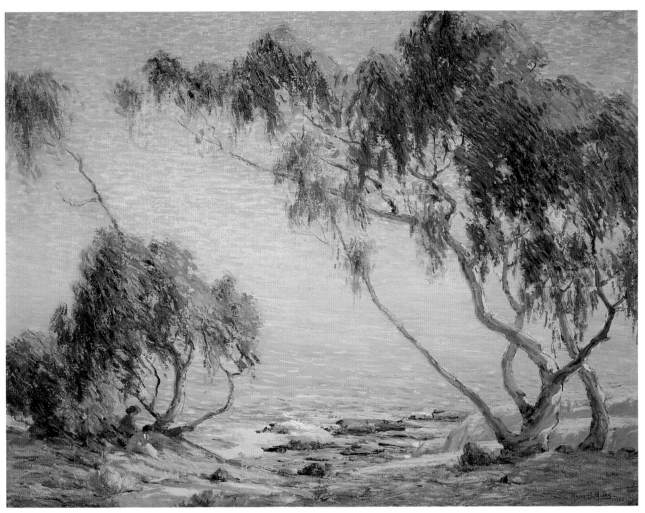

Anna Hills (1882–1930), *Laguna Beach, near Moss Point,* 1920, oil on canvas, 30 x 40 inches

ARTISTS' BIOGRAPHIES

The following are brief biographical notes for the artists represented. More detailed information on these artists may be found in a number of other publications listed in the Selected Bibliography.

Charles Percy Austin

Born March 23, 1883, in Denver, Colorado

Died March 17, 1948, in Santa Monica, California

Austin began his art studies at the Denver School of Art under Henry Read (1851–1935) and continued in New York, at the Art Students League, under John H. Twachtman (1853–1902), and later in Paris, under the Spanish painter Claudio Castelucho (1870–1927). He returned to Denver briefly before moving to Los Angeles in 1908, where he set himself up in Granville Redmond's old studio.

From about 1912, Austin began a long series of paintings of the Mission San Juan Capistrano that he exhibited frequently. He befriended Father John O'Sullivan, the resident priest who is called "the man who saved the Mission," and lived at the Mission for extended periods while he painted. In 1930 he illustrated the book, *Capistrano Nights,* by Saunders and O'Sullivan.

Austin painted several murals, including works for Our Lady of Mount Carmel, in Montecito, and for Saint Peter's Church in Los Angeles. The Mission San Juan Capistrano has one of his murals.

He was a member of the California Art Club and the California Watercolor Society. In 1915 he was awarded a Silver Medal at the Panama-California Exposition in San Diego. He painted in the Southwest and in Mexico on many occasions. He retired to Santa Monica, where he died in 1948.

Paul Grimm (1892–1974), *The Desert in All Its Glory* (detail), oil on canvas, 24 x 48 inches

Louis Betts

Born October 5, 1873, in Little Rock, Arkansas
Died in 1961

Betts was the son of Edwin D. Betts, one of the earliest artists in Little Rock. His brothers Edwin Jr. and Harold as well as his sister Grace were also artists. He studied under his father and in 1897 with William Merritt Chase at the Pennsylvania Academy of the Fine Arts. Betts was an excellent portrait painter and many of his works can be found in museums throughout the country.

In 1906–07, Betts participated in the Santa Fe Railroad's artist program where, in exchange for passage and board, artists would tour the Southwest and produce works which would be used in calendars and advertisements for the railroad. Our painting, *Midwinter, Coronado Beach,* was painted for this purpose and was once part of the Santa Fe Railroad's art collection.

Franz A. Bischoff

Born January 14, 1864, in Bomen, Austria
Died February 5, 1929, in Pasadena, California

Franz Bischoff received early artistic training at a craft school in Bomen. In 1882 he went to Vienna for further training in painting, design, and ceramic decoration. He emigrated to the United States in 1885 and obtained employment as a china decorator in New York City. He moved to Pittsburgh, then to Fostoria, Ohio, and finally to Dearborn, Michigan, continuing to work as a ceramic decorator. One of the foremost ceramic artists of his day, he founded the Bischoff School of Ceramic Art in Detroit and another such school in New York City. He formulated and manufactured many of his own colors, participated in exhibitions and won awards, earning a reputation as "King of the Rose Painters."

He first visited California in 1900 and, finding the climate and scenery appealing, moved his family there in 1906, settling briefly in San Francisco, then in Los Angeles. In 1908 he built a studio-home along the Arroyo Seco in South Pasadena, which included a gallery, ceramic workshop, and painting studio. In 1912 he took an extended tour of Europe where he studied the works of the Old Masters and the Impressionists.

After moving to California, Bischoff began painting on canvas in addition to continuing his ceramic work. He painted the coastal areas of Monterey and Laguna Beach, the Sierras, and the deserts near Palm Springs. He also painted the harbor at San Pedro and the farms in Cambria. In 1928 he made a trip to Utah where he painted in Zion National Park. In addition, he painted exquisite still lifes depicting flowers — roses, peonies, and mums.

Bischoff exhibited with the California Art Club and the Laguna Beach Art Association. In 1924 he received the Huntington Prize at the California Art Club. His ceramic works were exhibited at the 1893 World's Columbian Exposition in Chicago and at the 1904 Louisiana Purchase Exposition in St. Louis.

Jessie Arms Botke

Born May 27, 1883, in Chicago, Illinois
Died October 2, 1971, in Santa Paula, California

Jessie Arms attended the Art Institute of Chicago beginning in 1902 and later spent one summer studying with Charles Woodbury (1864–1940) in Ogunquit, Maine. Moving to New York City in 1911, she worked at Herter Looms, preparing tapestry cartoons under the guidance of Albert Herter (1871–1950). She developed a special talent for depicting birds and assisted Herter with a mural for the St. Francis Hotel in San Francisco.

In 1914 the artist traveled to Santa Barbara to assist Herter's wife Adele with the decoration of a private home. On a brief stopover in Chicago, she met the Dutch-born artist Cornelis Botke (1887–1954). They were married in 1915 in Leonia, New Jersey.

Botke and her husband then moved to Chicago where they collaborated on two major mural commissions: one for the Kellogg Company, the other for Noyes Hall at the University of Chicago. They visited California in 1918 and moved there the following year, settling in Carmel. From 1923 to 1925 they traveled throughout Europe. In 1927 they moved to the southern part of the state, living in Wheeler Canyon near Santa Paula.

Botke was not a plein air painter, but instead focused on decorative paintings of birds, both domestic and exotic. She worked in oil, watercolor, or gouache, and often employed gold leaf in the background. Her paintings were widely exhibited both in the West and in the East.

Botke was a member of the California Art Club, the California Water Color Society, the National Association of Women Artists, the Chicago Galleries Association, and the Foundation of Western Art. Her many awards included the Martin B. Cahn Prize, Art Institute of Chicago, 1918; the Shaffer Prize, Art Institute of Chicago, 1926; and the Carpenter Prize, Chicago Society for Sanity in Art, 1938.

George Kennedy Brandriff

Born February 13, 1890, in Millville, New Jersey

Died August 14, 1936, in Laguna Beach, California

George Brandriff had no formal art training although his interest in art began in childhood where he received encouragement from his uncle, William Kennedy, a watercolorist. He held a brief career as a piano salesman both in his hometown and in California where he moved in 1913. A year later he enrolled in the College of Dentistry at the University of Southern California. In 1918 he opened his practice in dentistry in Hemet.

He enjoyed painting in his free time and took lessons from Anna HIlls and Carl Oscar Borg in Laguna Beach and also studied weekends with Jack Wilkinson Smith beginning in 1923. He also developed friendships with and received criticisms from artists Edgar and Elsie Payne, Hanson Puthuff, William Wendt, Arthur Hill Gilbert, Clarence Hinkle, and William Griffith

He built a studio in Laguna Beach in 1927 and a year later closed his practice and moved to Laguna to become a full-time professional painter. His subjects included landscapes, seascapes, still lifes, figure studies, and harbor scenes. He painted in California, Arizona, and in Europe, which he visited in 1929.

Brandriff was an active member of the California Art Club and the Painters of the West beginning in 1925. He also served as president of the Laguna Beach Art Association from 1934 until his death by suicide in 1936. During his brief career he garnered a number of awards, including a silver medal from the Painters of the West in 1929 and second prize from the California State Fair in 1930.

Maurice Braun

Born October 1, 1877, in Nagy, Bittse, Hungary

Died November 7, 1941, in San Diego, California

Maurice Braun emigrated to the United States with his family when the artist was four years of age. A precocious talent, he copied works of art at the Metropolitan Museum and in 1897 enrolled in the National Academy of Design. He spent three years there and then studied under William Merritt Chase (1849–1916) for an additional year. In 1902 he went to Europe, visiting Austria, Germany, and Hungary, the country of his birth.

Returning to New York in 1903, he soon earned a reputation as a figure and portrait painter. However, his interest in landscape painting led him to a decision to move to California. In 1910 he opened a studio on Point Loma in San Diego. He became an active member of the art community and founded the San Diego Academy of Art in 1912. One of his most important pupils was Alfred R. Mitchell. Braun was also active in art circles in San Francisco and Los Angeles, exhibiting with the California Art Club, at Kanst Galleries, and with the Laguna Beach Art Association.

In 1921 Braun returned to the East and established studios in New York City, Silvermine, Connecticut, and, finally, in the art colony in Old Lyme. After a few years he returned to San Diego, but continued from 1924 to 1929 to spend part of each year in the East. In 1929 he joined nine other artists in forming the Contemporary Artists of San Diego.

Braun was affiliated with the Theosophical Society, whose tenets included transcendentalism and speculation on man, God, and the universe. Theosophy had a profound influence on his art. His paintings were expressions of nature's moods, rather than purely descriptions of the landscape.

Braun enjoyed a national reputation and his paintings were exhibited in Chicago, Philadelphia, Pittsburgh, and New York. A one man show was held at Milch Galleries in New York City in 1915, the same year that he received a gold medal at the Panama-California Exposition in San Diego. Other prizes included the Hallgarten Prize from the National Academy of Design in 1900 and a purchase award from the Witte Memorial Museum in San Antonio, Texas, in 1929.

Benjamin Chambers Brown

Born July 14, 1865, in Marion, Arkansas
Died January 19, 1942, in Pasadena, California

Benjamin Brown studied at the St. Louis School of Fine Arts. In 1886 he made a trip to California with his parents who were considering moving to Pasadena. While in California he made numerous pencil sketches of landmarks. He returned to St. Louis where he continued his studies and then opened his own art school in Little Rock while specializing in portrait painting.

In 1890 Brown went to Europe with his friends, artists William A. Griffith and Edmund H. Wuerpel (1866–1958). In Paris he studied at the Académie Julian for one year. After returning to the United States, he moved to Pasadena in 1896. He continued to do portraiture, but finding few patrons for his works, began also to paint the landscape.

Brown was active with many of the developing art societies in Southern California. He was also an etcher and, along with his brother Howell (1880–1954), founded the Print Makers Society of California, which sponsored annual international print exhibitions for many years.

An avid impressionist, he was outspoken in his criticism of other styles of art. He had patrons both in California and in the East. Hoping to encourage more sales, one New York dealer suggested that Brown open a studio there and conceal the fact that he was from California. Brown flatly refused and defiantly began painting the word "California" beneath his signature, affirming his pride in being a Californian.

Brown was a member of the American Federation of Arts, the California Art Club, the California Society of Printmakers, and the Pasadena Society of Artists. He received numerous awards, including a bronze medal at the Portland World's Fair in 1905, a silver medal at the Seattle World's Fair in 1909, and a bronze medal for etching from the Panama-Pacific International Exposition in San Francisco in 1915.

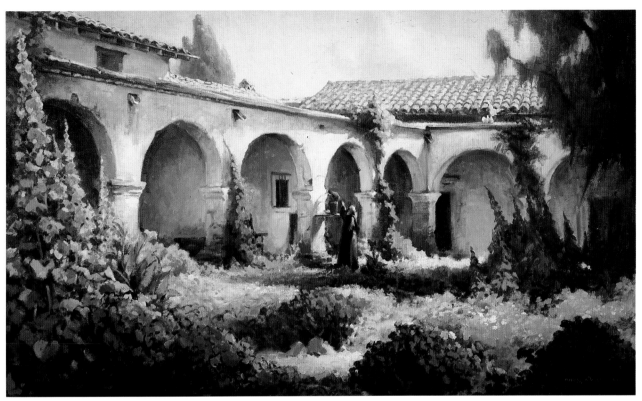

Charles Percy Austin (1883–1948), *San Juan Capistrano*, 1924, oil on canvas, 30 x 60 inches

Alson Skinner Clark

Born March 25, 1876, in Chicago, Illinois
Died March 23, 1949, in Pasadena, California

Alson Clark enrolled in Saturday classes at the Art Institute of Chicago in 1887 at the age of eleven. He also received private tutoring from a German painter while visiting Europe with his family a few years later. After completing his public school education, he studied at the Art Institute for several months from November 1895 through March 1896. Not satisfied with the teaching methods at the institute, he left for New York where he enrolled in the newly formed school of William Merritt Chase (1849–1916).

Late in 1898 Clark went to Paris where he enrolled in the Académie Carmen, the atelier of James MacNeill Whistler (1834–1903). He remained there for about six months. He traveled around France and to Holland and Belgium. He continued his studies in Paris at the Académie Delacluse and with Alphonse Mucha (1860–1939). In 1901 his painting *Violinist* was accepted at the Paris Salon.

Clark returned to the United States and early in 1902 opened a studio in Watertown, New York. Newly married, he returned to Paris in the fall of 1902, and he and his wife thereafter divided their time between France and the United States until the outbreak of World War I. Clark exhibited at the Art Institute of Chicago, which held a one-man show for him in January 1906. His works from this period — including figure works, especially studies of Medora, his wife, as well as landscapes, city scenes, and interiors — reflect the influence of Whistler.

On a summer trip in France in 1907, Clark began to lighten his palette to the higher key of his first teacher, Chase. The change in his style to a stronger impressionist method was reinforced during a trip to Spain in 1909 and would be seen in his work thereafter. In October and November of 1910 he visited Giverny where he saw Lawton Parker, an old classmate, Frederick Frieseke, and Guy Rose.

An inveterate sojourner, Clark traveled throughout Europe and the United States. In 1913, on his way to Paris, he stopped in Panama and decided to undertake the project of recording the construction of the Panama Canal. Eighteen of those paintings were exhibited at the Panama-Pacific International Exposition in 1915.

The Clarks returned to America at the outbreak of World War I. After the United States entered the war, Clark enlisted in the Navy and was sent to France to work as an aerial photographer. Clark visited California the winter of 1919 for reasons of health, then, in January 1920, decided to remain, acquiring a home and studio along the Arroyo Seco in Pasadena. He renewed his acquaintance with Guy Rose, who had returned to California in 1914. In 1921, along with Rose, Clark began teaching at the Stickney Memorial School of Art.

Attracted to the Southwest landscape, Clark made numerous painting trips in California and in Mexico. He sent works for exhibition to New York and Chicago, was represented by Stendahl Galleries, and also received mural commissions. He received numerous awards, including a bronze medal, St. Louis Exposition, 1904; the Martin B. Cahn Prize, Art Institute of Chicago, 1906; a bronze medal, Panama-Pacific International Exposition, 1915; the grand prize, Southwest Museum, 1923; the Huntington Prize, California Art Club, 1924; and a first prize, Pasadena Art Institute, 1933.

Roi Clarkson Colman

Born January 27, 1884, in Elgin, Illinois
Died November 29, 1945, in San Diego, California

Colman studied in Chicago, taking lessons with an artist named L.H. Yarwood in 1900. He then moved to Dallas, Texas, where he lived from 1903 to 1911. He sketched widely, especially along the Gulf Coast and produced a series of historical paintings of old Army forts in West Texas. In 1911 he went to Paris

where he studied for two years at the Julian Academy under Jean-Paul Laurens (1838–1921).

Returning to America in 1913, he lived in Pasadena, California, and in 1916 moved to La Jolla. Here he turned to painting seascapes, a subject that would fascinate him for the rest of his life and for which he is best known.

In 1917 he became director of the Santa Ana Art Academy and in 1920, he purchased a beach front home in Laguna Beach. Much of his endeavor in Laguna Beach was directed at marine painting. He was a member of the California Art Club, the San Diego Art Guild, and the Laguna Beach Art Association where he won prizes in 1920 and 1922 for his sparkling seascapes.

He spent a year in Carmel in 1928 and toured Europe the following year. In 1940 he returned to La Jolla, remaining in the San Diego area for the rest of his life.

Colin Campbell Cooper

Born March 8, 1856, in Philadelphia, Pennsylvania
Died November 6, 1937, in Santa Barbara, California

Colin Campbell Cooper attended the Pennsylvania Academy of the Fine Arts beginning in 1879. In 1886 he went to Europe, first painting in Holland and Belgium before moving on to Paris. In Paris he studied at the Académie Juilan, the Académie Delecluse, and the Académie Viti.

After his return to the United States in 1895, he taught watercolor painting at the Drexel Institute in Philadelphia for three years. He returned to Europe in 1898, traveling and painting in Holland, Italy, and Spain, and developing a reputation as a painter of the great architectural treasures of Europe. He continued to be interested in the interpretation of architecture after his return to the United States in 1902, painting a series of impressionist cityscapes of New

York, Philadelphia, and Chicago. Over the next several years he continued his European sojourns and in 1913 went to India.

Cooper spent the winter of 1915 in Los Angeles and, in the spring of 1916, visited San Diego. In January 1920 he established permanent residency in Santa Barbara, and during the 1920s he served as Dean of the School of Painting at the Santa Barbara School of the Arts. He made another trip to India and visited England, France, and Spain in 1923.

Cooper was elected to the National Academy of Design in 1902, gaining National Academician status in 1912. He was also a member of the Philadelphia Watercolor Club, the American Watercolor Society, the National Arts Club, the New York Society of Painters, the New York Watercolor Club, the California Art Club, the San Diego Art Guild, and the Santa Barbara Art Club.

He won numerous awards, among them the W. T. Evans Prize, American Watercolor Society, 1903; the Seinan Prize, the Pennsylvania Academy of the Fine Arts, 1904; a silver medal, International Fine Arts Exposition, Buenos Aires, 1910; a gold medal in oils and a silver medal in watercolor, Panama-Pacific International Exposition, 1915; and the Hudnut Prize, New York Watercolor Club, 1918.

Meta Cressey

Born May 3, 1882, in Ohio
Died May 4, 1964, in Los Angeles, California

Meta Cresssey was one of the earliest Modernist artists in Los Angeles, painting in a colorful and decorative style. While studying art in New York, she met and married Bert Cressey (1883–1944), an art student who was born and raised in Los Angeles and was at the time studying at the National Academy of Design. In 1914 they came to Los Angeles.

In 1916 she and Bert were among a small group of Modernist artists who founded the Los Angeles Modern Art Society. The group also included

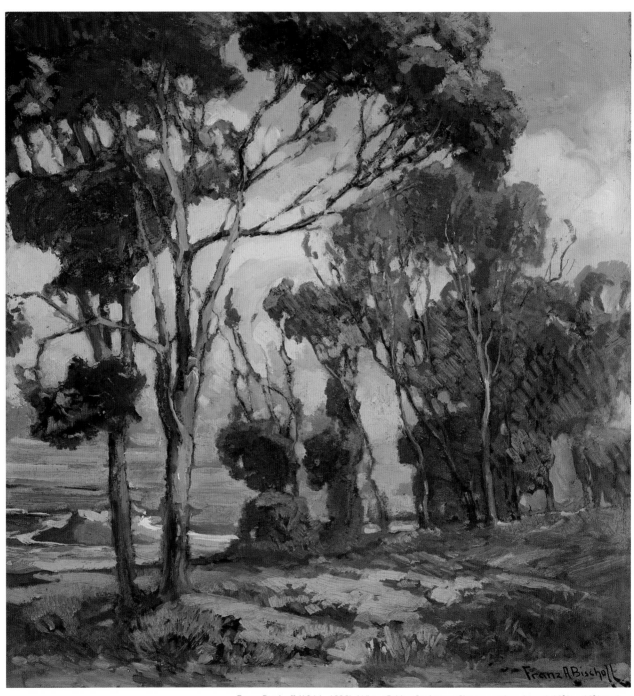

Franz Bischoff (1864–1929), *When Golden Sunbeams Shimmer,* oil on board, 19³/₄ x 18³/₄ inches

Helena Dunlap (1876–1955), Edgar Keller (1868–1932), Henrietta Shore (1880–1963) and Karl Yens (1868–1945). The society held non-juried invitational shows, featuring Modern works by local as well as foreign artists.

Meta Cressey was a member and frequent exhibitor at the California Art Club. In 1927, she showed *Under the Pepper Tree* at the Painters and Sculptors Annual Exhibition at the Los Angeles Museum.

Frank William Cuprien

Born August 23, 1871, in Brooklyn, New York
Died June 21, 1948, in Laguna Beach, California

Frank Cuprien attended the Cooper Union Art School and the Art Students League in New York City. He later studied in Philadelphia with Carl Weber (1850–1921) and also received criticism from noted marine painter William Trost Richards (1833–1905), who would be a major influence.

Cuprien completed his education with several years of study in Europe, in Munich with Karl Raupp (1837–1918) and in Paris at the Académie Julian. In addition he studied music — voice and piano — at the Royal Conservatories in Munich and Leipzig, from which he graduated in 1905.

Returning to the United States, he first went to Florida and the Gulf of Mexico. He then settled in Waco, Texas, where he taught at Baylor University. Around 1912 he moved to California, living first in Santa Monica and on Catalina Island. In 1914 he built a studio-home in Laguna Beach, which he called "The Viking." He became one of the leading artists of the community and helped to found the Laguna Beach Art Association in 1918 and served as president from 1921 to 1922. A master of seascapes, Cuprien was often voted the popular prize in the Laguna Beach Art Association exhibitions during the 1920s and 1930s.

Cuprien garnered a number of awards during his career. Among them were a first prize, Fifth Annual Cotton Exhibition, Galveston, Texas, 1913; a silver medal, Panama-California Exposition, 1915; and a bronze medal, California State Fair, 1919.

Paul DeLongpre

Born 1855, in Lyon, France
Died June 29, 1911, in Hollywood, California

Born in a large family of noted artists, Paul DeLongpre started painting as a young child. By the age of twelve, he was earning a living decorating folding fans in Lyon, at the time a center for the European silk industry. He became well known for his renditions of flowers, especially roses.

He gained wide popularity in France before coming to the United States sometime in 1890, settling in New York City. In 1898 he moved to Los Angeles, purchasing a double lot on he corner of Hollywood Boulevard and Cahuenga Avenue in the heart of present day Hollywood. He built a large, Moorish-style mansion and planted a three acre garden, boasting more than 4,000 rose bushes. His garden became a popular tourist attraction and one of the streets that bordered his property is now called DeLongpre Avenue.

He is most renowned for his beautiful and botanically exact watercolor paintings of roses. His garden was often the source for his artistic inspiration. He was called "Le Roi de Fleurs" (The King of Flowers) and won many awards during his lifetime.

John Frost

Born May 14, 1890, in Philadelphia, Pennsylvania
Died June 5, 1937, in Pasadena, California

John Frost was introduced to art by his father, Arthur B. Frost (1851–1928), a well-known American illustrator. When the family moved to Paris, John and his older brother, Arthur B., Jr., took classes at the Académie Julian under Jean-Paul Laurens. Young John worked with the American Impressionist Richard Miller in Paris from 1906–1908 and remained a close friend of the painter, visiting him often at Miller's home in Giverny. In Europe Frost contracted tuberculosis, a disease that would kill his brother, and spent two years in a sanitorium in Switzerland.

The outbreak of World War I saw the Frost family back in New York in 1915, where John worked as an illustrator. In 1919 the family moved to Pasadena, where the warm, dry climate diminished the lingering effects of John's tuberculosis.

Frost admired the works of the Impressionists and maintained that style all his life. He was a close friend and painting companion of Alson S. Clark and Guy Rose, whom he had known in France and who both now lived in Pasadena. Rose had been a life-long painting and fishing companion of Arthur B. Frost, Sr.

John Frost was a member of the California Art Club, the Painters and Sculptors Club of Los Angeles, and the Pasadena Society of Artists. He won prizes at the Southwest Museum in 1921, 1922, and 1923, and a gold medal at the Painters and Sculptors Club Exhibition in 1924.

John Marshall Gamble

Born November 25, 1863, in Morristown, New Jersey
Died April 7, 1957, in Santa Barbara, California

John Gamble entered the San Francisco School of Design in 1886, studying there under Emil Carlsen (1853–1931) and Virgil Williams (1830–1886). In 1890 he went to Paris to study at the Académie Julian and the Académie Colarossi. He returned to San Francisco in 1893 to begin his professional career.

He established a national reputation as a painter of wildflowers, although he said that he saw the flowers simply as patches of color. "I liked the way they designed themselves across the field."

When the earthquake and fire of struck San Francisco in 1906, Gamble lost his studio and complete inventory of work. Only three paintings, which had been out with a dealer, survived. By the end of the year, Gamble made the decision to move to Los Angeles to be near his close friend, artist Elmer Wachtel. A brief stopover in Santa Barbara persuaded him to relocate to that idyllic community on the coast. He became an active member of the arts community and served on the Santa Barbara architectural Board of Review, acting as color advisor for new construction.

Gamble was a member of the American Federation of Arts, Foundation of Western Artists, the San Francisco Art Association, and the Santa Barbara Art Association. In 1909 he received a gold medal at the Alaska-Yukon-Pacific Exposition, Seattle.

Arthur Hill Gilbert

Born June 10, 1894, in Mt. Vernon, Illinois
Died April 28, 1970, in Stockton, California

Gilbert was educated at Northwestern University and at the United States Naval Academy in Annapolis. After his military service, he came to California, in 1920, and began his art studies. He enrolled at the Otis Art Institute and continued his training by taking classes in Paris and London.

In 1928 Gilbert moved to Monterey and became well known for his paintings of the picturesque trees, dunes and rugged coastline. In 1929 his painting *Monterey Oaks* won the coveted Hallgarten Prize at the National Academy. In 1930, he won two more significant awards, the Murphy and Ranger Prizes, and was elected Associate Member of the National Academy.

In his later years, he moved to a ranch near Stockton, where he died.

Henry Percy Gray

Born October 3, 1869, in San Francisco, California

Died October 10, 1952, in San Francisco, California

Gray's family lineage included a number of writers and painters. That genetic predisposition to artistic talent was evident in his youth. He studied at the San Francisco School of Design beginning in 1886. In 1891 he secured employment as a sketch artist for the *San Francisco Call.* He developed the skills necessary to record a scene rapidly, excellent training for a plein air painter.

In 1895 Gray moved to New York City where he worked as an illustrator for the *New York Journal,* a Hearst publication, and in 1898 he was made head of the department. While in New York he studied at the Art Students League with William Merritt Chase. When the earthquake and fire devastated San Francisco in 1906, Gray returned home where he went to work for the Hearst paper *Examiner.* The highlight of his career with the *Examiner* was when he was sent to New York to sketch the proceedings of the Harry Thaw trial for the murder of architect Sanford White.

During this period Gray began to focus more time on landscape painting, specializing in the medium of watercolor. He traveled throughout Northern California and to Oregon and Arizona. Over the next fifteen years he maintained studios at various locations in and around San Francisco — in the Alameda home of his parents, in Burlingame, in the Portola Valley, and on Montgomery Street. After his marriage in

1923, he moved to the Monterey Peninsula. He joined the Carmel Art Association and became a close friend to artist Arthur Hill Gilbert.

While living in Monterey, Gray would take students on painting trips to Marin and Sonoma Counties. He would sketch on location, later creating finished works in his studio. He worked in oil, yet is best known for his paintings in watercolor. These quiet, lyric paintings are distinctly characteristic, following the English tradition of carefully applied, transparent washes. He noted that he was not so much painting the scene, as he was painting the atmosphere.

Gray was a member of the Bohemian Club, the Carmel Art Association, The Family (San Francisco), and the Society for Sanity in Art. His awards included a bronze medal for watercolor, Panama-Pacific International Exposition, San Francisco, 1915; and first prize for watercolor, Arizona Art Exhibition, Phoenix, 1915.

Paul Grimm

Born 1892, in South America

Died December 30, 1974, in Palm Springs, California

Grimm came to America with his family in 1899 and settled in Rochester, New York. At the age of 18, he won an art scholarship to study at the Royal Academy in Dusseldorf, Germany.

He came to California in 1919 and resided in Hollywood. There, he supported himself by doing design and advertising work as well as painting backdrops for early Hollywood studios. He moved to Palm Springs in 1932 and remained there for the rest of his life.

Grimm's early works are magnificent views of the California landscape, highlighted by dramatic, cloud-filled skies. After he settled in Palm Springs, he became the most renowned of the California desert painters. He won early popular fame and his studio-gallery there became a familiar stop for residents and tourists. President Dwight D. Eisenhower was one of his best known patrons.

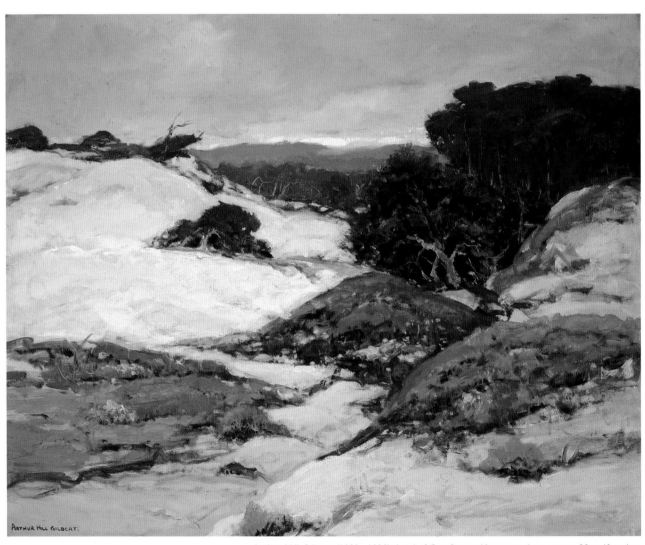

Arthur Hill Gilbert (1882–1930), *Land of Gray Dunes, Monterey*, oil on canvas, 32 x 40 inches

Harry Raymond Henry

Born March 21, 1882, in Woodson, Illinois
Died May 16, 1974, in Costa Mesa, California

Henry was apprenticed to an artist as a youth and later studied at the Art Institute of Chicago and the St. Louis Art Academy. He kept a studio in New York City until 1910, when he moved to California.

In the 1920s, he kept a studio in an old adobe building in San Juan Capistrano before moving to the Los Angeles area in 1929. In 1934 he was living in Hollywood where he became an art critic for the *Hollywood Citizen News*. By the mid 1940s, he was living in Laguna Beach, where he produced a good part of his work.

Henry's work is characteristically fluid, with loose brush strokes and distinctive, vivid harmonies of colors, especially blues, pinks and yellows.

Anna Althea Hills

Born January 28, 1882, in Ravenna, Ohio
Died June 13, 1930, in Laguna Beach, California

Anna Hills received her education at Olivet College in Michigan, the Art Institute of Chicago, and the Cooper Union Art School in New York City. She worked with Arthur Wesley Dow (1857–1922) for two years. She then went to Europe where she studied at the Académie Julian and traveled and painted in Holland and England, where she studied with John Noble Barlow (1861–1917).

She returned to the United States and moved to Los Angeles around 1912. A year later she relocated to Laguna Beach where she became a founding member of the Laguna Beach Art Association in 1918. She became an indefatigable leader of that group, serving as president from 1922 to 1925 and from 1927 to 1930,

the period during which the group raised the funds necessary to build their permanent gallery on Cliff Drive. A highly respected teacher, Hills promoted the visual arts through lectures and the organization of special exhibits which circulated among Orange County public schools.

Originally a figure painter, Hills turned to the landscape after her move to California. In addition to the Laguna Beach Art Association, Hills held memberships in the California Art Club and the Washington Water Color Club. Among her awards were a bronze medal, Panama-California Exposition, San Diego, 1915; a bronze medal, California State Fair, 1919; and the landscape prize, Laguna Beach Art Association, 1922, 1923.

John Hilton

Born September 9, 1904, in Carrington, North Dakota
Died November 27, 1983, in Lahaina, Hawaii

Having never studied art, Hilton came to Los Angeles in 1918 and worked in various jobs. During the Depression he owned a souvenir store in Twenty-Nine Palms, in the Mojave Desert. He befriended several artists of the desert and soon began to paint alongside of them.

His first solo exhibition was in Palm Springs in 1935, and he quickly became one of the best known and most collectable artists of the desert. During his career he produced a large number of illustrations, which were reproduced in national magazines, and he wrote and illustrated several books on desert life.

Thomas Lorraine Hunt

Born February 11, 1882, in London, Ontario, Canada
Died April 17, 1938, in Santa Ana, California

Hunt studied with his father, Canadian artist John Powell Hunt, later with Hugh Breckenridge at the Pennsylvania Academy of the Fine Arts, and in Gloucester, Massachusetts.

Settling in Cleveland, Ohio, Hunt worked in construction and painted in his spare time. In 1924 he came to California, living in Hollywood and in San Bernardino. In 1927 he established himself in Laguna Beach and actively participated in local exhibitions.

Thomas Hunt gradually evolved from Impressionism to a distinctive and unique form of Post Impressionism. His mature works are visual statements that concentrate on the surface plane of the painting. They are characterized by almost flat areas of vivid color, arranged in representational patterns, resulting in bold, dramatic canvases that celebrate color. He was uncommonly modernistic for the period in which he worked.

Ferdinand Kaufmann

Born October 17, 1864, in Oberhausen, Germany
Died March 23, 1942, in Los Angeles, California

Kaufmann studied art in Paris with Jean-Paul Larens, Benjamin Constant, William Bouguereau and Edouard Manet. He came to the Untied States and lived in Pittsburgh before coming to California in 1921.

Kaufmann lived and painted in Pasadena and Laguna Beach. He was awarded a first prize at the Pasadena Art Association Exhibition in 1929 and an honorable mention at the 1935 California State Fair. He was a member of the Laguna Beach Art Association.

Aaron Edward Kilpatrick

Born April 7, 1872, in St. Thomas, Canada
Died August 17, 1953, in San Luis Obispo County, California

Kilpatrick came to the United States in 1892 and established himself as a competent businessman. He began painting later in life. By the time he came to California, about 1915, he was a proficient artist.

He studied with William Wendt. The two artists became close friends and took several painting trips together, particularly in Central California at Moro Bay and San Luis Obispo.

In 1915 Kilpatrick won a bronze and silver Medal for art at the Panama-California Exposition, in Balboa Park in San Diego. He was elected Associate Member of the National Academy of Design.

Joseph Kleitsch

Born June 6, 1882, in Nemet Szent Mihaly, Hungary (present day Romania)
Died November 16, 1931, in Santa Ana, California

In his teens Joseph Kleitsch was apprenticed to a sign painter, but left after about eighteen months to open his own studio as a portrait painter. Around 1901 he emigrated to Germany and then to the United States, settling in Cincinnati, Ohio. Around 1905 he moved to Denver where he did portraits of prominent businessmen. Around 1907 he was in Hutchinson, Kansas, but, after only a short time, he relocated to Mexico City, residing there between 1907 and 1909. Sometime in 1909 he moved to Chicago.

In 1912 Kleitsch achieved recognition for commissioned portraits he had done of Mexican President Francisco Madero and his wife. Well established as a portrait painter, he joined the Palette and Chisel Club and began participating in local exhibitions with the club and at the Art Institute of Chicago

around 1914. He began to paint figures in interior settings, often placed in front of a window. He received high praise for these works and was compared favorably to the Spanish artist Joaquin Sorolla (1863–1923) as well as to Rembrandt.

In 1920 Kleitsch moved to Southern California, establishing residency in Laguna Beach. He was already acquainted with artists who had preceded him such as Edgar Payne. He again established himself as a portrait painter — his main source of income — but also began to include landscape and still life in his oeuvre. He was as a bold colorist, employing a bravura brushstroke. He especially enjoyed painting in and around Laguna Beach, whose charms he knew would soon succumb to real estate development.

In 1925 Kleitsch traveled to Europe, visiting France and Spain where he painted portraits and landscapes. He returned to California in November 1927 where he continued to paint until his untimely death at the age of forty-nine.

Kleitsch held memberships with the Chicago Society of Artists, the Laguna Beach Art Association, the Palette and Chisel Club of Chicago, and the Painters and Sculptors Club, which he cofounded in 1923 with Grayson Sayre. The numerous awards which he garnered during his career included a gold medal, Palette and Chisel Club; a silver medal, Painters and Sculptors Club; a first prize, California State Fair, and a first prize and figure prize, Laguna Beach Art Association.

Edgar Alwin Payne

Born March 1, 1883, in Washburn, Missouri

Died April 8, 1947, in Hollywood, California

Edgar Payne was essentially a self-taught artist who left home around 1902 at the age of nineteen. He traveled for a number of years throughout the South, the Midwest, and in Mexico, taking various jobs as a house painter, sign painter, scenic painter, and portrait and mural artist. He settled in Chicago in 1907 where he enrolled briefly in a portraiture class at the Art Institute of Chicago, leaving after only two weeks. At this time he began landscape painting in the form of murals and small easel works. He exhibited with the Palette and Chisel Club, from which he sold some of his paintings.

Payne visited California in 1909 and spent some time painting in Laguna Beach. He also visited San Francisco where he met his future wife, artist Elsie Palmer (1884–1971). He visited California a second time in 1911 and married Elsie in November 1912. They lived in Chicago until 1917 during which time they became well established in the art circles. Payne exhibited at the Art Institute of Chicago as well as the Palette and Chisel Club. He continued with his mural work and made annual trips to California.

In the summer of 1917 they moved to Glendale, California; then, in November they moved to Laguna Beach. Payne became active in the art colony there and was a founding member and first president of the Laguna Beach Art Association in 1918.

Payne was an inveterate traveler who painted throughout California, Arizona, and New Mexico, as well as in Canada. No locale was too remote, and he spent a great deal of time in the High Sierras, living for weeks at his elaborate campsites. In the summer of 1922 the Paynes went to Europe, painting over a two-year period in France, Switzerland, and Italy. His favorite painting locations were the Alps and in

the fishing ports. His painting of Mont Blanc, en-titled *The Great White Peak,* received an honorable mention at the Paris Salon in the spring of 1923.

After their return to the United States in the fall of 1924, the Paynes spent some time again in Chicago, then returned to Laguna Beach. Over the next several years they spent time in California, Connecticut, and New York and made painting trips to the California Sierras, Utah, and New Mexico. In 1928 another trip was made to Europe where Payne painted in the harbors of Chioggia and Brittany.

Payne was a member of the California Art Club, the Painters and Sculptors of Southern Califor-nia, the Chicago Art Club, the Palette and Chisel Club of Chicago, and the Salmagundi Club in New York City. His works were exhibited nationally in Chicago and New York. His many awards included the Martin B. Cahn Prize, Art Institute of Chicago, 1921; a gold medal, California Art Club, 1925; and the Ranger Fund Purchase Award, National Academy of Design, 1929. He wrote *Composition of Outdoor Painting,* pub-lished in 1941, which is now in its fifth printing.

Granville Richard Seymour Redmond

Born March 9, 1871, in Philadelphia, Pennsylvania
Died May 24, 1935, in Los Angeles, California

Granville Redmond contracted scarlet fever at the age of two and a half which resulted in permanent deafness. His family moved to California in 1874, and in 1879 Redmond enrolled in the Institution for the Deaf, Dumb, and Blind at Berkeley (now the California School for the Deaf, Fremont). His artistic talents were recognized and encouraged by the deaf photographer and teacher Theophilus Hope de'Estrella (1851–1929), who taught him drawing and panto-mime. He also received sculpture lessons from the deaf sculptor Douglas Tilden (1860–1935).

After graduation in 1890 Redmond enrolled in the California School of Design. In 1893, with a stipend from the Institution for the Deaf, he went to Paris where he enrolled in the Académie Julian. After five years in France, he returned to California and opened a studio in Los Angeles. For the next several years he painted in and around the area, including Laguna Beach, Long Beach, Catalina Island, and San Pedro. He visited and painted in Northern California in 1902 and 1905.

In 1908 he relocated to Parkfield on the Mon-terey Peninsula where he resumed his friendships with his former classmates from the California School of Design, Gottardo Piazzoni (1872–1945) and Xavier Martinez (1869–1943). He moved to San Mateo in 1910 and located his studio in Menlo Park.

In 1917 he traveled to Los Angeles with Got-tardo Piazzoni and, with his natural skills as a panto-mimist, decided to try his hand in motion pictures. He met Charlie Chaplin, who cast him in a small role in *A Dog's Life.* Chaplin became a close friend and set up a painting studio for Redmond on his movie lot. In turn, he taught Chaplin sign language and, between 1918 and 1929, had small rolls in seven movies. During this period he painted through-out Southern California.

Redmond was, without question, one of Cali-fornia's leading landscape painters. Although he pre-ferred his works done in a more tonalist style, his patrons favored his paintings of the rolling hills cov-ered with golden poppies. He was a member of the Bohemian Club, the San Francisco Art Association, the California Art Club, and the Laguna Beach Art Association. His awards included the W. E. Brown Gold Medal, California School of Design, 1891; award, Louisiana Purchase Exposition, St. Louis, 1904; and a silver medal, Alaska-Yukon-Pacific Ex-position, Seattle, 1909.

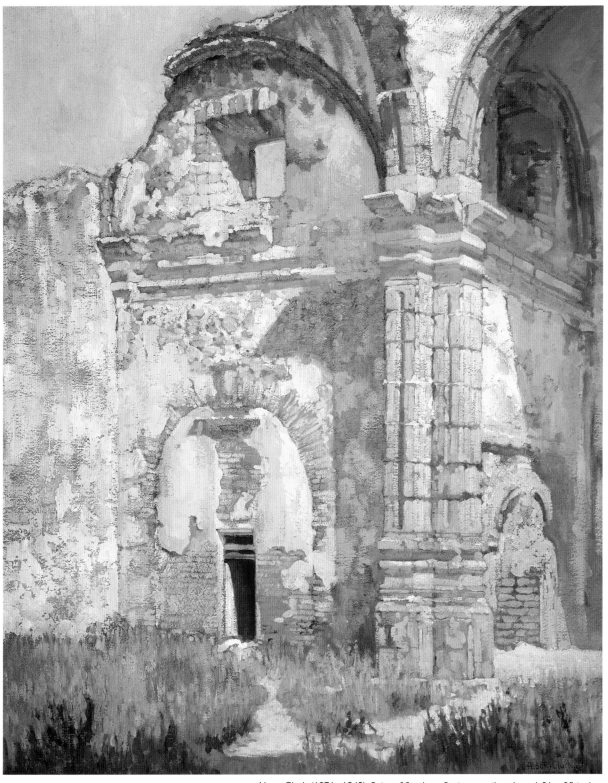

Alson Clark (1876–1949), *Ruins of San Juan Capistrano*, oil on board, 31 x 25 inches

Arthur Grover Rider

Born March 21, 1886, in Chicago, Illinois

Died January 25, 1976, in Los Angeles, California

Arthur Rider attended the Chicago Academy of Fine Arts. He then went to Europe where he studied at the Académie Colarossi and the Académie de la Grande Chaumiere in Paris. He spent several summers in Valencia, Spain, studying at the Werntz Academy of Fine Arts. It was there that he befriended noted artist Joaquin Sorolla (1863–1923), who would be a great influenceon his work.

Rider returned to Chicago where he became an active participant in the art community. After visiting California in the late 1920s, Rider settled permanently there in 1931. He worked for Twentieth Century Fox and MGM Studios, retiring at the age of eighty-four.

Rider painted throughout California and Mexico, seeking locales which would remind him of the color and light he had seen in Spain. His paintings are rich in color with intense, brilliant light. Many of his Spanish pictures depict the activities of fisherman on the beach in Valencia and their boats with the single, white, billowing sail.

Rider held memberships in the Palette and Chisel Club, the Chicago Galleries Association, the California Art Club, the Painters and Sculptors Club, and the Laguna Beach Art Association. He was awarded a purchase prize, Art Institute of Chicago, 1923; second prize, California State Fair, 1936; first prize, California Art Club, 1940; and first prize, Painters and Sculptors Club, 1954.

Guy Rose

Born March 3, 1867, in San Gabriel, California

Died November 17, 1925, in Pasadena, California

Guy Rose attended the California School of Design in 1886 and 1887, studying under Virgil Williams and Emil Carlsen (1853–1932). In 1888 he went to Paris and enrolled in the Académie Julian. He was an apt student who soon found his paintings accepted for the annual Paris Salon exhibitions.

In 1894 Rose experienced a bout of lead poisoning which forced him to abandoned oil painting. He returned to the United States in the winter of 1895 and began a career as an illustrator. He also taught drawing and portraiture at Pratt Institute in Brooklyn. He began to paint again around 1897.

In 1899 he returned to Paris, where he continued to do illustration work for *Harper's Bazaar* and other American magazines. In 1904 he settled in Giverny, becoming a member of the American art colony there. He associated with artists Alson Clark, Richard Miller, Lawton Parker, and Frederick Frieseke. He was strongly influenced by Monet, although it is not established whether the two ever met. Frieseke, Miller, Parker, and Rose exhibited in New York in 1910 as "The Giverny Group."

Rose returned permanently to the United States in 1912, settling for a time in New York. He moved to Pasadena at the end of 1914 and became active in the local art circles, serving for several years on the board of trustees of the Los Angeles Museum of History, Science and Art. He became the director of the Stickney Memorial School of Fine Arts in Pasadena and persuaded Richard Miller to teach at the school in 1916.

Rose painted primarily in the southern part of the state until about 1918 at which time he went to Carmel and Monterey. He developed a serial style of painting, like that of Monet, in which the same scene would be depicted in different seasons and at different times of day.

Rose was a member of the California Art Club and the Laguna Beach Art Association. Three one-man exhibitions were held for him at the Los Angeles Museum, in 1916, 1918, and 1919. He was represented in Los Angeles by Stendahl Galleries and in New York by William MacBeth. Among his numerous awards were a bronze medal, Pan-American Exposition, Buffalo, 1901; a silver medal, Panama-Pacific International Exposition, San Francisco, 1915; and the William Preston Harrison Prize, California Art Club, 1921. He was disabled by a stroke in 1921, four years before his death.

Donna Norine Schuster

Born January 6, 1883, in Milwaukee, Wisconsin

Died December 27, 1953, in Los Angeles, California

Donna Schuster attended the Art Institute of Chicago where she graduated with honors. She then studied at the Boston Museum of Fine arts School with Edmund C. Tarbell (1862–1938) and Frank W. Benson (1862–1951). She went on a painting tour of Belgium in 1912 with William Merritt Chase (1849–1916) and won the William Merritt Chase Prize.

Schuster moved to Los angeles in 1913 and the following summer studied once again with Chase at the Carmel Summer School. In the fall of 1914 she made a series of watercolor sketches in San Francisco depicting the construction of the buildings for the Panama-Pacific International Exposition. These were later exhibited at the Los Angeles Museum of History, Science, and Art.

In 1923 she built a studio-home in the hills of Griffith Park in Los Angeles. She joined the faculty of Otis Art Institute. She spent her summers at a second studio-home in Laguna Beach. In 1928 she began to study with Stanton MacDonald-Wright, and thereafter her work reflected the influence of Cubism and, later, Abstract Expressionism.

Schuster was active in many arts organizations, holding memberships in the California Art Club, the Laguna Beach Art Association, West Coast Arts, and the California Water Color Society, of which she was a founding member. She was also a member of the "Group of Eight," who considered themselves modernist in their use of rich color, expressive painting techniques, and an emphasis on the human figure. She received numerous awards including a silver medal, watercolors, Panama-Pacific International Exposition, San Francisco, 1915; a gold medal, California State Fair, 1919; and a gold medal, Painters of the West, 1924 and 1929.

Edwin Roscoe Shrader

Born December 14, 1878, in Quincy, Illinois

Died January 18, 1960, in La Canada, California

Shrader came to California as a child, settling in Los Angeles. His first art studies were with William Lees Judson (1842–1928) at the University of Southern California. He also studied music and was an accomplished cellist, playing in several string quartets. In 1902, Shrader returned to Illinois and took two years of classes at the Art Institute of Chicago. Thereupon, he continued his training in Delaware with Howard Pyle (1853–1911), the prominent illustrator.

After a brief career as a book and magazine illustrator, he returned to Los Angeles in 1917 and became and active participant in the California Art Club and the Painters and Sculptors annual exhibitions in the Los Angeles Museum. That same year, he began a lifelong association with the Otis Art Institute, first as a teacher, then as director in 1921 and as dean of the faculty in 1923, a post he retained until his retirement in 1948.

Jack Wilkinson Smith

Born February 7, 1873, in Paterson, New Jersey

Died January 8, 1949, in Monterey Park, California

Jack Wilkinson Smith began his art career while still in this teens, working as a "paint boy" in a Chicago scenic painting shop under artist Gardner Symons. He also studied at the Art Institute of Chicago and was influenced by the work of William Wendt. He later obtained employment as a sketch artist with the *Cincinnati Enquirer*. He received national recognition for his front-line sketches of battle scenes of the Spanish-American War. In Cincinnati he studied with Frank Duveneck (1848–1919) at the Cincinnati Art Academy.

In 1906 Smith visited Los Angeles, then traveled north to Oregon. Returning to Southern California, he established a studio-home in Alhambra, in an area known as "Artists' Alley." His neighbors there included sculptor Eli Harvey (1860–1957) and painter Frank Tenney Johnson (1874–1939).

In 1923 he helped to found the Biltmore Salon, a gallery devoted to Western artists. It featured the work of Smith, Johnson, Clyde Forsythe (1885–1962), George Brandriff, Carl Oscar Borg, Hanson Puthuff, and William Wendt, among others.

Smith was best known for his seascapes and mountain landscapes. He was a member of the California Art Club, the Sketch Club, and the Laguna Beach Art Association. His awards included a silver medal, Panama-California Exposition, San Diego, 1915; a gold medal, California State Fair, 1919; and gold medals, Painters of the West, 1924 and 1929.

Harold Arthur Streator

Born August 5, 1861, in Cleveland, Ohio

Died July 14, 1926, in Pasadena, California

Streator trained as an artist at the Art Students League in New York, and at the Boston Museum School. He lived in Cleveland and regularly exhibited at the National Academy in New York, the Art Institute of Chicago, and the Pennsylvania Academy of the Fine Arts, in Philadelphia.

In 1919 he moved to Pasadena and became active in the local art community.

Elmer Wachtel

Born January 21, 1864, in Baltimore, Maryland

Died August 31, 1929, in Guadalajara, Mexico

In 1882 Elmer Wachtel came to Southern California to live with his older brother John, who was married to the sister of Guy Rose and was managing the Rose family ranch, Sunny Slope. An aspiring violinist, Wachtel became first violin of the Philharmonic Orchestra in Los Angeles in 1888. He also held the same position from 1893 to 1894 with A. J. Stamm's Philharmonic Orchestra.

During this time he also pursued an interest in drawing and painting. He became involved in local art circles which included Gutzon Borglum (1871–1941) and J. Bond Francisco (1863–1931). With several other artists they founded the Los Angeles Art Association in the late 1880s.

Some time in 1895 Wachtel went to New York and enrolled in the Art Students League, but, unhappy with the teaching methods, left after only two weeks. He remained in New York and received criticism from William Merritt Chase (1849–1916). Working in watercolor, he exhibited with the New York Water Color Society. After returning to California in 1896,

he spent a brief period in San Francisco where he exhibited with the San Francisco Art Association. He then returned permanently to Los Angeles.

Wachtel worked as a pen and ink illustrator for *Land of Sunshine* and *Californian* magazines. Around 1900 he went to England and Europe, studying at the Lambeth Art School in London and visiting and painting with his friend Gutzon Borglum who was living there. He also associated with the English illustrators Fred and Tom Wilkinson.

Wachtel returned to Los Angeles and, within a few years, established a reputation as an accomplished landscape artist. William Keith sent the young artist Marion Kavanaugh to see him in 1903, and they were married in Chicago the following year.

Elmer Wachtel and Marion Kavanagh Wachtel (she began to omit the "u" from her maiden name) spent the next twenty-five years as inseparable painting companions, he working in oils and she in watercolor. They traveled throughout California, the deserts of Arizona and New Mexico, and in Mexico. It was during a painting in Guadalajara in 1929 that Wachtel died.

Wachtel was an individualist who shunned the many arts organizations that developed in the early 1900s. He refused to join the California Art Club at its founding in 1905. This in no way affected the esteem in which he was held by his fellow artists. One-man exhibitions were held for him at the Museum of History, Science, and Art in 1915 and 1918. A memorial exhibition was held at Kanst Art Gallery in 1930. He received two awards from the San Francisco Art Association: for watercolor, in 1902; and for oils, in 1906.

Marion Kavanagh (nee Kavanaugh) Wachtel

Born June 10, 1876, in Milwaukee, Wisconsin
Died May 22, 1954, in Pasadena, California

Marion Kavanaugh studied at the Art Institute of Chicago and in New York with William Merritt Chase (1849–1916). For several years she taught at the Art Institute of Chicago. She then traveled to San Francisco to study with William Keith (1838–1911). Keith recommended that she go to Los Angeles to see artist Elmer Wachtel. They met in 1903 and were married the following year in Chicago. Thereafter she signed her name as "Marion Kavanagh Wachtel."

Returning to Los Angeles, the couple built a studio-home in the Mt. Washington area. They remained there until 1921 when they moved to the Arroyo Seco area of Pasadena. As inseparable painting companions, they traveled throughout Southern California and the desert Southwest. Originally trained as a portrait artist, Wachtel painted portraits of the Hopi Indians on a trip to Northern Arizona and New Mexico in 1908.

Perhaps so as not to compete with her husband, Wachtel worked primarily in watercolor throughout their marriage and displayed remarkable dexterity in the handling of the medium, which could be quite unforgiving even to the most skilled. She received high praise for her works, which are delicate, lyrical interpretations of the landscape. She was elected to the New York Water Color Club in 1911, was elected an associate of the American Water Color Society in 1912, and was a founding member of the California Water Color Society in 1921. She also held memberships in the Pasadena Society of Artists and the Academy of Western Painters. Her works were exhibited

jointly with her husband's, as well as in solo exhibitions in Los Angeles. One-person exhibitions of her paintings were held at the Los Angeles Museum of History, Science, and Art in 1915 and 1917.

After her husband's death in 1929, Wachtel temporarily lost interest in painting. She resumed working around 1931, painting the landscape around her home on the Arroyo Seco.

William Wendt

Born February 20, 1865, in Bentzen, Germany

Died December 29, 1946, in Laguna Beach, California

William Wendt emigrated to the United States in 1880, settling in Chicago where he worked in a commercial art firm. Essentially self-taught, for a brief period he attended evening classes at the Art Institute of Chicago. He preferred painting the landscape and became an active exhibitor in Chicago, winning the Second Yerkes Prize at the Chicago Society of Artists exhibition in 1893.

Wendt became friends with artist Gardner Symons, and they made a number of trips together to California between 1896 and 1904 and, in 1898, to the art colony at St. Ives in Cornwall. Works from those trips were exhibited at the Art Institute of Chicago.

Wendt settled in Los Angeles with his wife, sculptor Julia Bracken, in 1906. Already a successful painter, he quickly became a leading member in the art community and was a founding member of the California Art Club in 1909. He moved his home and studio to the art colony at Laguna Beach in 1912, the same year that he was elected to the National Academy of Design. He was a founding member of the Laguna Beach Art Association in 1918 and, although somewhat shy and reclusive, he was the art colony's most important resident artist-teacher.

Wendt perceived nature as the manifestation of God and viewed himself as nature's faithful interpreter. Only rarely did he include figures or animals in his landscapes. He worked out of doors, sometimes sketching, and sometimes making large, finished works. His early works reflect the feathery brushstrokes and hazy atmosphere of Impressionism. In his later works, after about 1912, he employed a distinctive block or hatch-like brushwork giving solidity to natural forms. A prolific painter, he became known as the "dean" of Southern California's landscape painters.

Exhibiting regularly in exhibitions in Los Angeles, Chicago, and New York, Wendt received numerous awards for his works. Among these were a bronze medal, Pan-American Exposition, Buffalo, 1901; a silver medal, Louisiana Purchase Exposition, St. Louis, 1904; and a silver medal, Panama-Pacific International Exposition, San Francisco, 1915. In 1925 he received a gold medal at the Pan-American Exhibition in Los Angeles for *Where Nature's God Hath Wrought,* which is now in the collection of the Los Angeles County Museum of Art.

John Gamble (1863–1957), *Santa Barbara Landscape,* oil on canvas, 24 x 36 inches

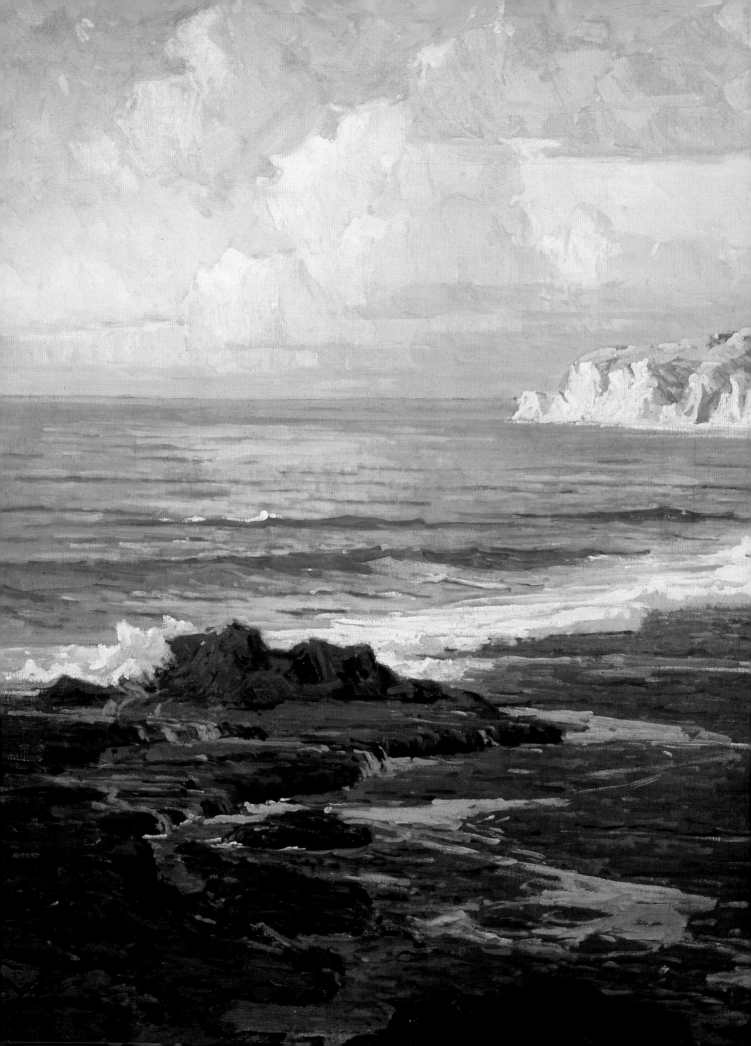

EXHIBITION CHECKLIST

Louis Betts (1873–1961)

1 *Midwinter, Coronado Beach*, circa 1907
 oil on canvas, 29 x 24 inches

Franz Bischoff (1864–1929)

2 *Canna Lilies*
 oil on board, 26 x 19 inches

3 *When Golden Sunbeams Shimmer*
 oil on board, 19³/₄ x 18³/₄

4 *San Juan Capistrano Mission Yard*, circa 1922
 oil on canvas, 24 x 30 inches

5 *Roses*
 oil on canvas, 30 x 40 inches

Jessie Arms Botke (1883–1971)

6 *Macaw and Cockatoos*, 1926
 oil on canvas on board, 25 x 30 inches

7 *Demoiselles Cranes and Lotus*
 oil on canvas, 40 x 30 inches

George Brandriff (1890–1936)

8 *Cannery Row, Newport Harbor*
 oil on board, 14 x 18 inches

Maurice Braun (1877–1941)

9 *San Diego Countryside with River*
 oil on canvas, 30 x 40 inches

10 *Springtime*
 oil on canvas, 25 x 30 inches

11 *The Oak*
 oil on canvas, 14 x 18 inches

12 *Road to the Canyon*
 oil on canvas, 24 x 30 inches

Benjamin Brown (1865–1942)

13 *A Quiet Reach, Matilija Creek*
 oil on canvas, 28 x 36 inches

14 *Poppy Field near Pasadena*
 oil on canvas, 16 x 22 inches

Alson Clark (1876–1949)

15 *Ruins of San Juan Capistrano*
 oil on board, 31 x 25 inches

Roi Clarkson Colman (1864–1945)

16 *The Opal Sea, Laguna Beach*, 1941
 oil on canvas, 22 x 30 inches

Colin Campbell Cooper (1856–1937)

17 *The Rustic Gate*
 oil on canvas, 46 x 36 inches

Meta Cressey (1882–1964)

18 *Under the Pepper Tree*
 oil on canvas, 36³/₄ x 40¹/₂ inches

Frank Cuprien (1871–1948)

19 *Evening's Iridescence*
 oil on canvas, 32 x 48 inches

20 *The Dream Ship*
 oil on canvas, 20 x 30 inches

21 *Tranquil Evening*
 oil on canvas, 24 x 32 inches

Paul DeLongpre (1855–1911)

22 *Roses*, 1909
 watercolor, 16¹/₂ x 25 inches

23 *Wild Roses*, 1898
 watercolor, 15 x 24 inches

24 *White Roses with Carpenter Bees*, 1905
 watercolor, 18 x 25 inches

Jack Wilkinson Smith (1873–1949), *Crystal Cove State Park* (detail), oil on canvas, 52 x 70 inches

John Frost (1890–1937)

25 *Mount San Jacinto,* 1926
 oil on canvas, 24 x 28 inches

26 *The Pool at Sundown,* 1923
 oil on panel, 24 x 28 inches

Arthur Hill Gilbert (1882–1930)

27 *Land of Gray Dunes, Monterey*
 oil on canvas, 32 x 40 inches

Percy Gray (1869–1952)

28 *Oak Tree and Poppies*
 watercolor, 12 x 15 inches

Paul Grimm (1892–1974)

29 *Eucalyptus and Clouds*
 oil on canvas, 25 x 30 inches

30 *The Desert in All Its Glory*
 oil on canvas, 24 x 48 inches

Anna Hills (1882–1930)

31 *Laguna Beach, near Moss Point,* 1920
 oil on canvas, 30 x 40 inches

32 *Fall, Orange County Park,* 1916
 oil on board, 14 x 18 inches

John Hilton (1904–1983)

33 *Dawn of the Primrose*
 oil on board, 16 x 20 inches

Thomas L. Hunt (1882–1938)

34 *Newport Harbor*
 oil on canvas, 28 x 31 inches

Aaron Kilpatrick (1872–1953)

35 *Eucalyptus,* 1911
 oil on canvas, 36 x 48 inches

Joseph Kleitsch (1882–1931)

36 *San Juan Capistrano,* 1924
 oil on canvas, 24 x 30 inches

37 *Bougainvillea, Capistrano Mission,* 1923
 oil on canvas, 30 x 24 inches

Edgar Payne (1883–1947)

38 *Thanksgiving at San Juan Capistrano*
 oil on canvas, 20 x 24 inches

39 *Hills of Altadena,* circa 1917
 oil on canvas, 36 x 45 inches

40 *Mountains at Sunset, Santa Barbara*
 oil on canvas, 36 x 44 inches

Granville Redmond (1871–1935)

41 *Lupines*
 oil on canvas, 9 x 12 inches

42 *Spring*
 oil on canvas, 18 x 20 inches

43 *Hazy Day in Antelope Valley*
 oil on canvas, 20 x 25 inches

44 *River with Oaks*
 oil on board, 5 1/2 x 7 1/2 inches

45 *Southern California Hills*
 oil on canvas, 25 x 30 1/4 inches

Guy Rose (1867–1925)

46 *In the Olive Orchard*
 oil on canvas, 15 x 18 inches

47 *Laguna Rocks, Low Tide,* circa 1916
 oil on canvas, 21 x 24 inches

48 *Lifting Fog, Laguna,* circa 1916
 oil on canvas, 23 1/2 x 28 1/2 inches
 Gift of James and Linda Ries

Donna Schuster (1883–1953)

49 *On the Beach, Laguna,* circa 1917
 oil on canvas, 29 x 29 inches

E. Roscoe Shrader (1878–1960)

50 *Geese*
 oil on canvas, 28 x 35 inches

Harold Streator (1861–1926)

51 *A California Garden in Santa Barbara*
 oil on canvas, 24 x 29 inches

Elmer Wachtel (1864–1929)

52 *In the Arroyo Seco*
 oil on board, 9 x 12 inches

Marion Kavanagh Wachtel (1876–1954)

53 *Matilija Canyon at Sunset*
 watercolor, 25 1/2 x 19 3/8 inches

54 *Monterey Coast*
 oil on board, 16 x 20 inches

55 *Sunset*
 watercolor, 24 x 18 inches

Wendt, William (1865–1946)

56 *There Is No Solitude, Even in Nature,* 1906
 oil on canvas, 34 x 36 inches

57 *San Juan Creek near the Mission*
 oil on canvas, 30 x 36

58 *Sermons in Stone,* 1934
 oil on canvas, 28 x 36 inches

59 *Crystal Cove,* 1912
 oil on canvas, 28 x 36 inches

60 *Sycamores*
 oil on canvas, 30 x 40 inches

SELECTED BIBLIOGRAPHY

Anderson, Susan M. *Regionalism: The California View, Watercolors, 1929–1945,* exhibition catalogue. Santa Barbara: Santa Barbara Museum of Art, 1988.

Anderson, Thomas R., and Bruce A. Kamerling. *Sunlight and Shadow: the Art of Alfred R. Mitchell, 1888–1972,* exhibition catalogue. San Diego: San Diego Historical Society, 1988.

Art of California. San Francisco: R.L. Bernier Publisher, 1916.

Baigell, Matthew. *The American Scene: American Painting of the 1930s.* New York: Praeger Publishers, 1974.

Baird, Joseph Armstrong, Jr., ed. *From Exposition to Exposition: Progressive and Conservataive Northern California Painting, 1915–1939,* exhibition catalogue. Sacramento: Crocker Art Museum, 1981.

Brinton, Christian. *Impressions of the Art at the Panama-Pacific Exposition.* New York: John Lane Co., 1916.

Brother Cornelius, F.S.C., *Keith: Old Master of California.* New York: G.P. Putnam's Sons, 1942.

Cahill, Holger. *American Art Today, New York World's Fair.* New York: National Art Society, 1939.

California Design 1910. Pasadena: California Design Publications, 1974.

California Grandeur and Genre: From the Collection of James L. Coran and Walter A. Nelson-Rees, exhibition catalogue. Palm Springs, California: Palm Springs Desert Museum, 1991.

Carl Oscar Borg: A Niche in Time, exhibition catalogue. Palm Springs: Palm Springs Desert Museum, 1990.

Coen, Rena Neumann. *The Paynes, Edgar and Elsie: American Artists.* Minneapolis: Payne Studios Inc.,1988.

Color and Impressions: The Early Work of E. Charlton Fortune, exhibition catalogue. Monterey, California: Monterey Peninsula Museum of Art, 1990.

Dominik, Janet Blake. *Early Artists in Laguna Beach: The Impressionists,* exhibition catalogue. Laguna Beach, California: Laguna Art Museum, 1986.

Falk, Peter Hastings. *Who Was Who in American Art.* Madison, Connecticut: Sound View Press, 1985.

Gerdts, William H. *American Impressionism.* New York: Abbeville Press, Publishers, 1984.

_____. *American Impressionism,* exhibition catalogue. Seattle: the Henry Art Gallery, 1980.

Granville Redmond, exhibition catalogue. Oakland: The Oakland Museum, 1988.

Hailey, Gene, ed. *Abstract from California Art Research: Monographs.* W.P.A. Project 2874, O.P. 65–3–3632. 20 vols. San Francisco: Works Progress Administration, 1937.

Hatfield, Dalzell. *Millard Sheets.* Los Angeles and New York: Dalzell Hatfield, 1935.

Hughes, Edan Milton. *Artists in California: 1786–1940.* 2nd ed. San Francisco: Hughes Publishing, 1989.

Impressionism: The California View, exhibition catalogue. Oakland: the Oakland Museum, 1981.

Laird, Helen. *Carl Oscar Borg and the Magic Region.* Layton, Utah: Gibbs M. Smith, Inc., Peregrine Smith Books, 1986.

Lovoos, Janice, and Edmund F. Penney. *Millard Sheets: One-Man Renaissance.* Flagstaff, Arizona: Northland Press, 1984.

Lovoos, Janice, and Gordon T. McClelland. *Phil Dike.* Beverly Hills, California: Hillcrest Press, Inc., 1988.

McClelland, Gordon T., and Jay T. Last. *The California Style: California Watercolor Artists, 1929–1955.* Beverly Hills: Hillcrest Press, Inc., 1985.

Millier, Arthur. "Growth of Art in California." In *Land of Homes* by Frank J. Taylor. Los Angeles: Powell Publishing Company, 1929.

Moure, Nancy Dustin Wall. *Artists' Clubs and Exhibitions in Los Angeles before 1930.* Los Angeles: Privately Printed, 1974.

_____. *The California Water Color Society: Prize Winners, 1931–1954: Index to Exhibitions, 1921–1954.* Los Angeles: Privately Printed, 1973.

_____. *Dictionary of Art and Artists in Southern California before 1930.* Los Angeles: Privately Printed, 1975.

_____. *Loners, Mavericks and Dreamers: Art in Los Angeles before 1900,* exhibition catalogue. Laguna Beach, California: Laguna Art Museum, 1994.

_____. *Painting and Sculpture in Los Angeles: 1900–1945,* exhibition catalogue. Los Angeles: Los Angeles County Museum of Art, 1980.

_____. *Southern California Artists: 1890–1940,* exhibition catalogue. Introduction by Carl Dentzel. Laguna Beach, California: the Laguna Beach Museum of Art, 1979.

_____. *William Wendt, 1865–1946,* exhibition catalogue. Laguna Beach, California: Laguna Beach Museum of Art, 1977.

Nelson-Rees, Walter A. *Albert Thomas DeRome, 1885–1959.* Oakland: WIM, 1988.

Nochlin, Linda. *Realism.* New York: Penguin Books, 1971.

Orr-Cahall, Christina. *The Art of California: Selected Works of the Oakland Museum.* Oakland: The Oakland Museum Art Department, 1984.

Perine, Robert. *Chouinard: An Art Vision Betrayed.* Encinitas, California: Artra Publishing, Inc., 1985.

Petersen, Martin E. *Second Nature: Four Early San Diego Landscape Painters,* exhibition catalogue. San Diego: San Diego Museum of Art and Prestel-Verlag, Munich, 1991.

Stern, Jean. *Alson S. Clark.* Los Angeles: Petersen Publishing Co., 1983.

_____. *Masterworks of California Impressionism: The FFCA, Morton H. Fleischer Collection.* Phoenix: FFCA Publishing Company, 1986.

_____. *The Paintings of Franz A. Bischoff.* Los Angeles: Petersen Publishing Co., 1980.

_____. *The Paintings of Sam Hyde Harris.* Los Angeles: Petersen Publishing Co., 1980.

Stern, Jean, and Janet Blake Dominik, and Harvey L. Jones, *Selections from the Irvine Museum,* exhibition catalogue. Irvine, California: The Irvine Museum, 1993.

Tonalism: An American Experience. New York: Grand Central Art Galleries Art Education Association, 1982.

Trenton, Patricia, and William H. Gerdts. *California Light 1900–1930,* exhibition catalogue. Laguna Beach, California: Laguna Art Museum, 1990.

Vincent, Stephen, ed. *O California!: Nineteenth and Early Twentieth Century California Landscapes and Observations.* San Francisco: Bedford Arts, Publishers, 1990.

Westphal, Ruth Lilly. *Plein Air Painters of California: The North.* Irvine, California: Westphal Publishing, 1986.

_____. *Plein Air Painters of California: The Southland.* Irvine, California: Westphal Publishing, 1982.

Westphal, Ruth Lilly, and Janet Blake Dominik, eds. *American Scene Painting: California, 1930s and 1940s.* Irvine, California: Westphal Publishing, 1991.

THE IRVINE MUSEUM

Reflections of California: The Athalie Richardson Irvine Clarke Memorial Exhibition was compiled by Joan Irvine Smith and Jean Stern, and the manuscript was edited by David Parry. Paintings reproduced in this catalogue were photographed by Casey Brown. The book was designed by Lilli Colton and Steven Rachwal. Text was composed by Steven Rachwal in Perpetua, the first typeface by Eric Gill, which he created in 1927. The display type is Gill Sans, issued in 1928–30 by Eric Gill. The logotype was designed specifically for this publication and is a variation of Gill Sans. 5,000 copies of this book were lithographed on Quintessence Dull by Typecraft, Inc. and casebound by Rosswell Bookbinding. Production was coordinated by Lilli Colton. This is the first edition.